MW01042462

Cold Comfort

RMB

MARCUS PALADINO

COLD COMFORT

SURF PHOTOGRAPHY FROM CANADA'S WEST COAST

FOREWORD BY NOAH COHEN

I would like to acknowledge the traditional, ancestral, unceded territory of the Tla-o-qui-aht First Nations, of which much can be seen throughout this book. The lands of the Nuu-chah-nulth Peoples have enriched my life every day, and are truly the reason my career in photography has been possible. Waves have been breaking on this coast since the dawn of time, and it's important to acknowledge the people who have stewarded this land for centuries. These waters and this land would not be so beautifully intact without the preservation by the local Indigenous communities and land caregivers.

This is for Nora.

For always loving me, even when I don't love myself.

"Marcus's photography has seen constant evolution over the years that we've worked together, and continues to grow steadily. His creativity in shooting even the most mundane conditions continually produces quality imagery. His ability to look at a situation that has been shot many times before and see a new way to capture it is one of his greatest strengths."
—*Pete Devries*

FOREWORD

by Noah Cohen

I first happened upon a youthful Paladino perched on a rock, with his camera focused on the waves at Cox Bay. The surf was lacklustre, whipped by the beaters of summertime westerlies as it so often seems to be, coupled with a searing mid-afternoon glare. "Looks great out there, man!" he shouted down from the point. His sentiment was earnest, without even a hint of sarcasm. We chatted for a minute, before I hopped in the water. It was apparent from that first moment we spoke that Marcus housed an affinity for the ocean, and a passionate exuberance that would drive him toward capturing many special images in the years to come.

Throughout the decade preceding our meeting, Tofino has grown firmly into the premier tourist destination in the country, with droves of travellers flocking westward each year to experience the breathtaking beauty tucked amidst its mountains, sounds and watersheds. There is a powerful calm that shrouds the land, met with an equivocal strength in the waters that surge at its shoreline. A seemingly infinite amount of images from this area are captured, though rarely do I come across one that freezes me in my tracks. Perhaps it's a by-product of living here for so long, unintentionally numbed to the beauty that lies in bed beside me. But when I browsed through a pile of selects for this project, it felt like I was halted by so many of them, gripped by their power and forced to take a minute to absorb each and every feeling that emanated through Paladino's lens.

Paralleling Tofino's proverbial coming of age, so too has Marcus's work. He has held on to that same passionate spark that's been present since he arrived here as a fledgling photographer, and he's dedicated nearly every moment from then on to creatively capturing and documenting the immense beauty of Clayoquot Sound. It's been inspiring to watch him continue to hone and perfect his craft, as well as a privilege to frequently feature as a subject in his handiwork. This book offers a uniquely framed portal into a charismatic town that sits at the end of the road, delivered by one of its happiest and hardest-working residents. ∎

01

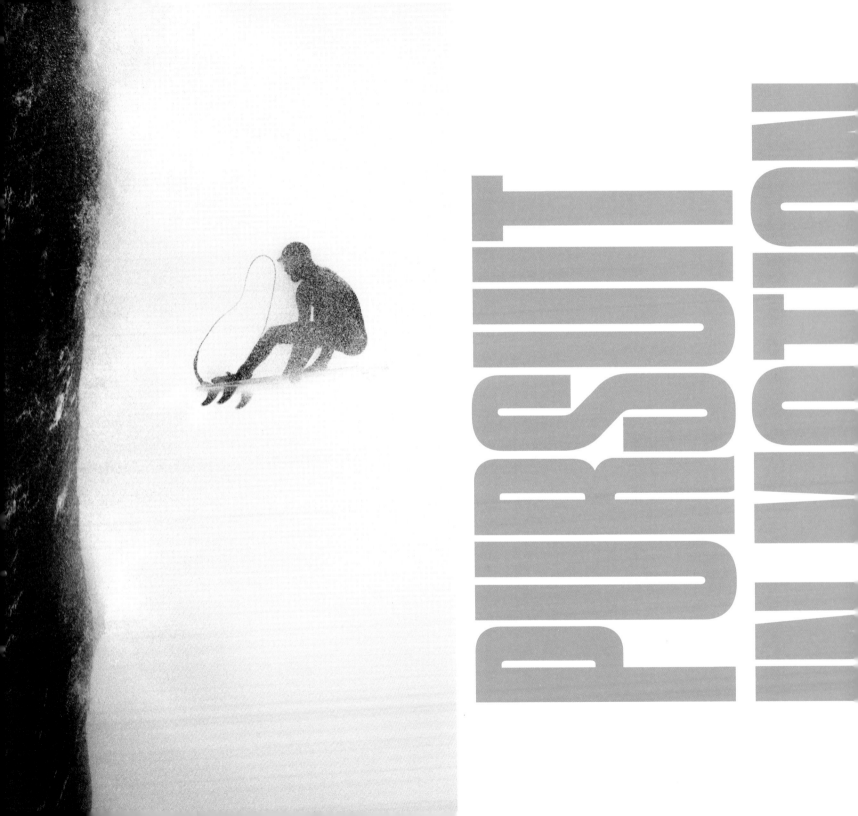

PURSUIT IN MOTION

MOTION

or How I learned to relax and let surf photography
take over my life.

Marcus Paladino

My godmother and I have always had a really powerful connection, almost as if we're the same person. She's like a drinking buddy and a motherly figure all rolled into one, which is why I've considered her my second mom. She is the person who got me my first camera. I never asked for one, nor did I have any previous interest in photography, but she got me a plastic point-and-shoot film camera anyway. It's as if she knew.

In my teenage years, that camera ended up being used mostly to hide my illegal paraphernalia. Where the roll of film would be, I'd hide my stash and no one could investigate because they would "expose the film and ruin my photos." I only signed up for photography in high school because my older sister said it was an easy A. Considering the only A I ever got in school was in PhysEd, I thought I could use the GPA boost. All my friends were in another class, so I ended up with the artistic outcasts, who actually paid attention to our lectures and assignments. My mind was always hard to keep up with, which is part of why I never did well in school, but working with 35mm film and creating timeless art slowed everything down and gave me a sense of calm. With no distractions, I found myself in a peaceful bliss, quietly working away in the darkroom.

At the end of the term I was granted an Outstanding Achievement award in Photography. For the first time in my life I had legitimate recognition for something that I enjoyed.

By the time graduation came, I was lost. Not sure what to do with my life, I sought counsel with one of my favourite teachers. His advice was simple: "Find what you love to do, then find a way to get paid for it." I got accepted to a college with a solid Fine Arts program, and to my satisfaction it was only a 30-minute drive from the local ski resort. However, my instructors were getting fed up with me trying to incorporate movement, action or sports into every assignment. It was either that or the fact that I'd show up to class straight from the mountain and still covered in snow. Thankfully, it was only a ten-month program. By the year's end my suspicions were confirmed: school wasn't for me. School felt more like a competition than a learning experience. I got told that I would never "make it" as a photographer if I avoided weddings. But in reality I didn't want to shoot weddings; they're not fast enough. I live above 1/800th of a second. So I left for the mountains with a dream and a large unpaid student loan.

03

Seasons went by, pow was slashed, friends were made, fun was had. I still struggled to make that transition from amateur to professional. Even though my certificate claimed I was, I refused to call myself one. That changed when a co-worker told me about his off-season in a small surf community on the edge of Vancouver Island. Tofino ... I had a feeling while riding the bus along that narrow, winding road that I was on my way home. Surfing was a natural attraction for someone who loves constant movement. Surfers complain about the difficulty of working with an ever-changing environment, but I loved it and thrived on the excitement the challenge presented. I lived in a staff accommodation at a beachfront resort, so the majority of my 20 roommates were avid surfers. Having that as my newly acquired addiction helped develop my surf photography and still plays an active role in my style. Staying for the summer turned into staying for the winter. Which changed into staying forever. Without realizing it I went from a transient ski bum into a grounded local.

With the hiatus of Canada's only surf magazine, I started filming/editing to fill any voids that might have opened up. I spent every day working to live, biking in the cold, standing in the rain and surfing as much as humanly possible. With a lack of sun, numb feet, no money, limited gear, amazing friends, talented professionals and constantly changing conditions, I got by. One short guerrilla film became an entire cult trilogy, and I was told that without realizing it we were keeping the Canadian surf culture alive. If you work hard enough, people start to notice. For me, the right person noticed. A local surfboard shaper liked what I was doing, and took a chance on a kid who had a blog and was making stupid videos with his friends. He hired me to promote his business and shoot with his team riders. My dream became a reality. Though the money was minimal it was enough to forgo a day job, and even though I was literally living paycheque to paycheque, it allowed me to focus on my craft full-time.

The worst part about living the dream is when it's time to wake up. I was thanked for all my hard work and enthusiasm, but we had to make a change with my subcontract employment. I was let go from my marketing manager duties and placed as a social media coordinator. When caught standing still, do you take a step forward or backward? My heart knew I had to keep going, even without that safety net. I made a decision to focus solely on achieving my goal, to be a freelance surf photographer. I started shooting full-time with one of Canada's top surfers, and his hard work and dedication rubbed off on me quickly. Working with him became (and still are) some of the most inspirational times of my life. This was my routine for the better part of a year: shoot, surf, shoot, edit, emails, sleep. Every single day. With a strict regimen like this, I ended up sacrificing a lot of potentially loving relationships. At the time I was willing to make that sacrifice – I didn't want to be distracted and

lose momentum. I worked so hard that it scared me, and at times it physically hurt. That was a constant reminder to keep my motivation from fading; you have to suffer to succeed. I would stare at my bank account and think: *If I don't make any more money, how many months do I have left?* I was starting to wear myself thin mentally. Anxiety developed, but I just couldn't shake it. I was living and breathing surf photography. It took over my life.

As the days started getting longer, a sense of relief began to come over me. Editors were replying to my emails, clients were asking for my rates and photos were starting to get published. All that stress had finally led me to comfort. It was as if this was no longer a struggle, but a new life I had made for myself. When I finally began to breathe normally and calm my mind, I realized that while I might not have *made it,* whatever *it* is, I finally could see that I was *on my way*. I'm proud to have done it *my way*. I had countless offers from friends to join them up north in the oilfields and make "real money," but I just couldn't sacrifice my happiness for dollars. And that's what all this is about … trying to be happy. It's easy to let money dominate my thoughts in a business that's always progressing, always changing. Stay on top, stay on top. Photography advances just as much as, if not more than, the sports it documents. I can always achieve more and take a better photo than I could the day before. An end goal is just an illusion. I've still got a long way to go and always will have, but where am I trying to go and what's driving me there? Money? No, not money. It took a while to realize this, but reflecting on who I am and the people who have influenced me shows that money has never defined me. My godmother didn't buy a camera for me because she thought it would make me rich. She knew me well and took a chance on something she thought would make me happy.

Trying to make a living as a surf photographer isn't easy. Technology is making it easier for more people to get into the business, which actually makes it financially harder for everyone to make money. But everybody already knows there are smoother paths to financial security beyond photography. Surf photography is about as rough as it can get, but I still want to do it. What else can I say other than I've always tried to be true to myself and I truly want to try and keep doing this for the rest of my life. I hope that when people look at my work they get a small portion of the joy I experienced in taking the photograph. I never take photos of myself, but I always try and put a little of me into each image. I think those images will be a more truthful expression of me than these words ever will. ■

PHOTOGRAP

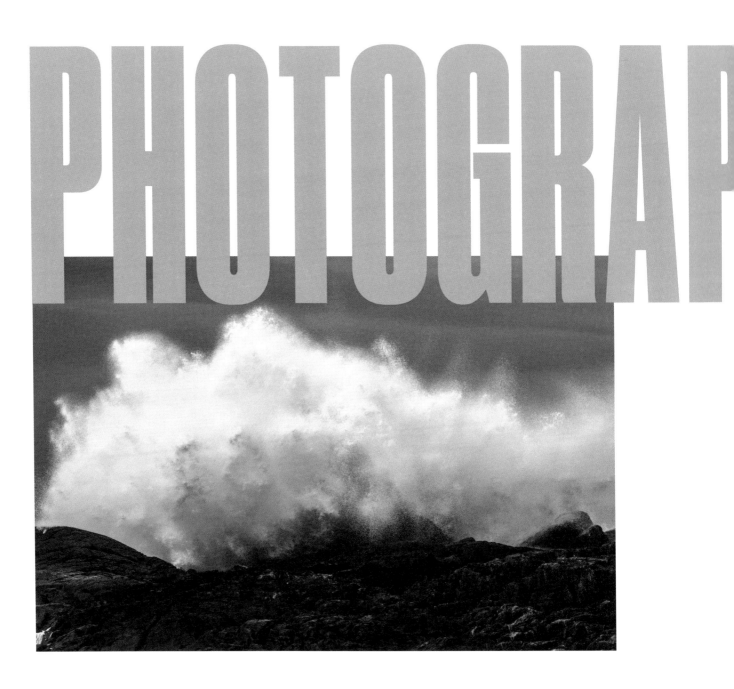

HER'S NOTE

Throughout this book you'll notice that I have often left out the location names for my work. In surfing, as with many other things, it is best to keep the names of specific waves quiet in order to prevent crowds and overpopulated breaks. Even if the location is obvious due to unique backdrops and landmarks, the golden rule applies: if you know, you know. Photographers have been traditionally known for shining a light on surf spots, and I have always intended to change that narrative over time. ∎

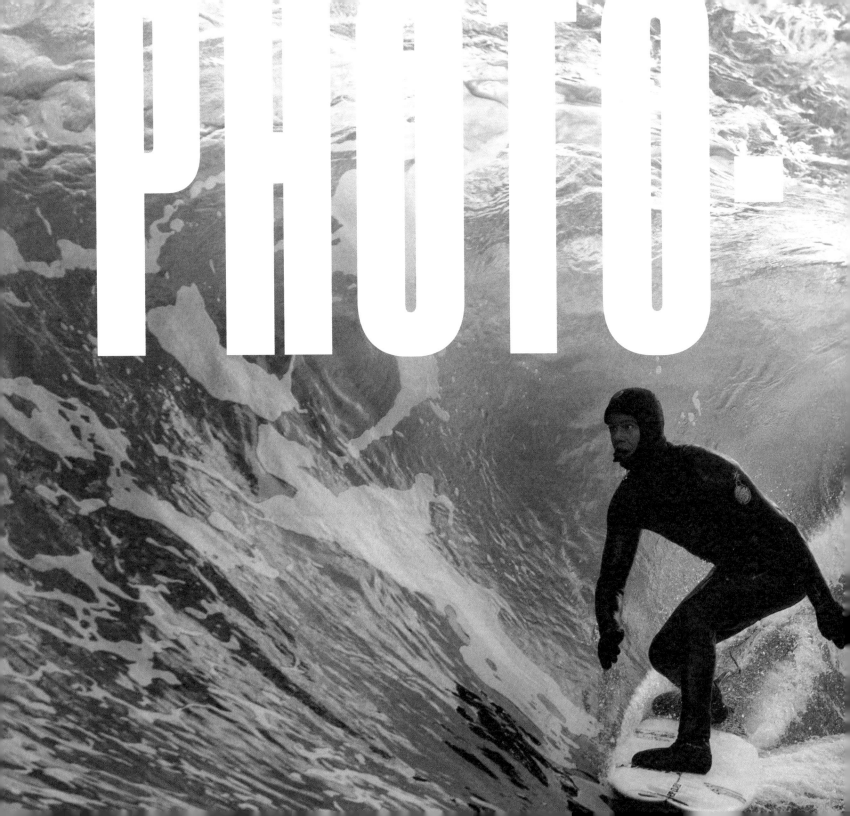

PHOTO·

GRAPHS

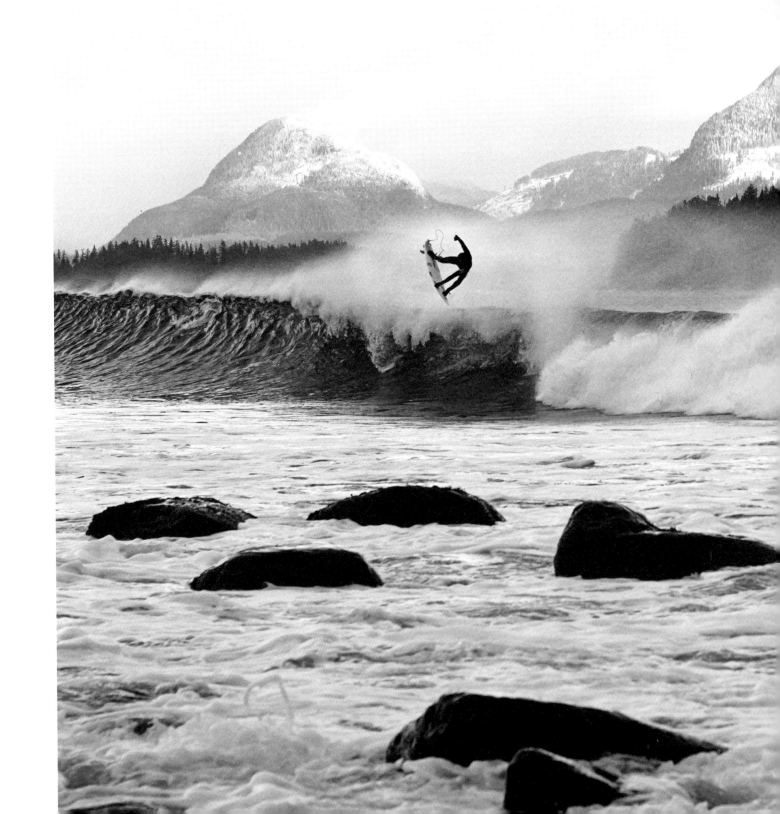

10

11

← This was the day I met Pete Devries. I ran into him while hiking to the surf and he asked if I'd brought any spare booties, as he had forgotten his. I offered up my only pair and opted to just shoot on the beach instead of surfing. I shot video most of the day but decided to switch and take a few photos before leaving. This was the only time I've ever yelled "YES!" while lining up my angle and firing the shutter. Little did I know how significant this day was. It started the beginning of my journey as a surf photographer. Canada's best surfer not only knew who I was, but this photo also ended up being my first internally paid/published photograph. I've always called this photo 'Numb Feet,' not for the obvious reasons, but because my gumboots had filled up with ice-cold river water on the way there.

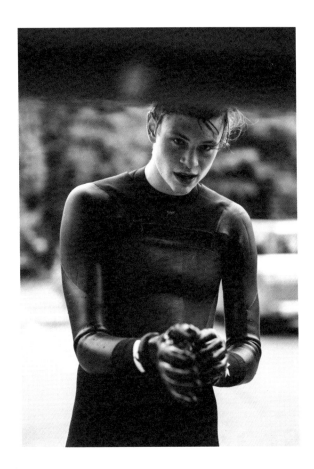

↑ Michael and I met through a mutual friend at the pub one night, at which point he ordered a coffee at 9 pm and only spoke when spoken to. His nickname is "Waterspider" because he's mostly arms and legs, and spends more time in the water than he does on land. We started working together while I was still filming my guerrilla surf flick *Kooks 3* and haven't looked back since.

→ This shot of Michael Darling was taken on the rooftop of Long Beach Lodge Resort. This was my first place of employment when I moved to Tofino. I worked from the laundry room, to the kitchen, to the surf school, and they always continued to give me opportunities to help turn my photography from a hobby into a career.

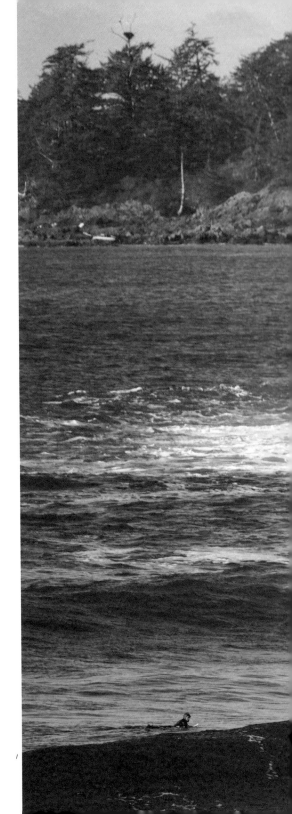

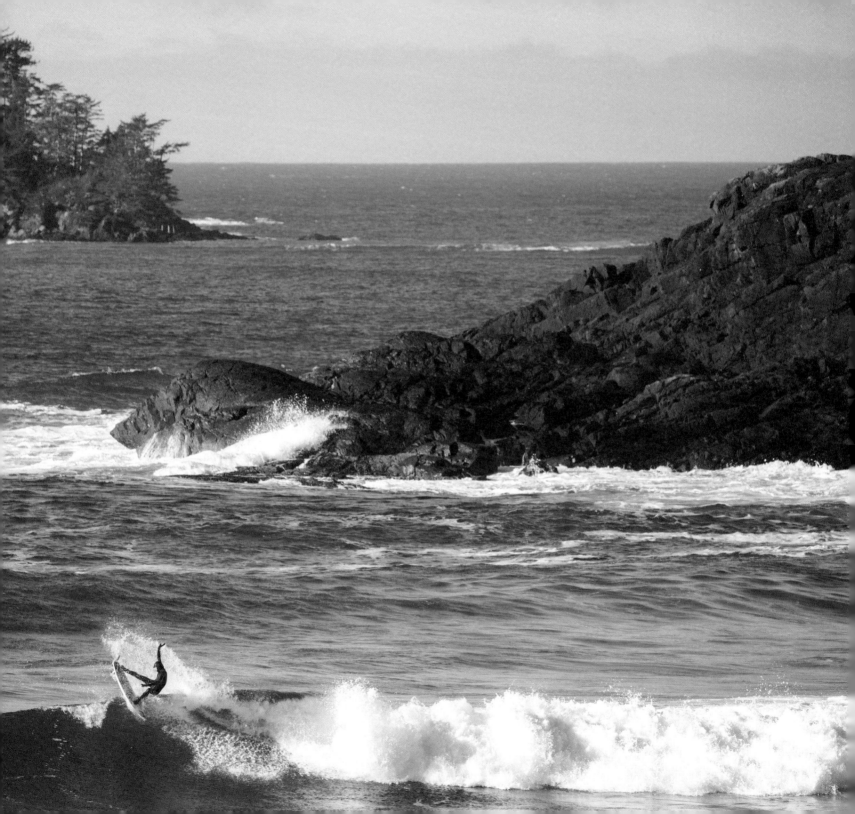

14

→ I've been dreaming of this angle, but it's impossibly hard to line up on any given day. A bit too far out and you miss the shot completely, a bit too far in and you'll get crushed on the inside. With such a shallow reef below, there's not much room for error here.

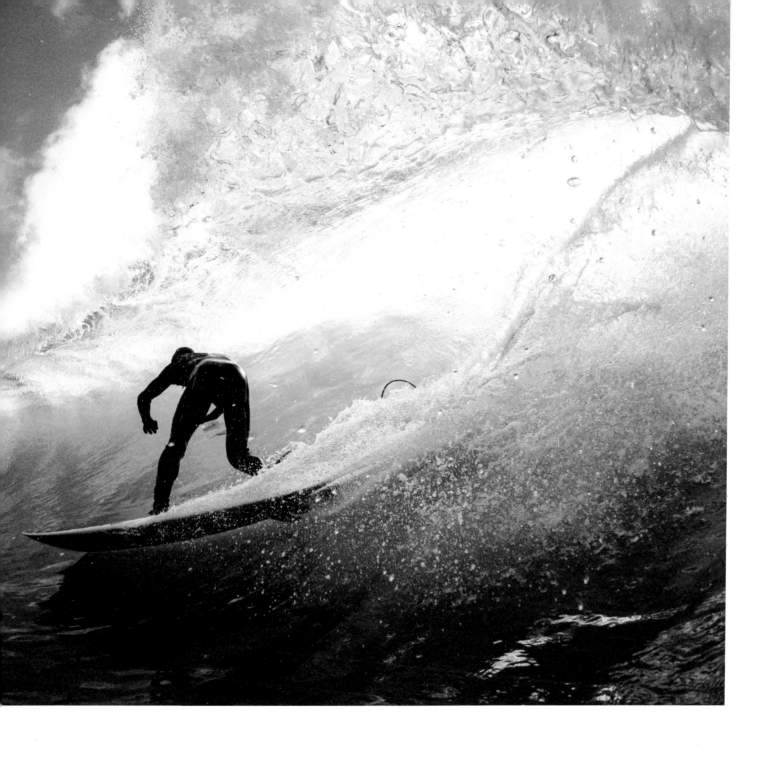

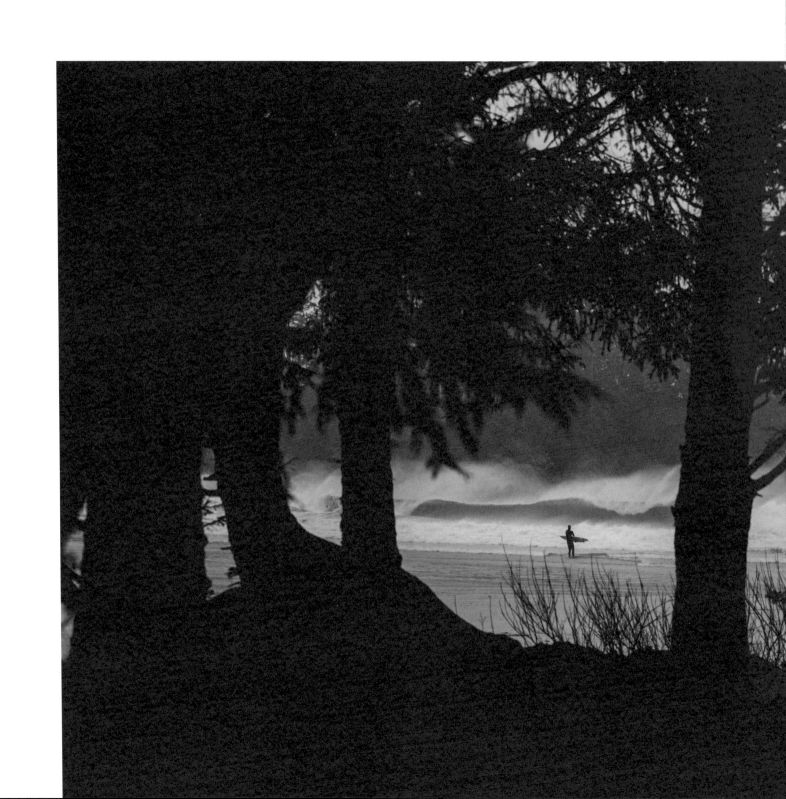

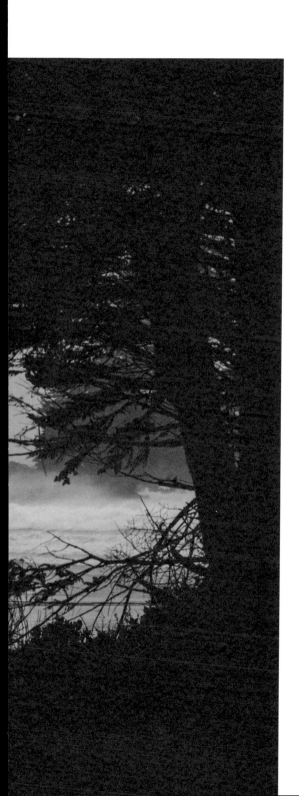

← A nameless surfer watching the wild Pacific Ocean in the winter.

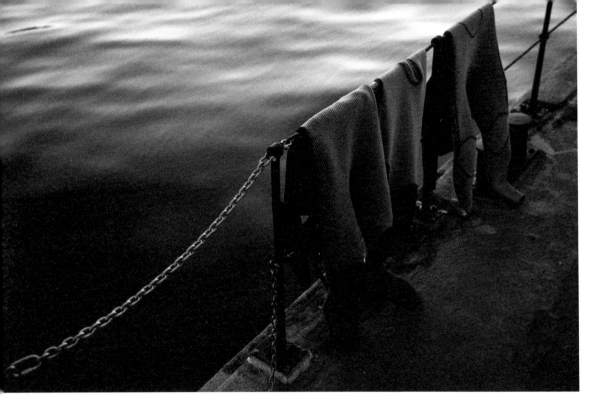

 A calm morning while our wetsuits hang to dry off the deck during a three-day boat excursion along Vancouver Island's coast.

→ With a snow-capped mountain in the background and Pete Devries in the foreground, I can't think of a better representation of surfing in Canada.

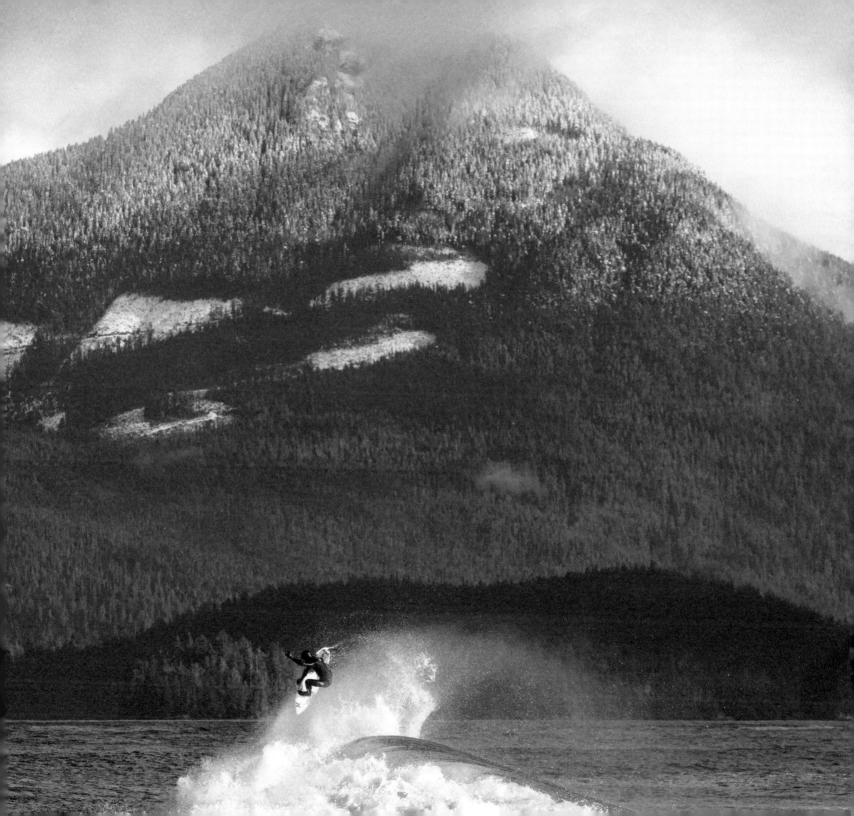

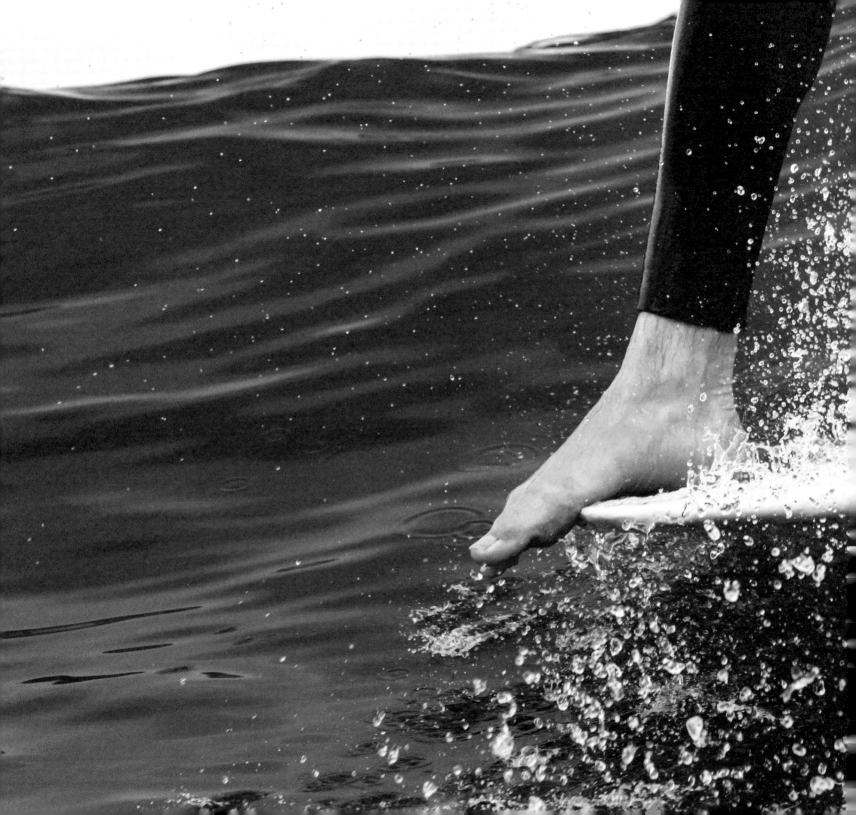

↰ Andy Jones perfectly demon-
strates what it means to have his
toes on the nose.

22

→ This was the only photo I shot
from the water that morning. My
camera housing malfunctioned
when I swam out and I had to go
back to shore investigate what
was wrong.

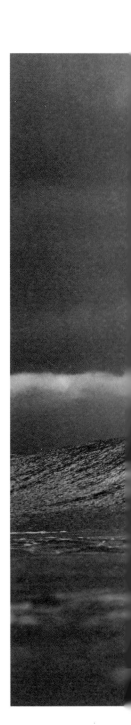

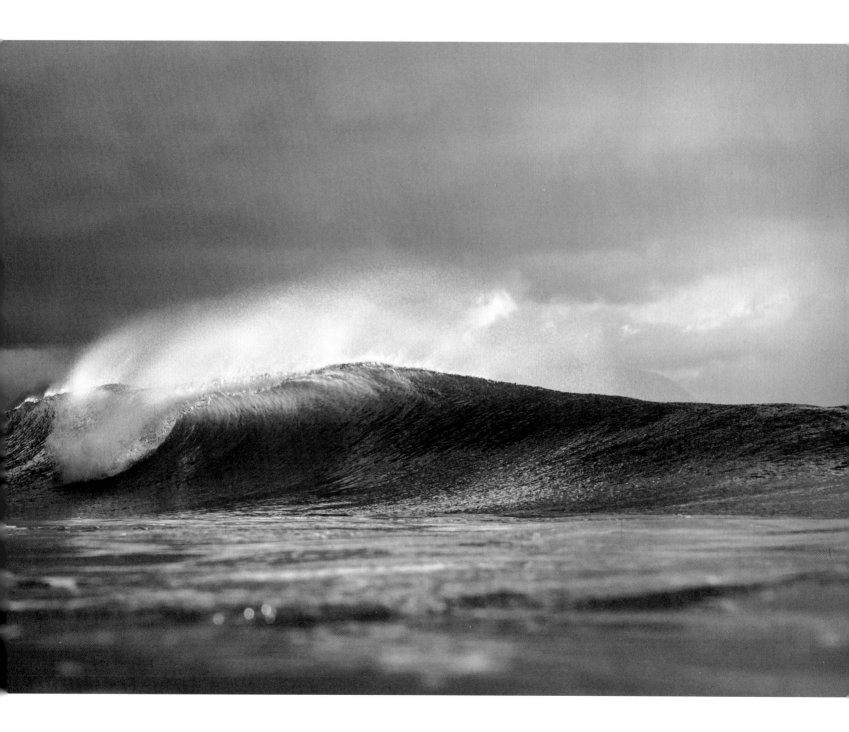

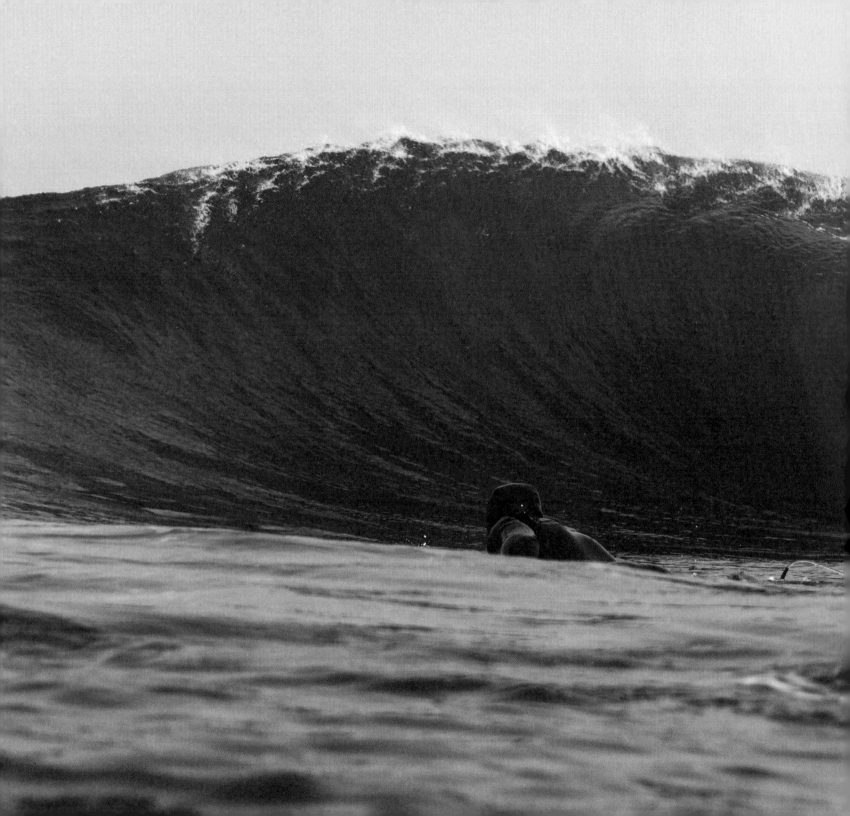

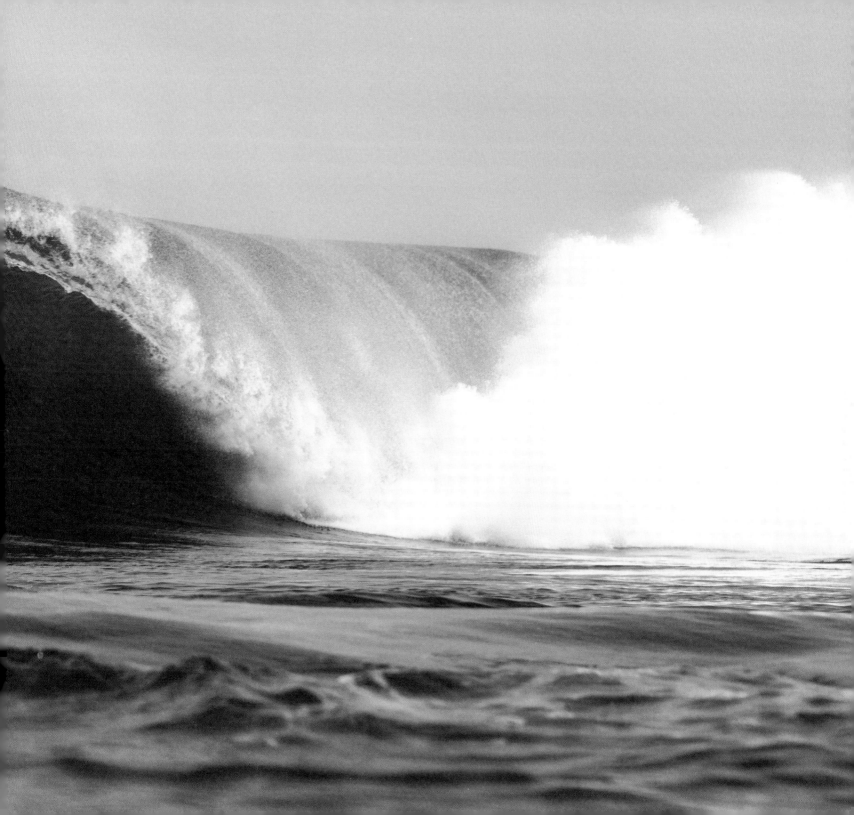

↰ *Surfer* magazine once claimed this as one of the top 100 waves in the world. This was shot during my first visit here, and it sure lived up to the hype. Unfortunately, I haven't seen it this clean since then.

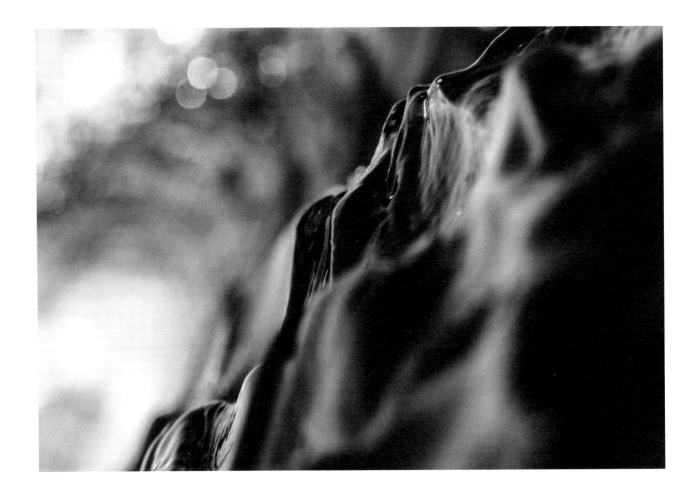

↑ When it comes to shooting waves, it's all about the little details.

≫ Pete Devries ended up breaking the nose clean off his board 30 minutes after this shot was taken.

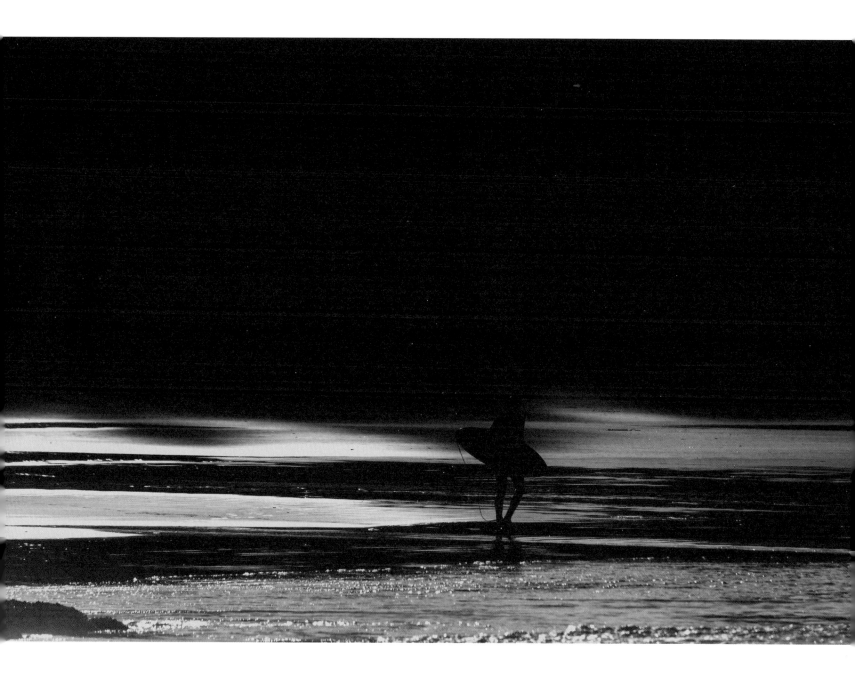

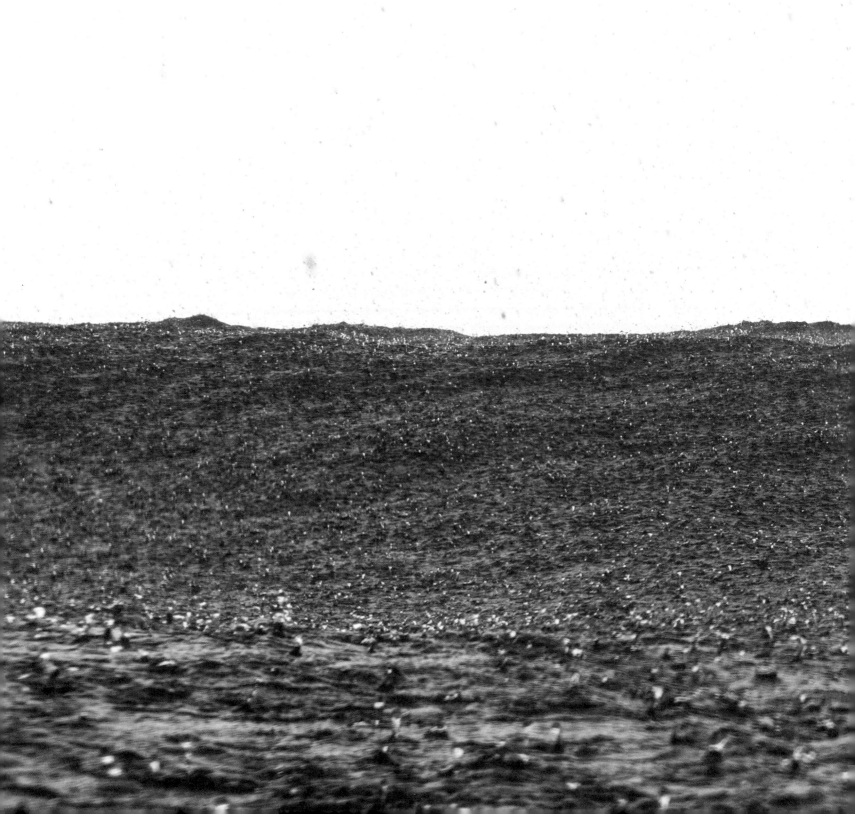

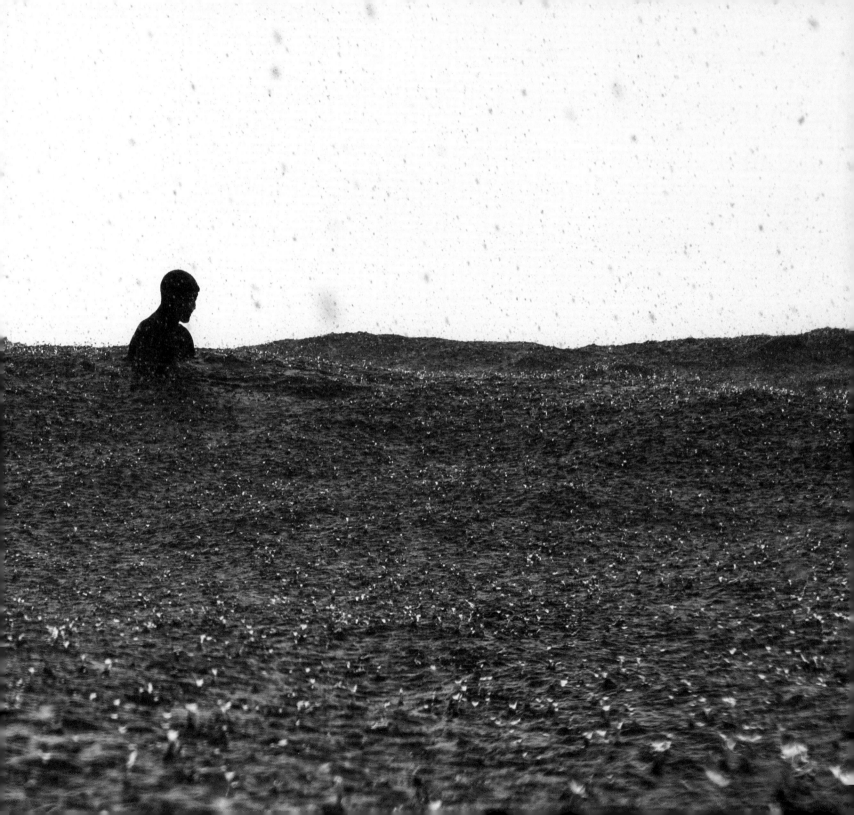

← Kalum Temple Bruhwiler, keeping calm during a torturous hailstorm. While everyone around him was hiding under their surfboards, he just waited for his next wave.

» For years and years I've been trying to figure out how to shoot from more helicopters without paying an arm and a leg. Thanks to drones these angles have become possible for me to find on a daily basis. It's all still very new to me, but I've been enjoying this new perspective to feed my creativity. It has brought me a new lens, quite literally, to an old scene that's one I have shot a thousand times over.

↓ With no access to drive down this abandoned road to the beach, it gives us an excuse to dust off the old skateboard.

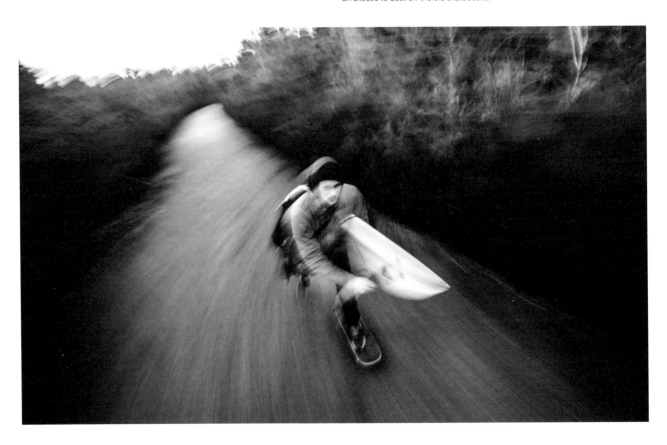

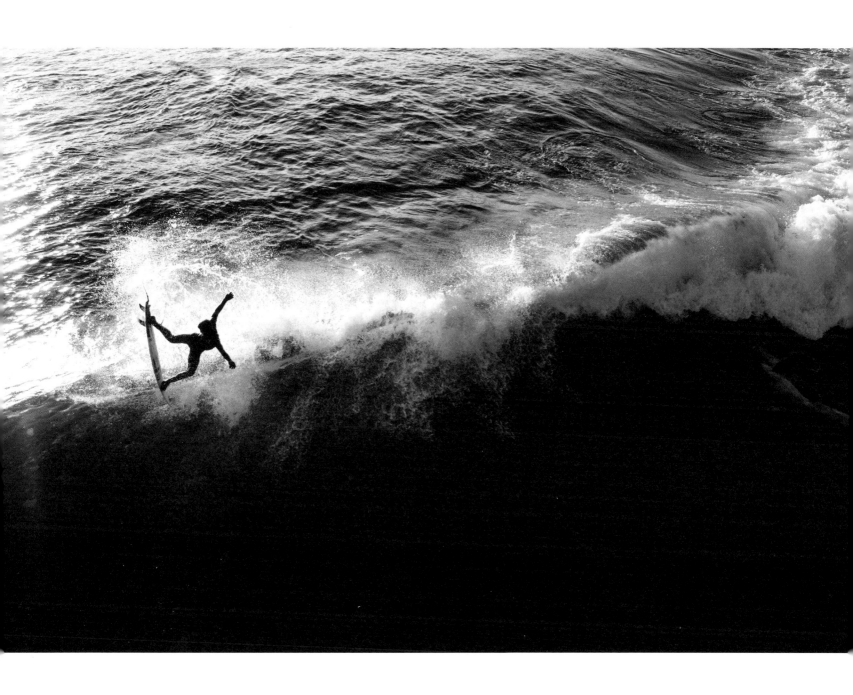

→ After twenty years of partnership, Pete Devries and Hurley parted ways at the end of 2019. On the first day of 2020, he took a sharpie to the old logo to sport a suit of pure black neoprene. He confirmed most of the surf world's suspicions that he doesn't need a sponsor to be the most barrelled man in cold water, though his time as an unsponsored surfer unsurprisingly didn't last long.

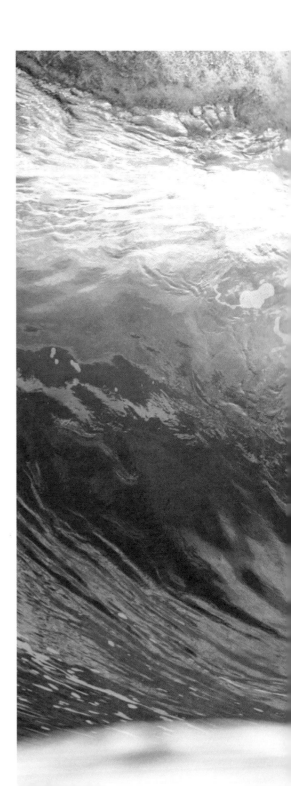

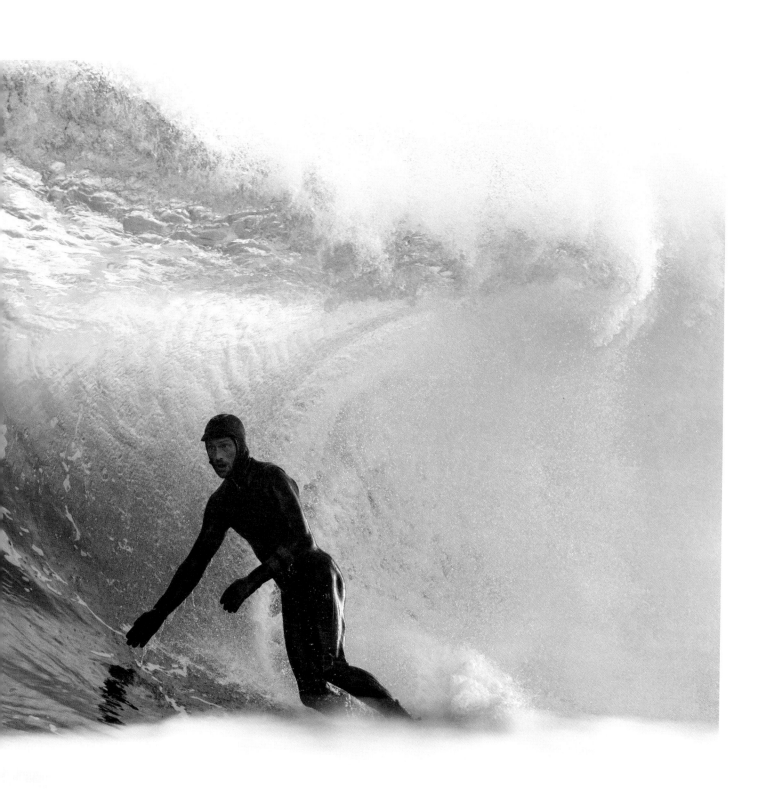

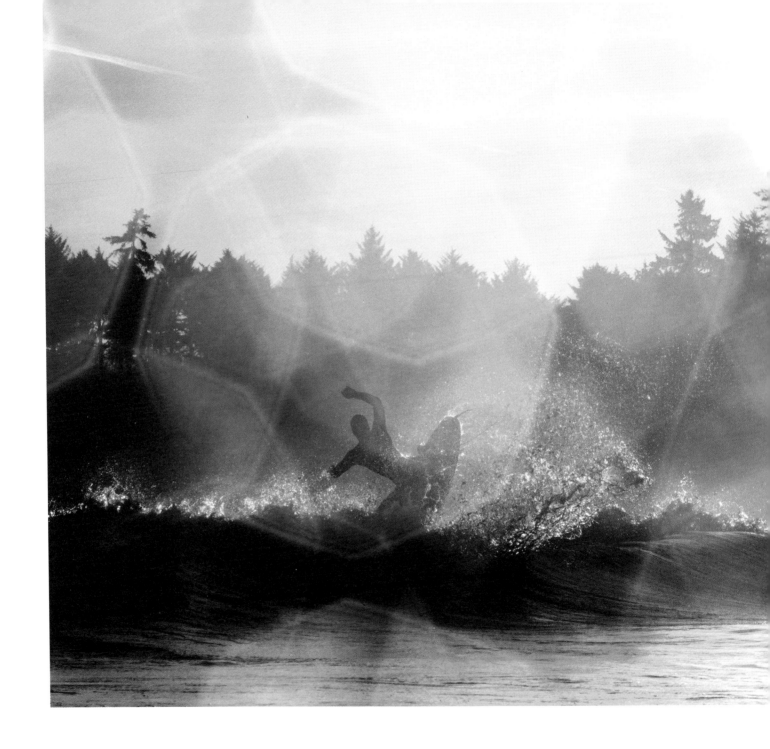

← Kalum Temple Bruhwiler is the nephew of Raph and Sepp Bruhwiler, two of Canada's first professional surfers. You could say that surfing is in his blood.

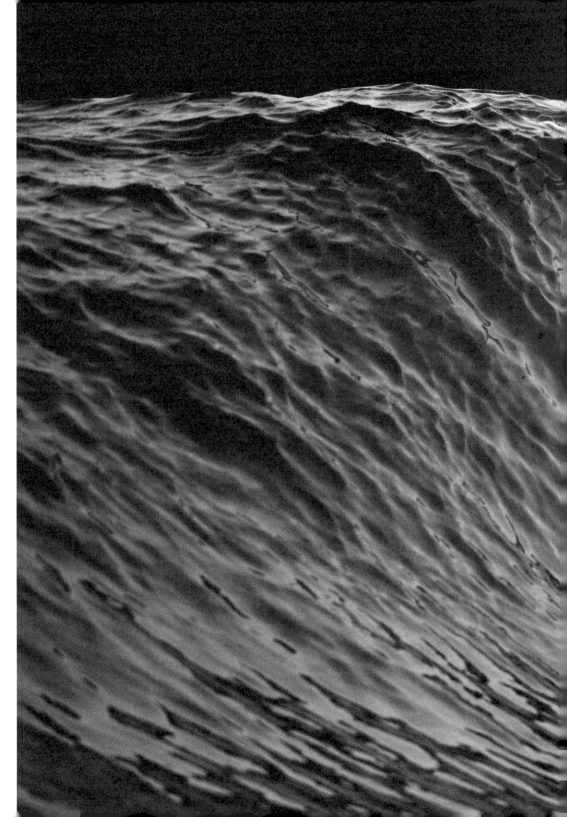

→ A wall of water about to
explode onto the shore.

36

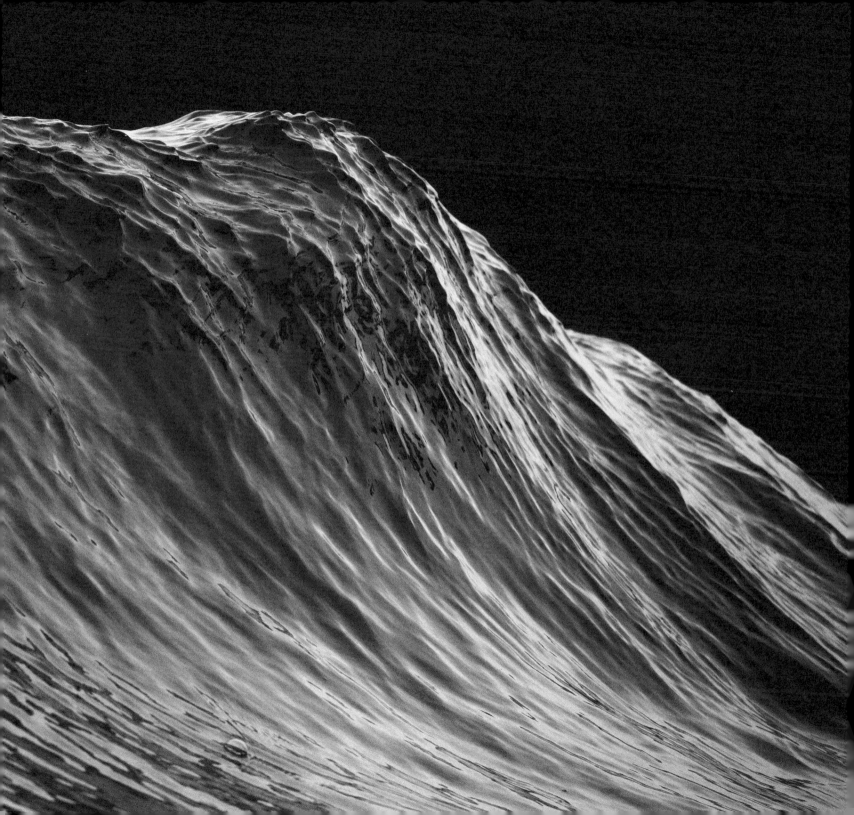

→ Michael Darling having to
straighten out and just try to
survive the impact behind him.

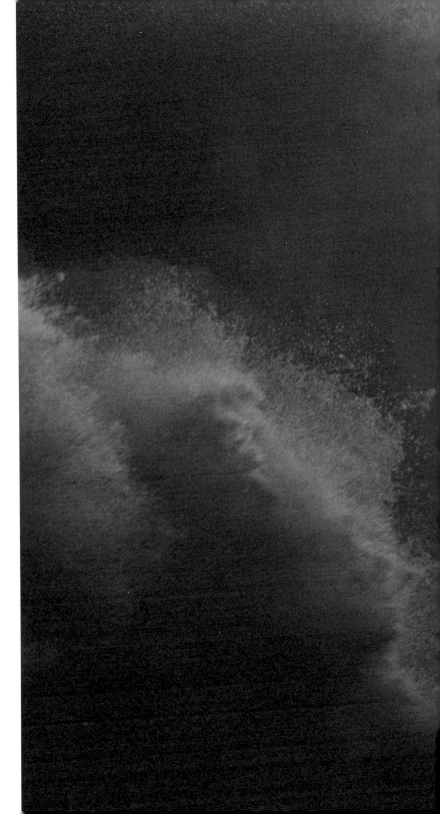

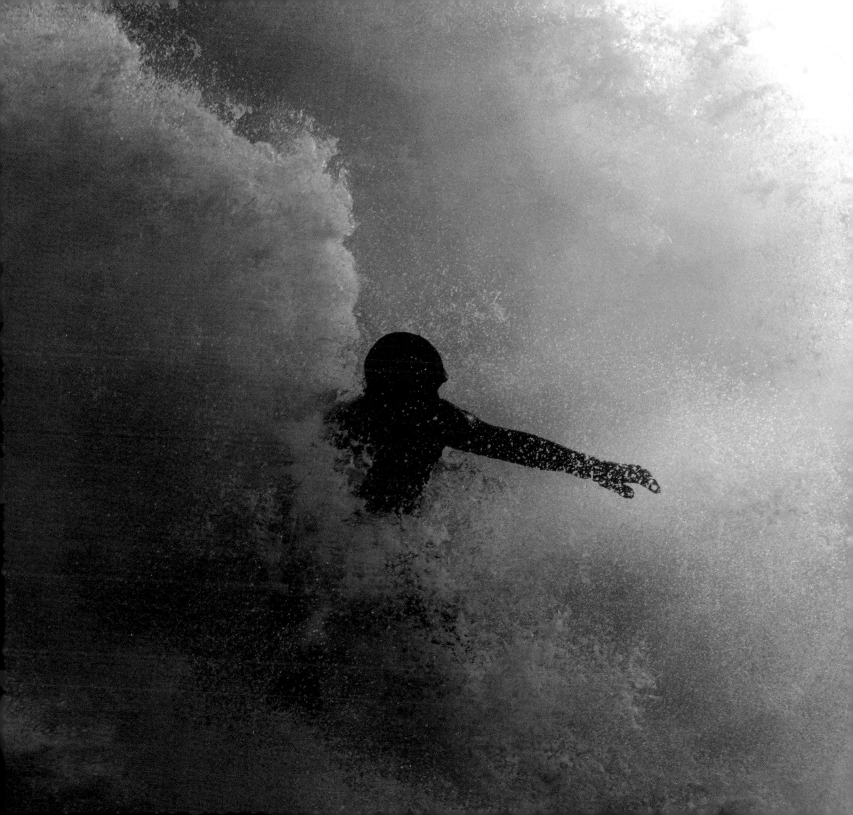

40

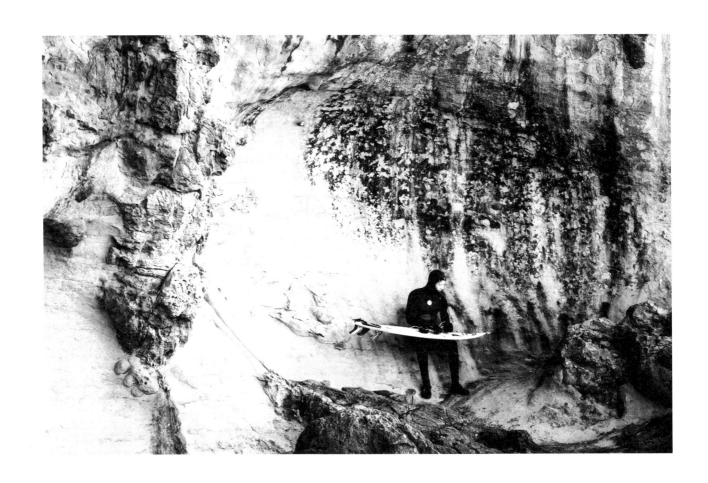

↑ Sometimes you get up at 5 am and hike for an hour in the dark only to get skunked. That's just the reality of surfing out here. Reed Platenius knows the feeling all too well. You never know until you go.

» 16-year-old Reed Platenius has really come into his own over the last couple of years. In the land of right, this goofy foot tube hungry grom is really making a name for himself with his aggressive pig dog style.

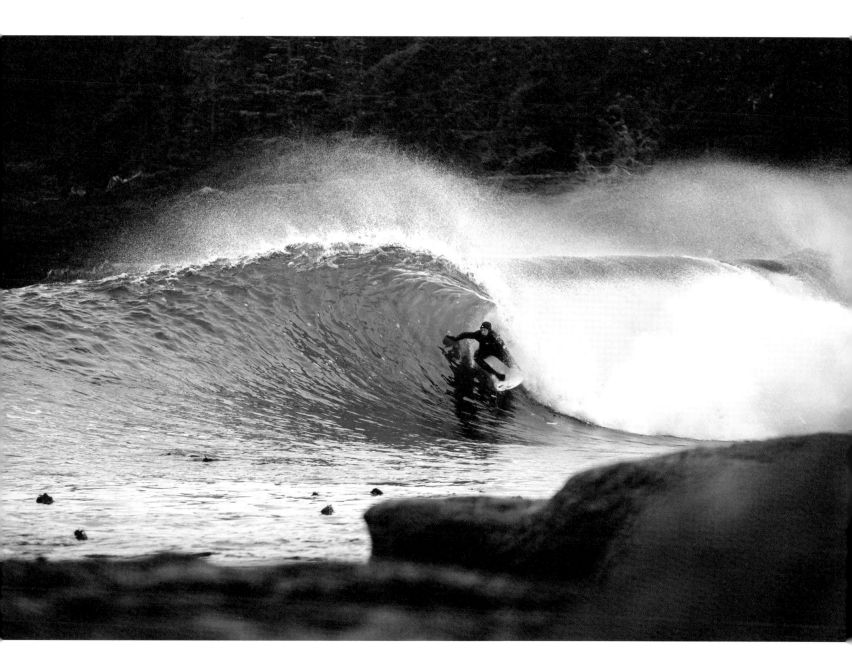

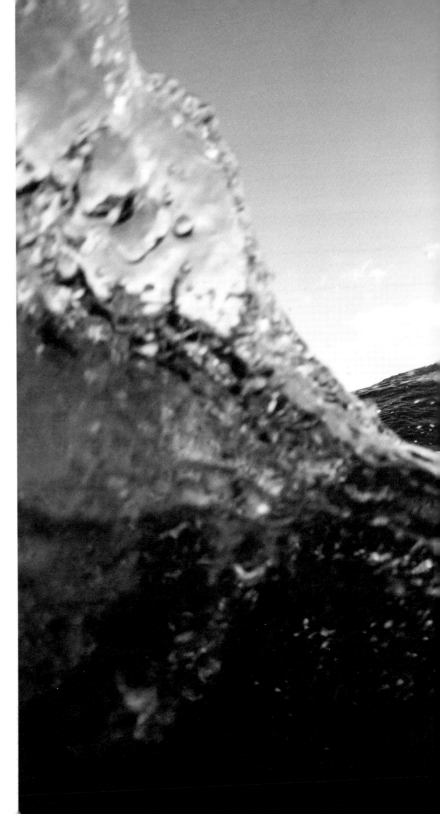

→ When people ask me "why do you do this?" I can never articulate a satisfactory response. I have a hard time expressing how I feel with my words, which is probably why I'm a photographer. But there are constantly unique images, angles or moments that burn away in my mind and the only way to be rid of them is to try to bring them to life. But that can be difficult. Sometimes very difficult. I am challenged to claim them as 'wasted frames,' because they'll never end up being exactly how I pictured — only kind of close if I am lucky. To make my point, I look forward to shooting a refined version of this image of Pete Devries in the future.

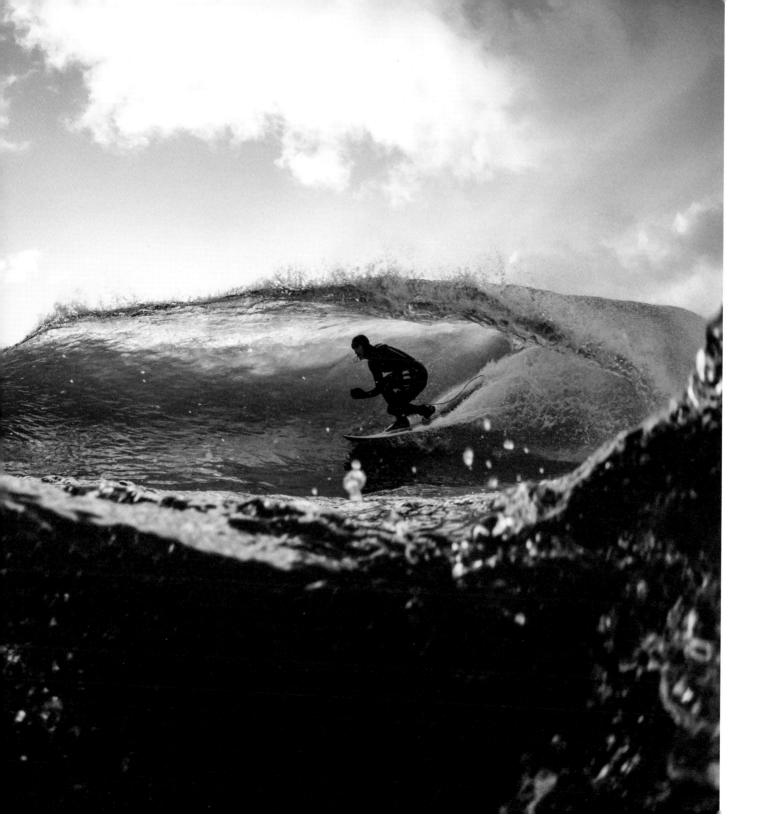

→ All along the coast of Vancouver Island, waves are breaking in the middle of nowhere and usually no one is around to see them.

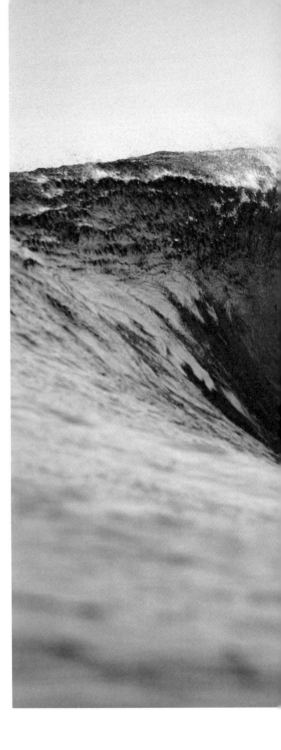

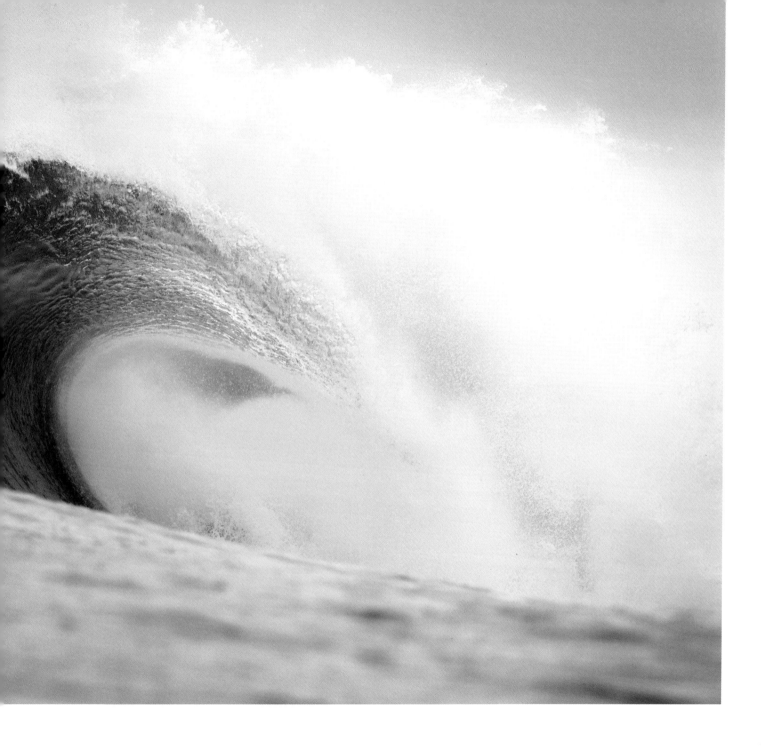

↓ Pete Devries is known as the cold-water messiah. He's just got everything dialled and is extremely calculated in the water. When it comes to this spot, he's the first one in and the last one to leave.

» We arrived late, I jumped out of the car, camera in hand. This was the first thing I saw: Pete Devries in a stand-up barrel with no one else around. When we finally swam in to meet him there, the first thing he said was "Where have you guys been?!"

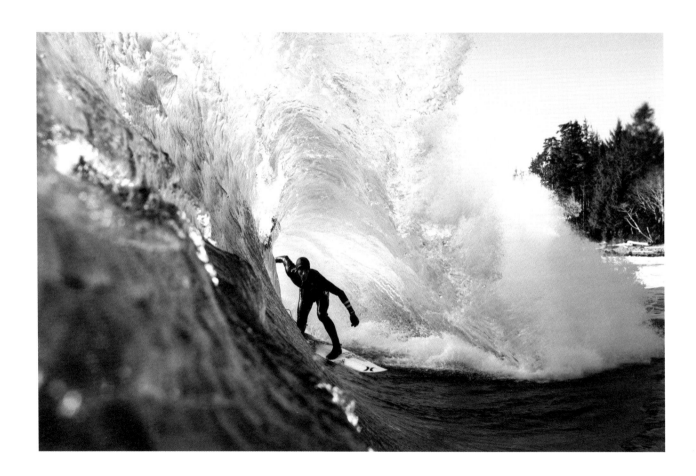

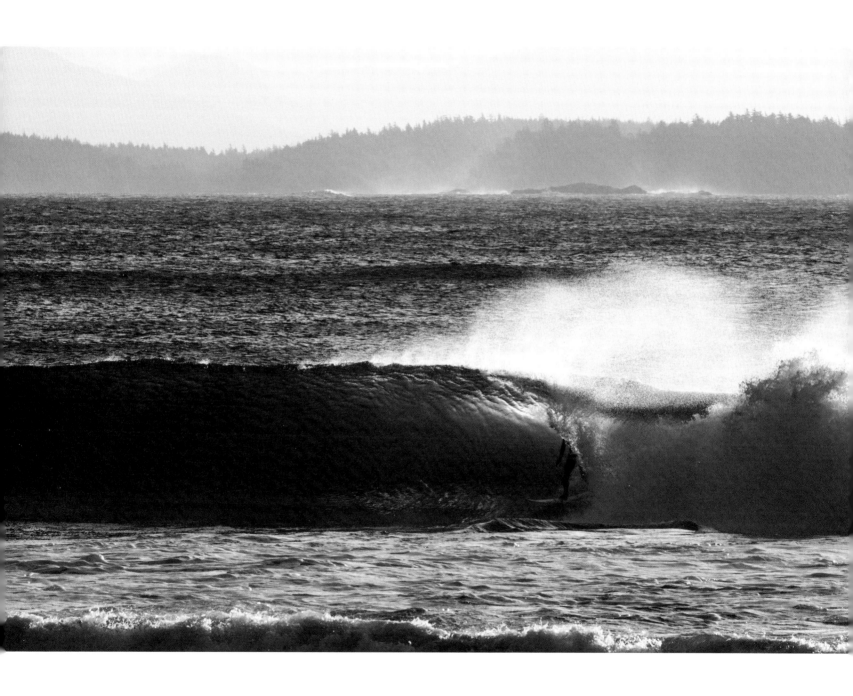

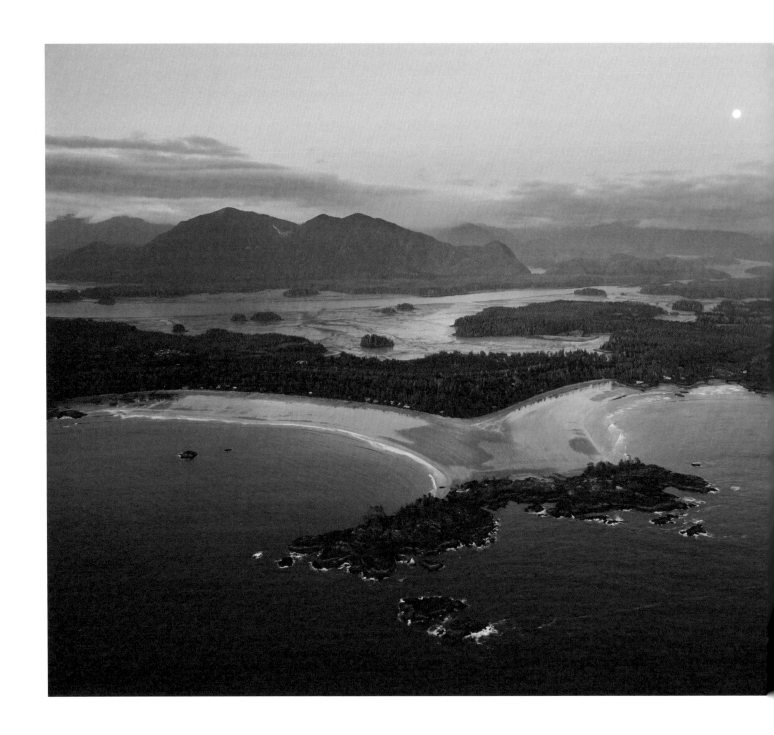

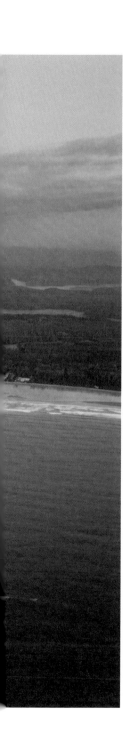

← The end of the road in the coastal rural community of Tofino, B.C. Shot from my first time in a helicopter with the doors off.

49

↳ My favourite view. It's hard to catch around here, but always worth the wait for me.

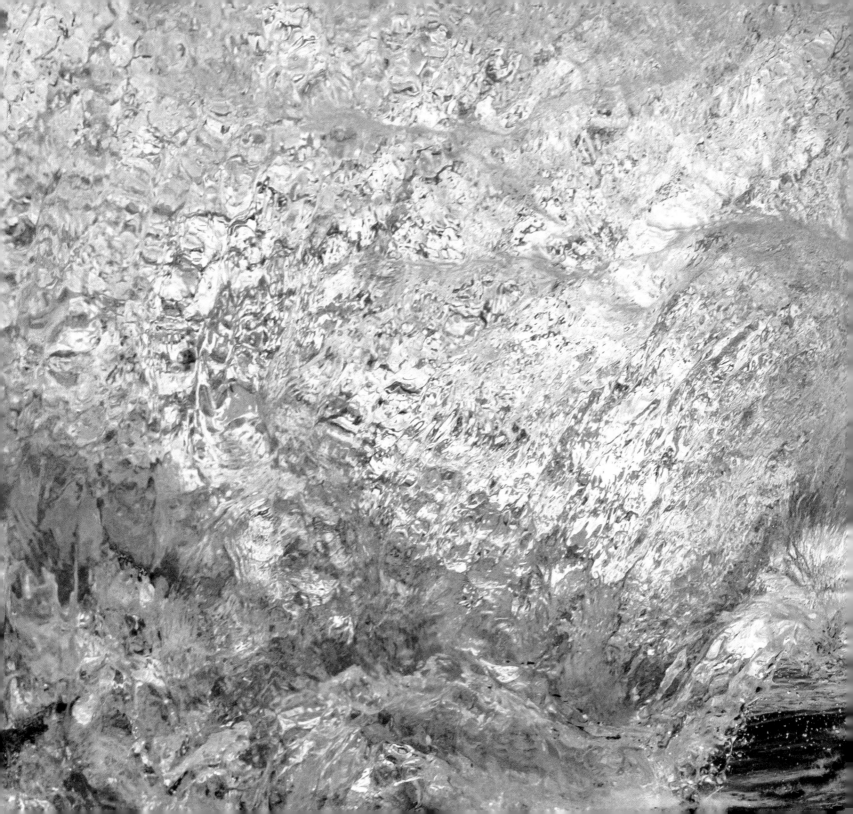

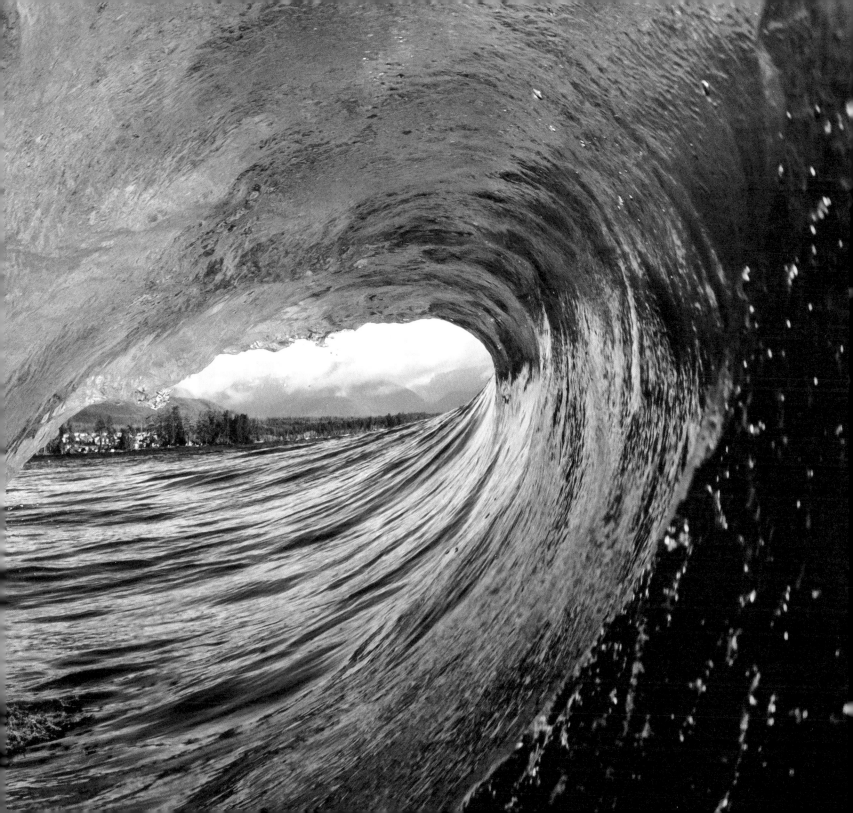

→ The problem with shooting long lens in the water is it completely throws off your depth perception. In this particular moment, from behind my camera I couldn't tell if Noah Cohen was a mile away or about to run me over. I probably should have zoomed out just a touch.

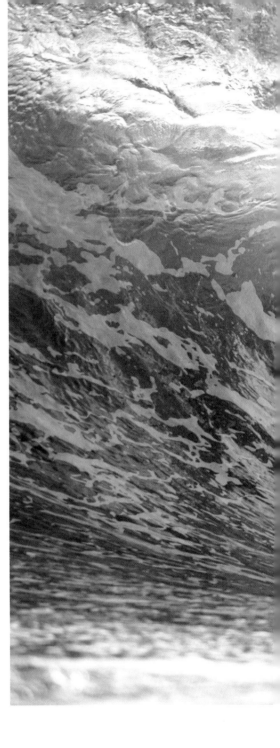

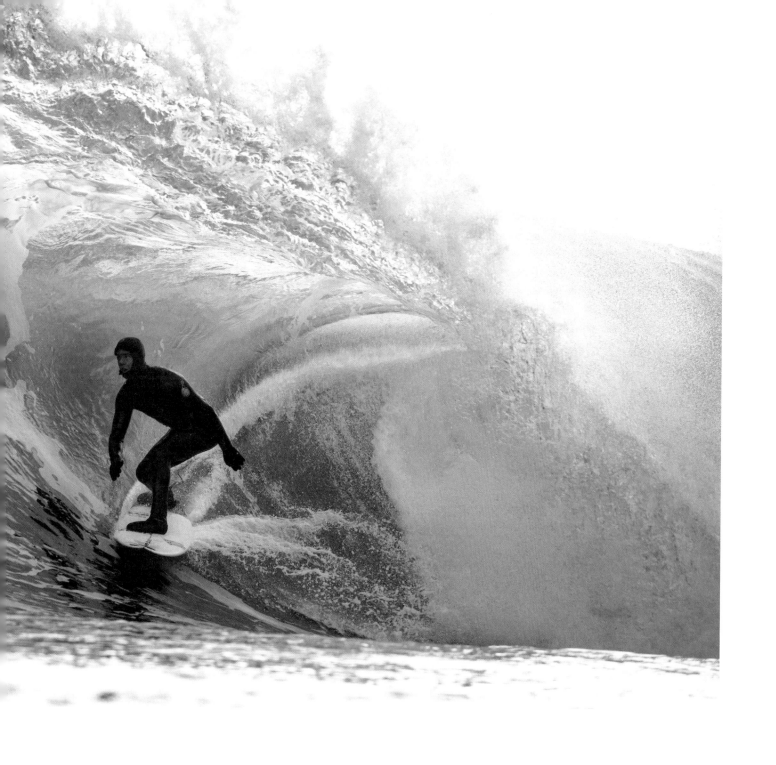

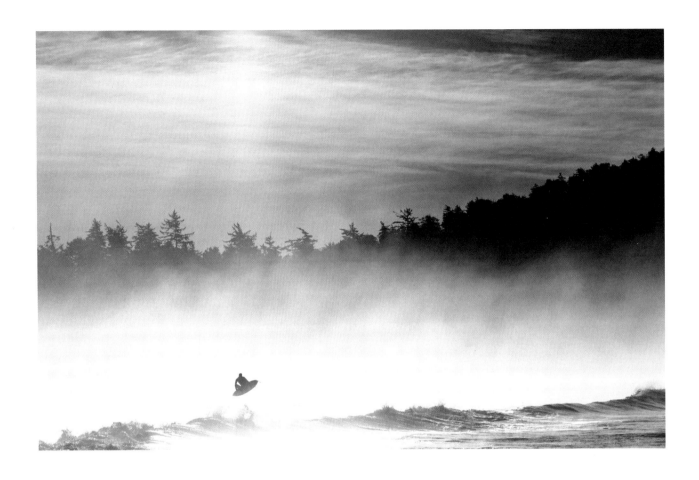

↑ People have told me to stop shooting this beach, as the waves just aren't good enough. I never liked that concept, that the waves had to be perfect or powerful to get good imagery. This shot helps showcase that as long as you have a talented subject and a creative angle, the wave quality doesn't necessarily matter.

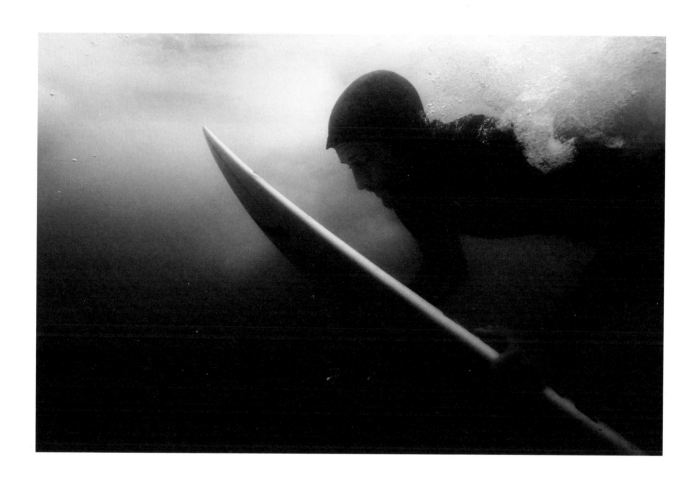

↑ The water clarity at the beach breaks in Tofino are usually murky and churning with sand. On any given day, shots like this are nearly impossible. But as Pete was coming up from his duck dive, I opened my eye and noticed a moment of clarity. This photo ended up being my first-ever cover shot for a magazine.

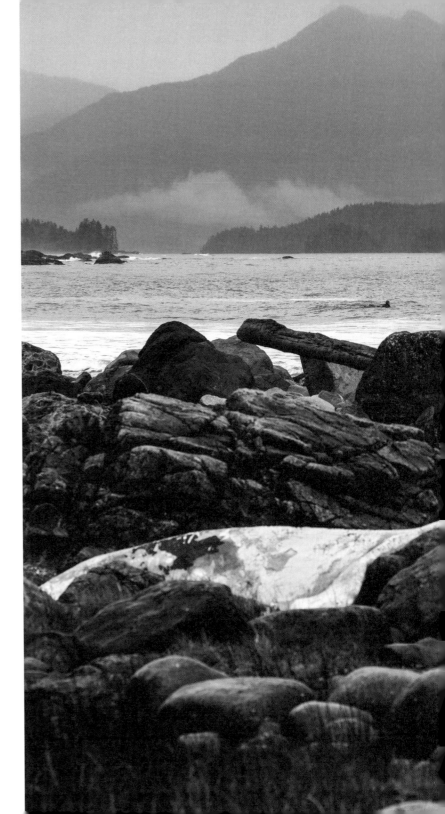

→ This whale supposedly broke its jaw when it was hit by an offshore vessel. The body drifted to shore and was beached right in front of this surf spot. I was determined to line up Noah Cohen surfing in the background, despite the terrible smell as I sat downwind.

56

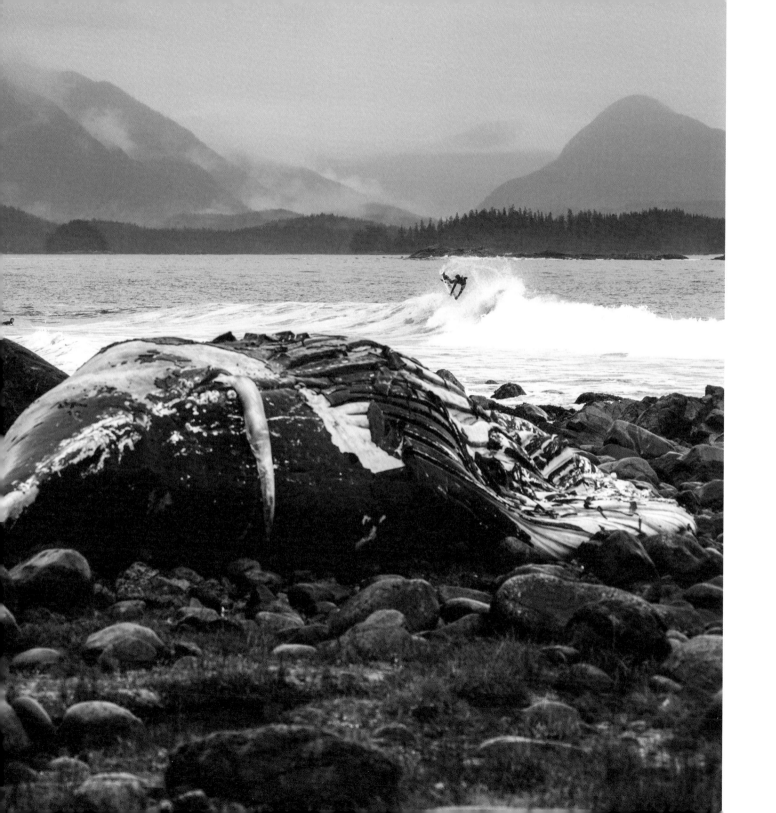

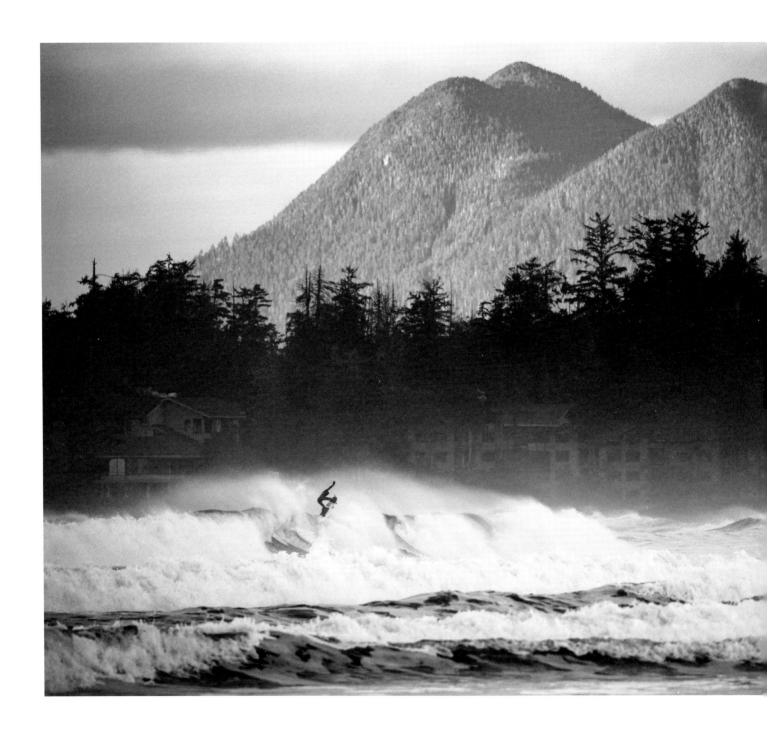

59

← Cam Richards came to Canada to film for Ben Gulliver's surf film *The Seawolf*, and he was putting on quite the show down the beach between a mountain and a 5-star resort.

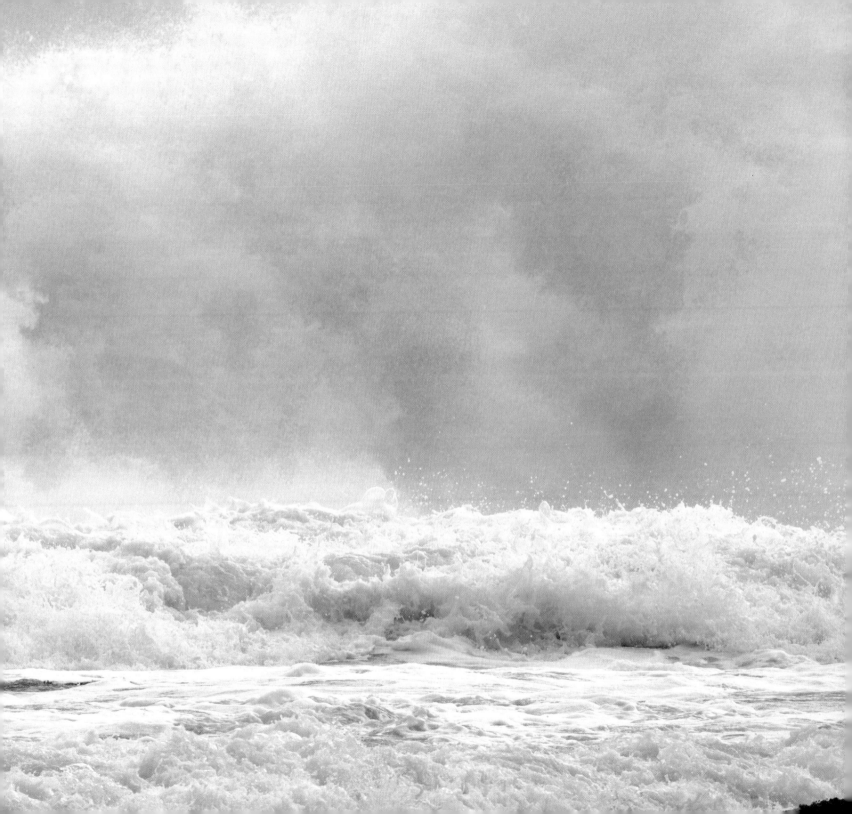

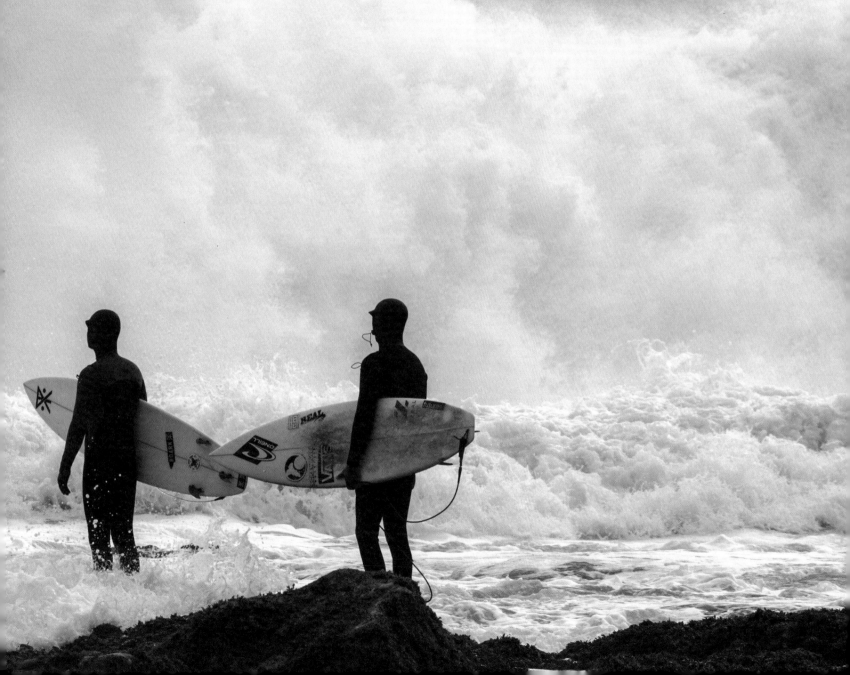

← This was one of the biggest days I have ever seen at this spot. Raph Bruhwiler and Josh Mulcoy brought their step-up boards and were the first ones here, though they had to wait patiently for a lull to paddle out.

→ I had been dreaming of this photo idea for years. The only difference is that I was expecting Noah Cohen to be inside the barrel, not sitting on the shoulder.

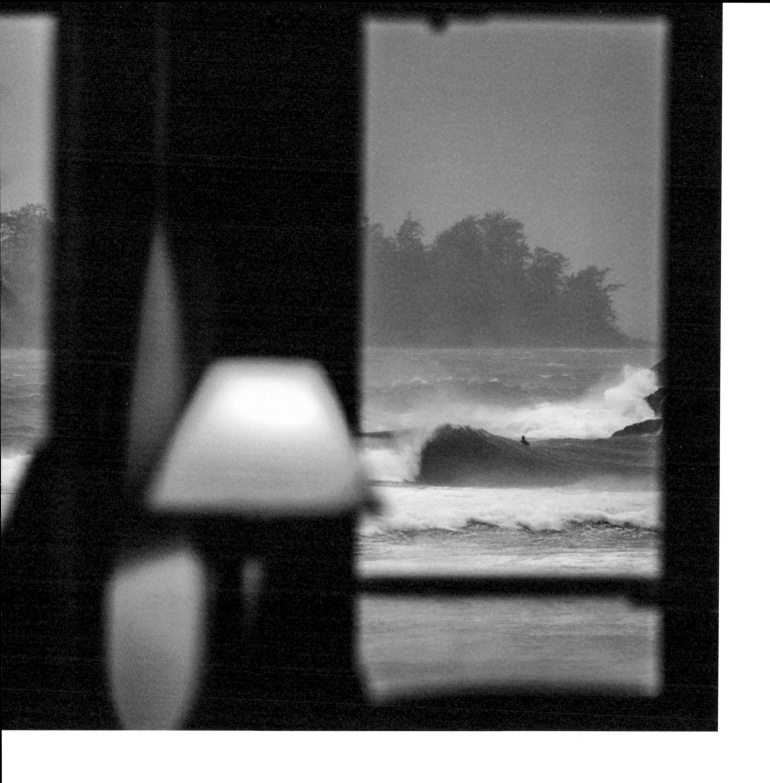

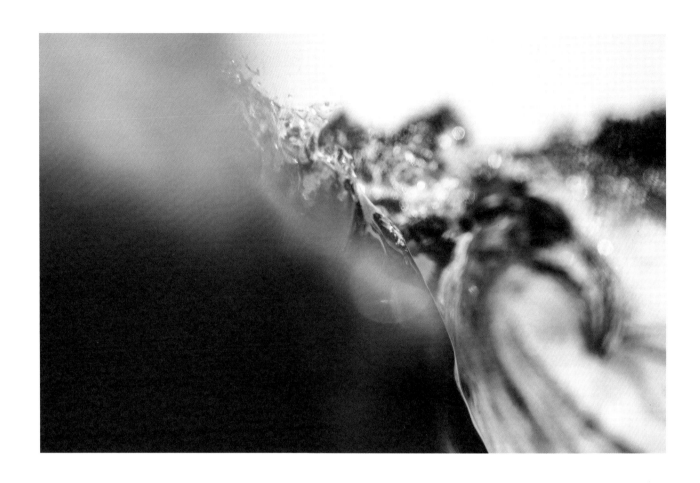

↑ A happy accident on a beautiful morning in the Pacific Northwest.

≫ You never know what's going to happen while shooting surfing. On this day the conditions were awful, the sunrise wasn't quite popping, and I was ready to pack it in. Just like that, Pete found the perfect air section. I realized that as an action sports photographer, if the athlete is still working, I should be too.

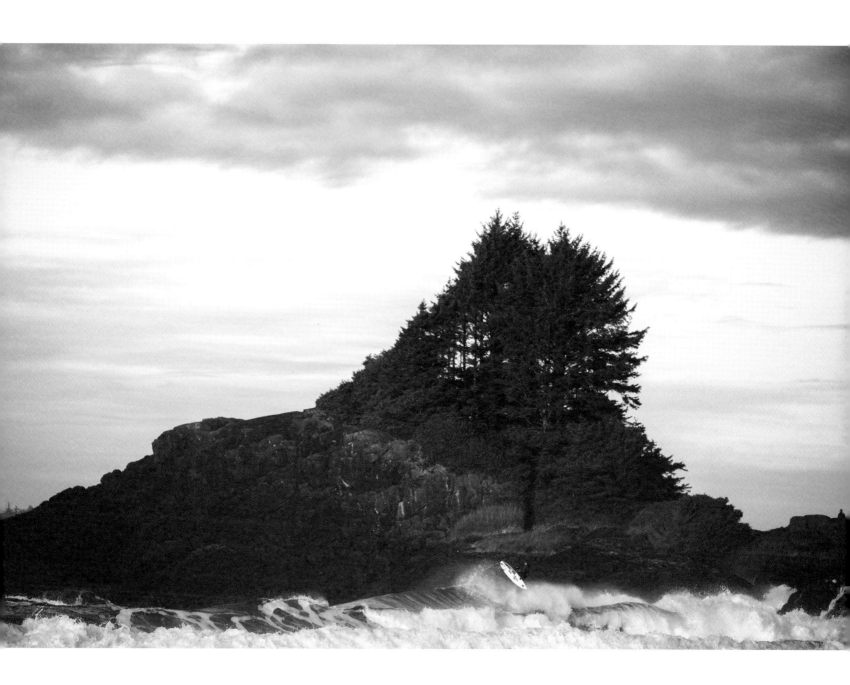

↓ The energy of the previous wave bounced off the shore and into an oncoming wave to create a vertical surge toward the sky.

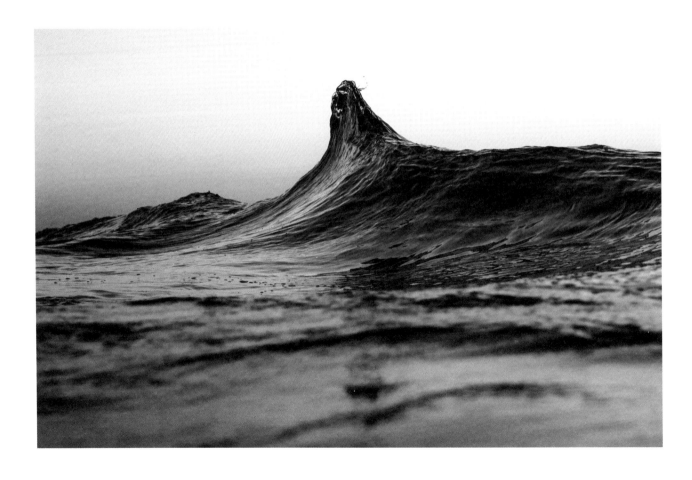

↓ This spot has been shot dead. But everyone focuses on the right. For this particular session we sat on the opposite side in hopes of shooting the left, which makes it look like a completely different wave.

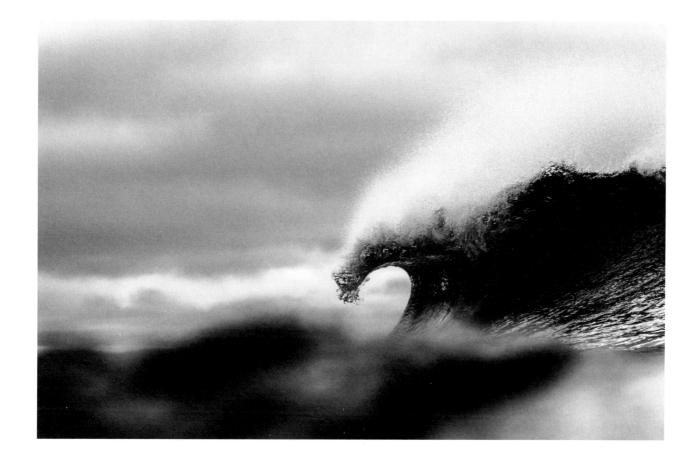

→ With no vehicle access, this old van was strategically abandoned so surfers wouldn't have to hike an hour down a washed-out logging road to get to the beach. Thankfully we knew where the key was hidden.

68

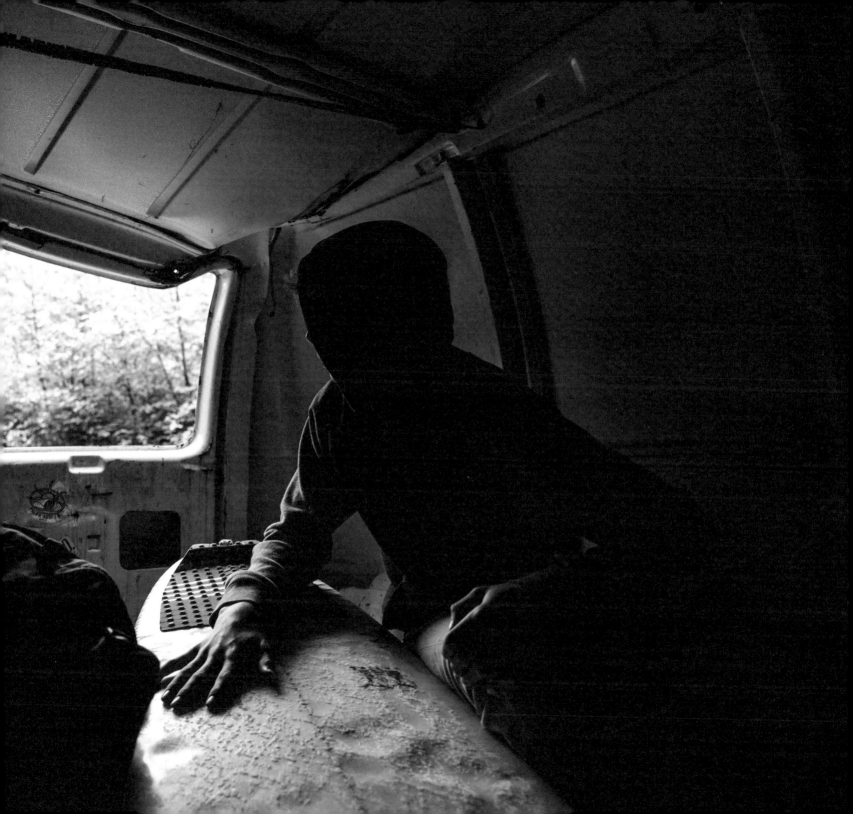

70

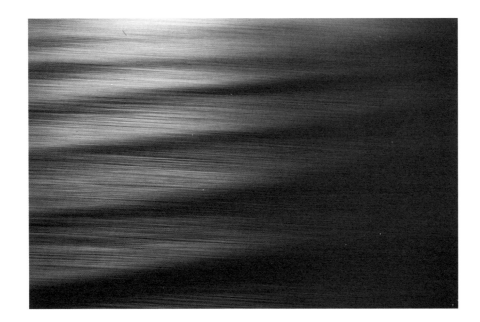

↑ The Pacific Ocean at sunset,
shot on a tripod, with a telephoto
lens, at a shutter speed of 1/6 of
a second.

→ Sepp Bruhwiler pushed through
the back of this wave as the
remnants from the offshore wind
rained down on both of us.

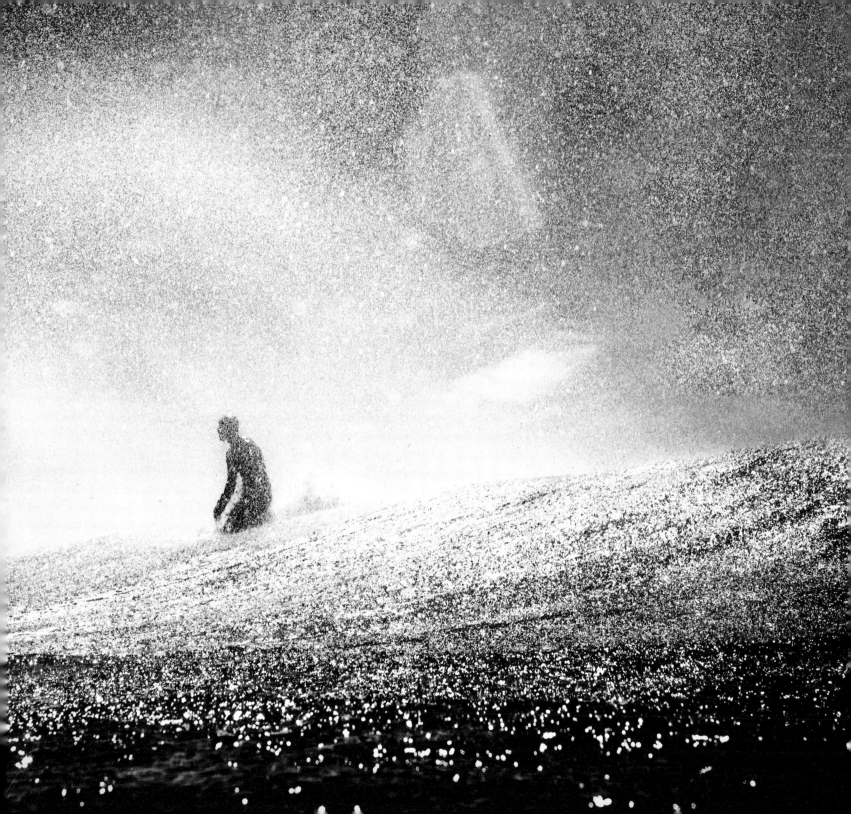

→ The inside of a wave as it breaks along the shore at one of Tofino's most popular beaches.

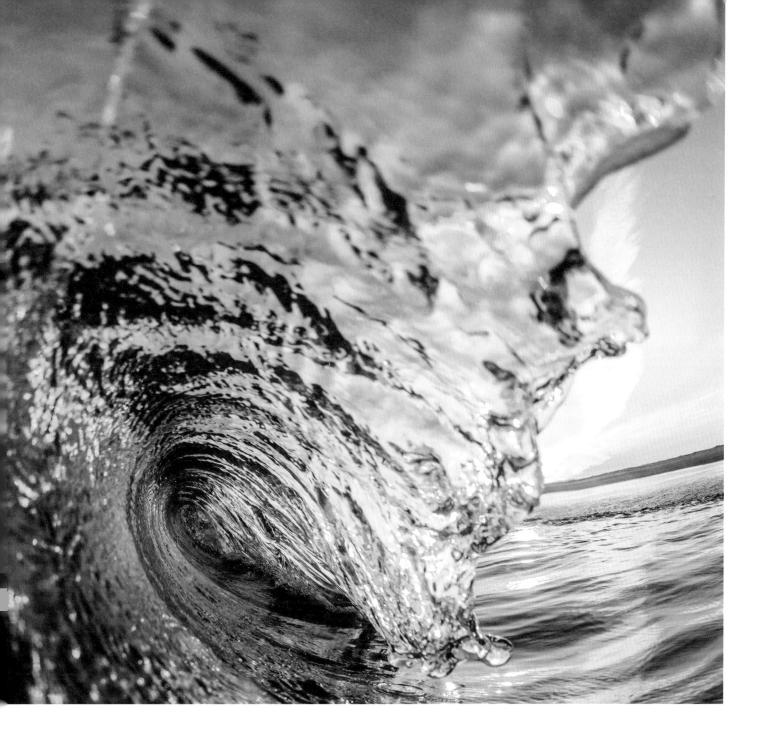

↑ The reflective sun off the low-tide shoreline as a surge of water begins to fill in.

↑ Reed Platenius opting to walk out along this finger of the reef, as opposed to paddling out all the way around to get to the lineup.

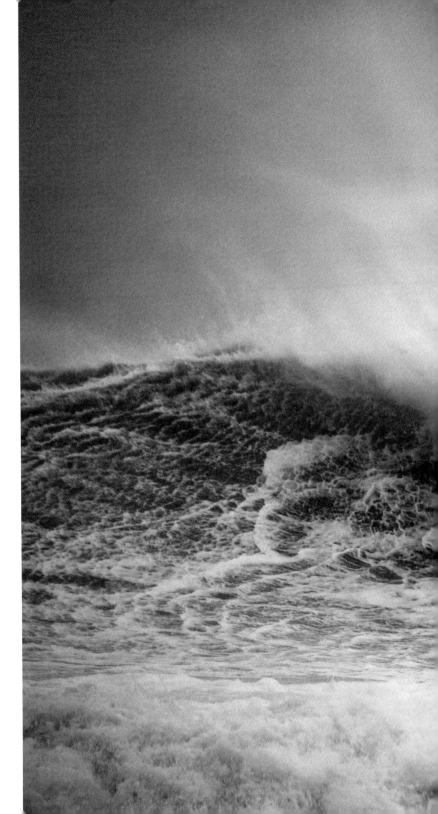

→ This is what surfing in 180 km/h wind looks like. After this day the power was out in Tofino for three days straight. Trees had fallen everywhere, blocking roads, cutting powerlines, sinking boats and even sending people to the hospital. It was how I would imagine an apocalypse would be, carnage throughout the town.

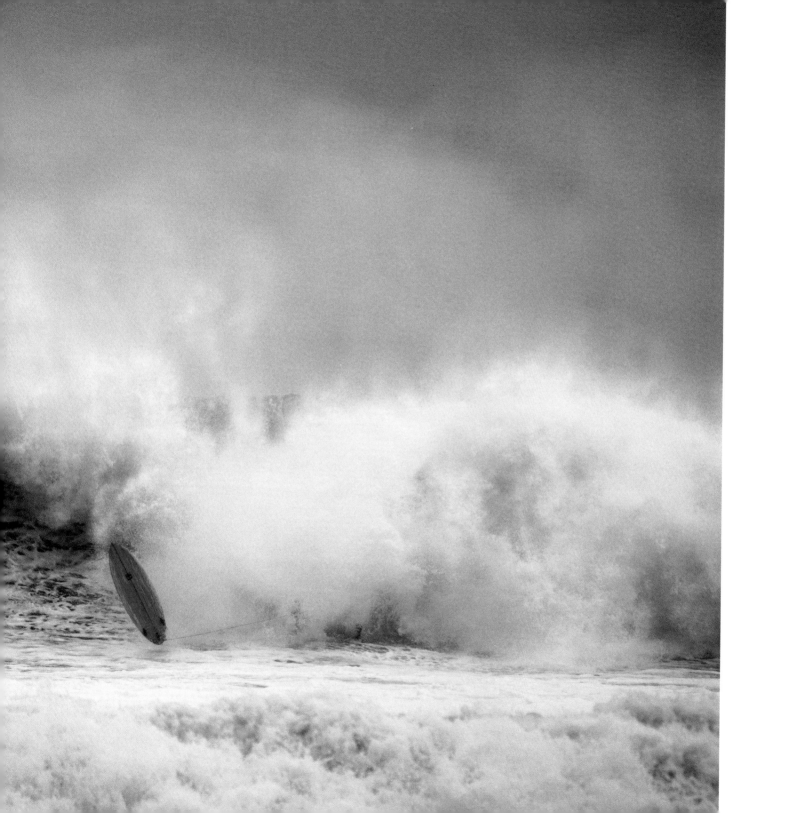

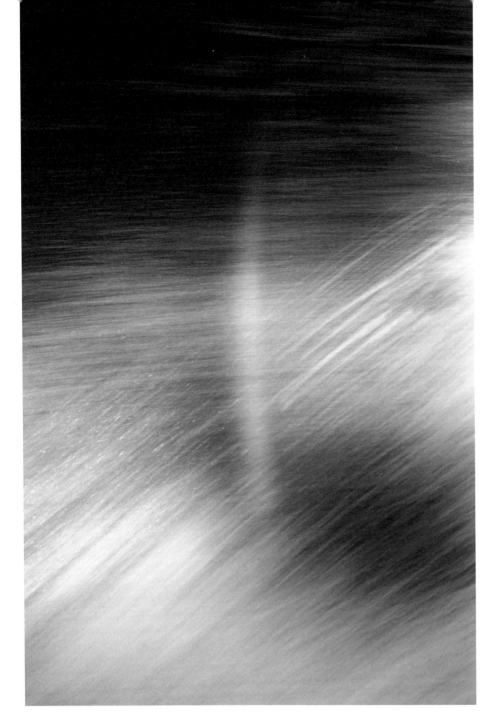

← We had just launched the boat and were heading north. As we were getting settled in and preparing for a bumpy ride, I couldn't help but notice the result of combining the right amount of moving water with the right angle of sunlight.

≫ 15-year-old Sanoa Olin has a bright future ahead of her as she takes one last look back at camp before continuing the long walk along the reef.

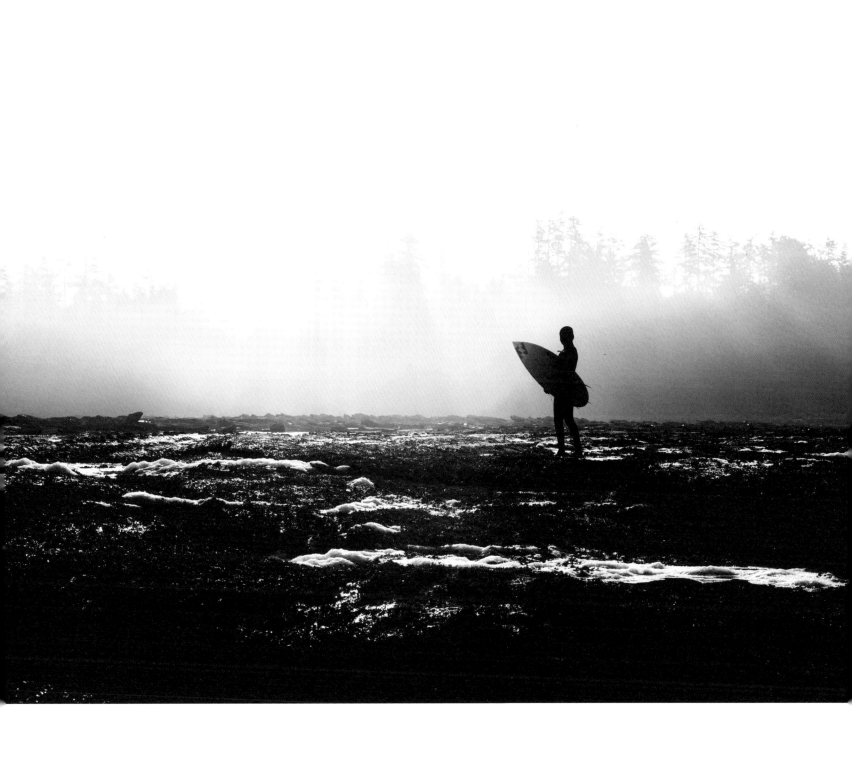

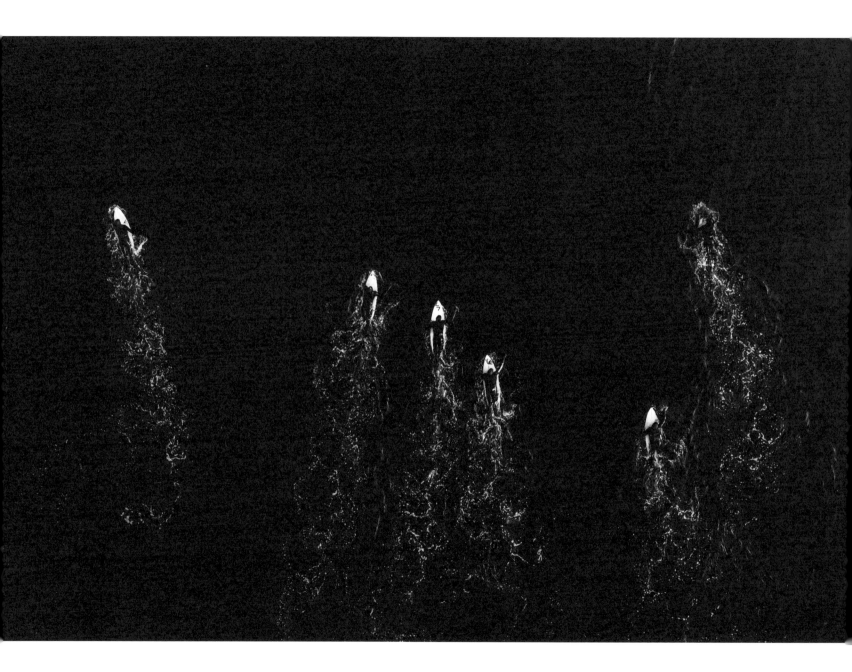

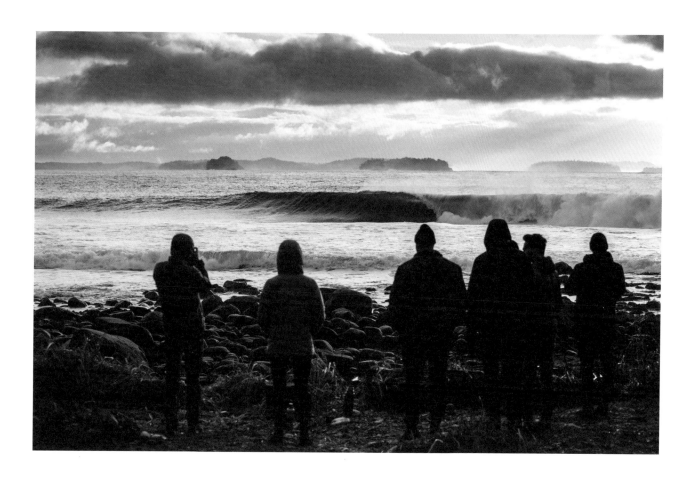

« This is how you can tell a set wave is coming: the classic lineup scramble out the back to get out of the way.

↑ Waves tend to get a bit of morning sickness. Some say that when the sunlight touches the water, that's when it cleans up and turns on.

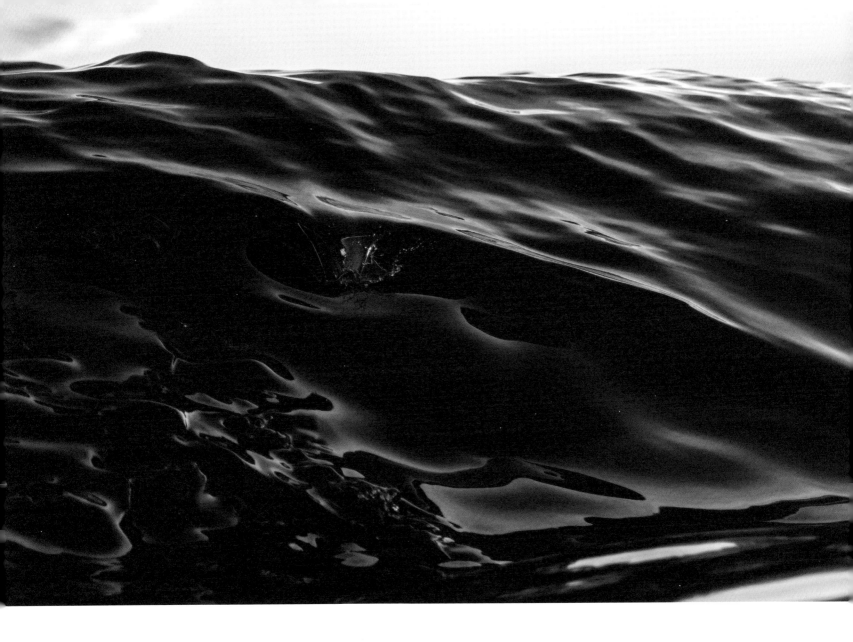

↑ I voluntarily left a beach fire, just to get pushed along the rocks trying to shoot this abstract surge of water breaking at sunset.

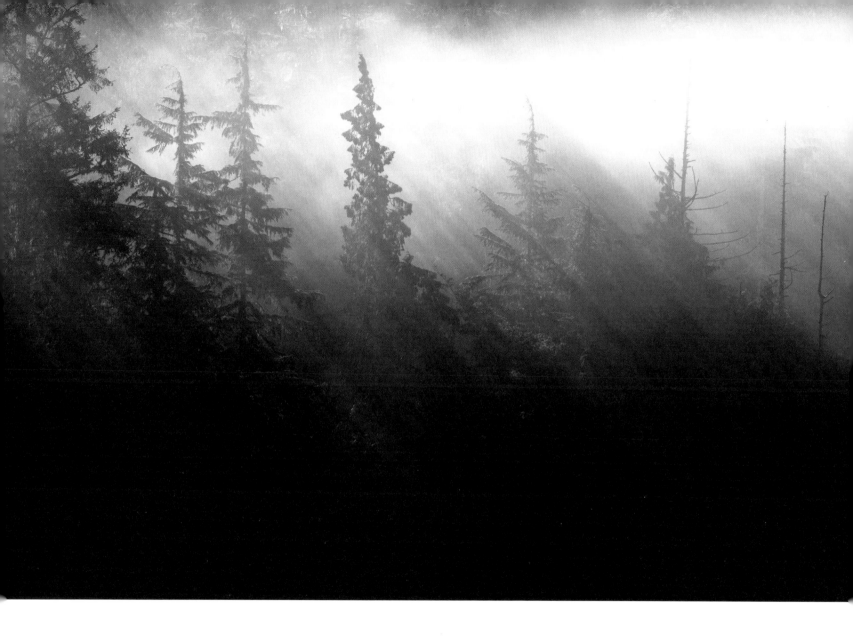

↑ A foggy morning in August – or as we like to call it "Fogust" – along the coast of Clayoquot Sound.

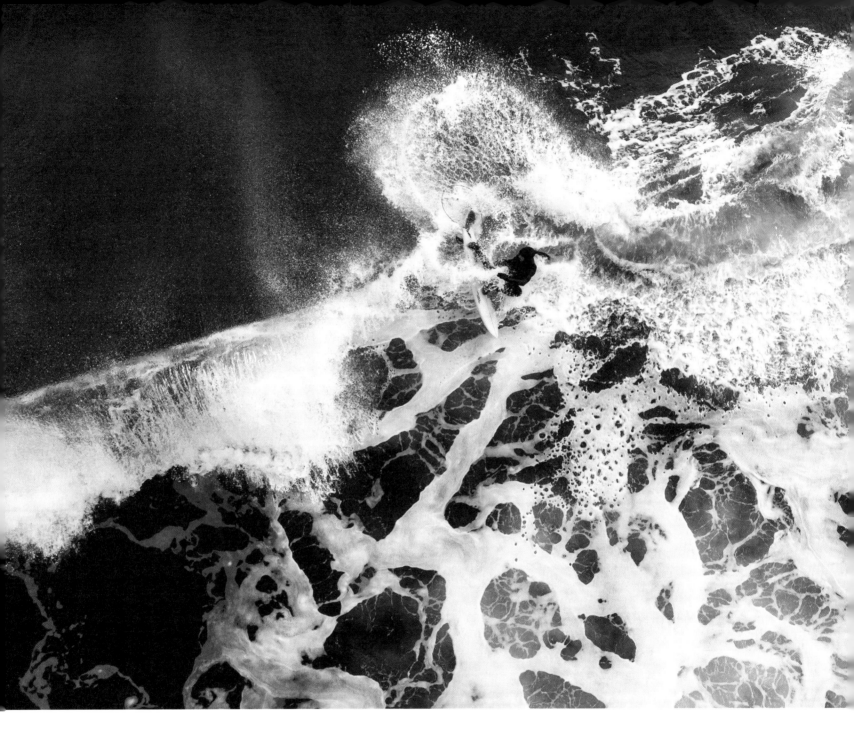

← A high-performance manoeuvre on an intermediate retro board. Pete Devries can really do it all.

→ Before Pete Devries paddled out, he read my mind and asked if he should go for a walk out to the point. That was perfectly timed, as the sun came out the moment he arrived.

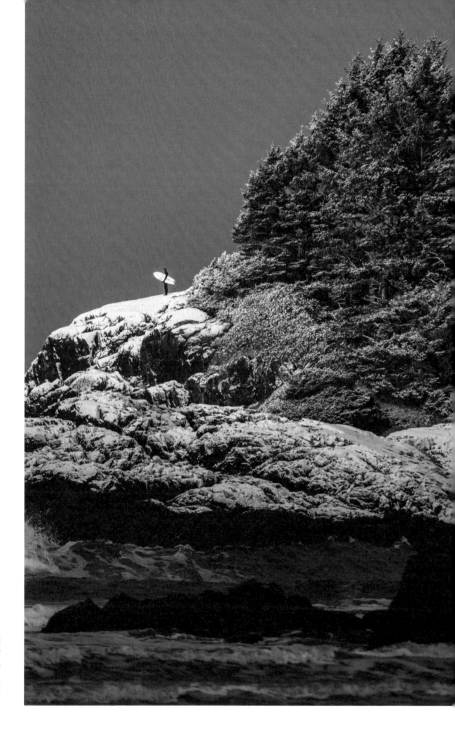

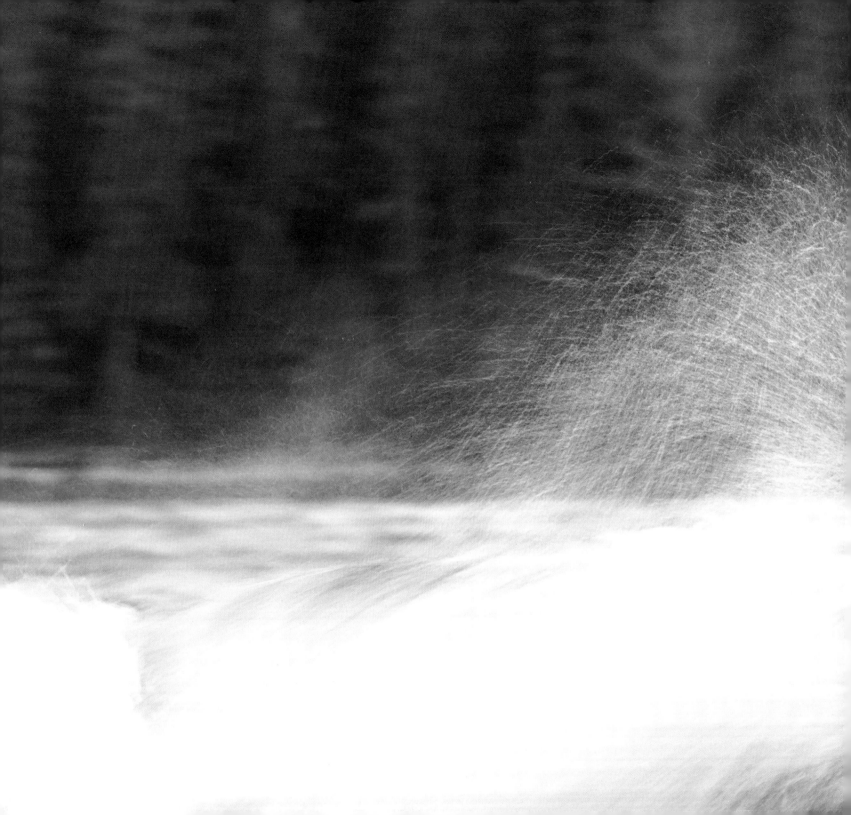

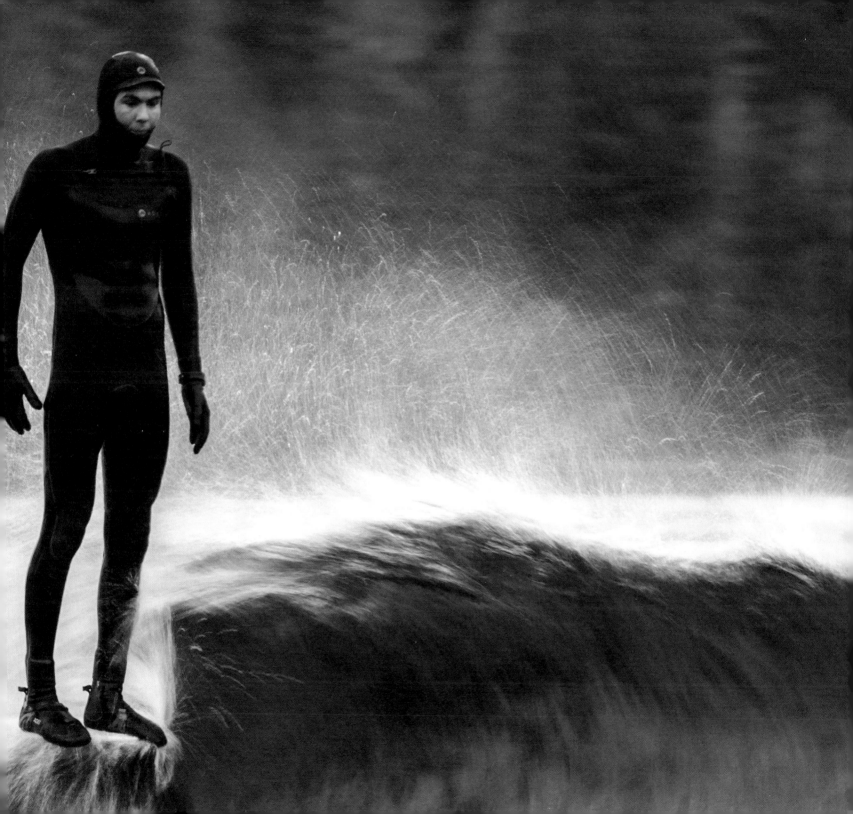

↰ Despite how free-spirited and easygoing Andy Jones is, he balances that by being extremely hard-working and dedicated. We woke up at the crack of dawn, drove and hiked for an hour and a half, only to surf this wave for 30 minutes before he had to head back so he could start his shift at Storm Surf Shop.

↓ Malcolm Daly and Michael Darling trekking through a river on their way to check the surf.

≫ There's something about back side barrel riding that is the perfect combination of beautiful and terrifying. When I asked Issac Raddysh how he got so good at it, his response was, "I hit the bottom a lot."

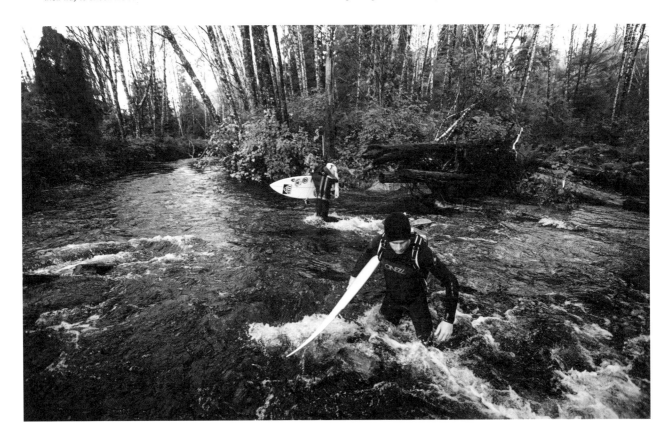

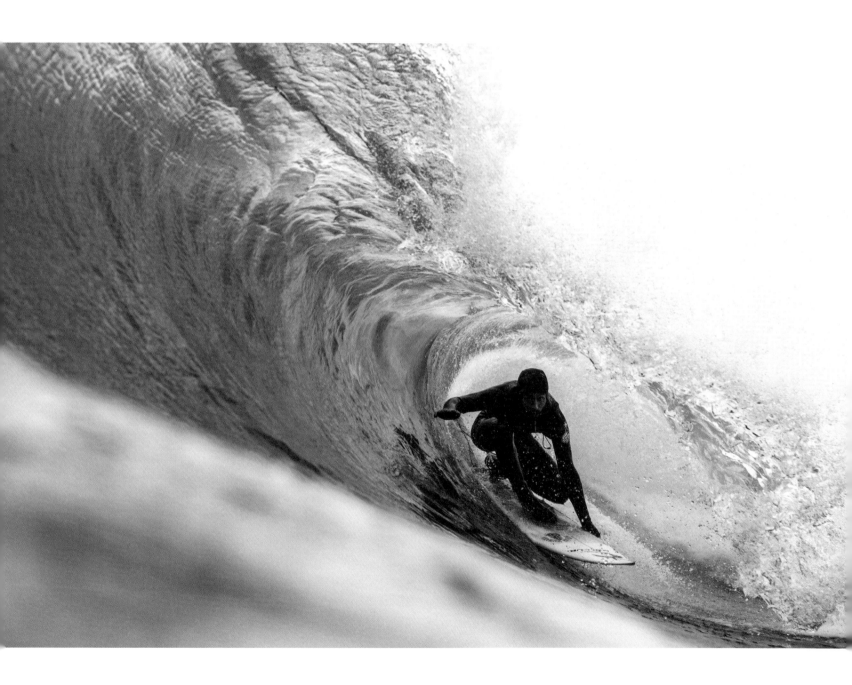

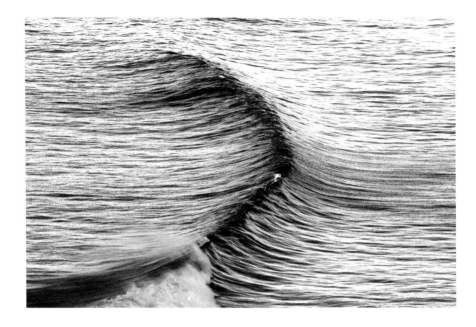

↑ I love the way this wave bends away from the beach to create this horseshoe shape. There's so much energy in waves and you can really see this when you're looking at them from above.

» Balaram Stack letting the first wave of the set roll through as he unknowingly waits for the one behind it, hoping for it to be bigger and better.

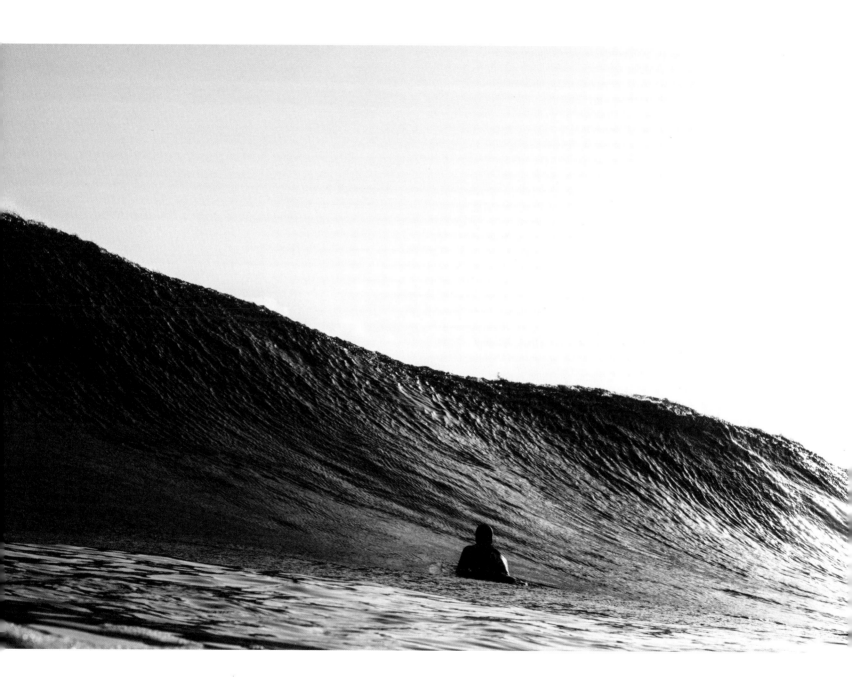

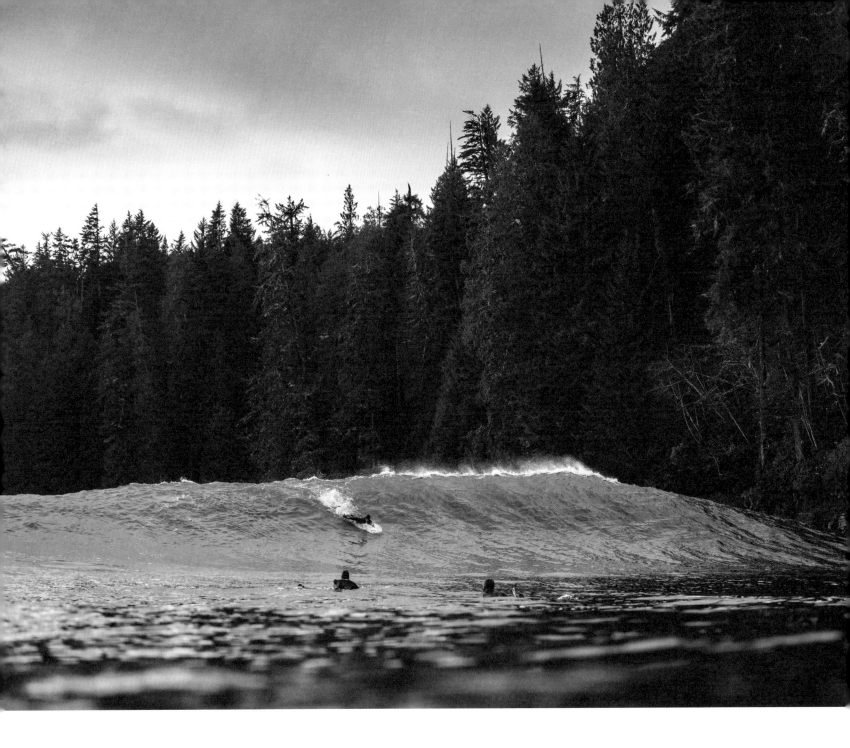

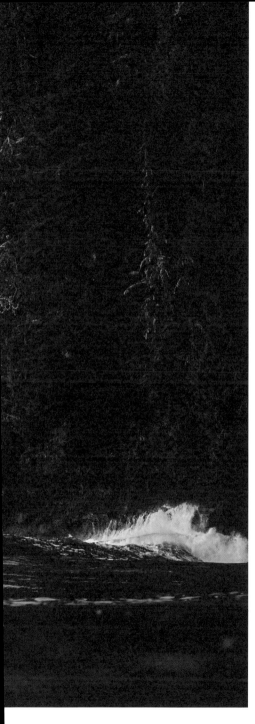

→ I didn't realize that this photo would be possible until I shot it. Any other time of year the sun will set either a little too far to the left or to the right on the horizon and be fully blocked by the surrounding islands. Though I was frantically trying to line this shot up between waves, it was a very calming experience.

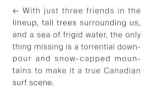

← With just three friends in the lineup, tall trees surrounding us, and a sea of frigid water, the only thing missing is a torrential downpour and snow-capped mountains to make it a true Canadian surf scene.

94

→ I met Gwaliga Hart many years ago through mutual friends, and later
we ended up working together in Haida Gwaii for Northern BC Tourism.
He holds so much knowledge, and as visitors, we couldn't have dreamt of
anyone better to share the Haida Nation's culture, land and history with us.

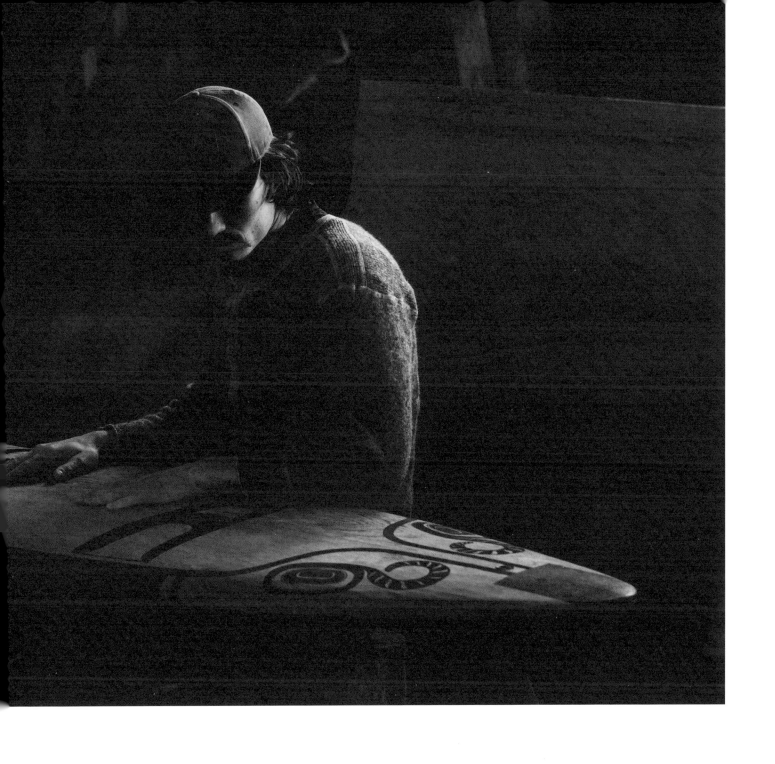

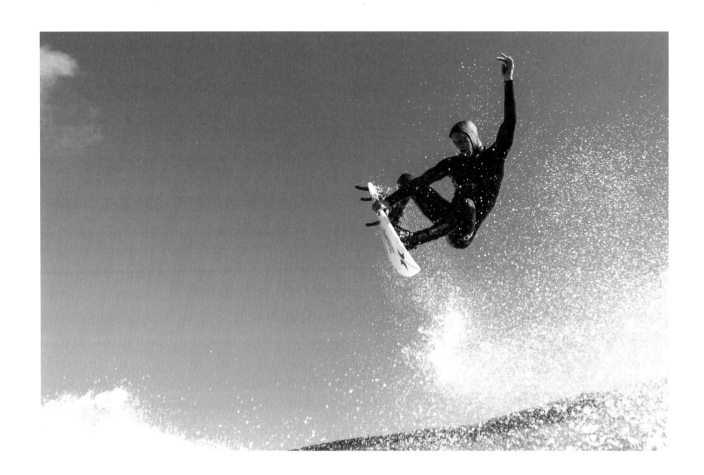

↑ Pete Devries clear for landing on a rare mid-winter bluebird day.

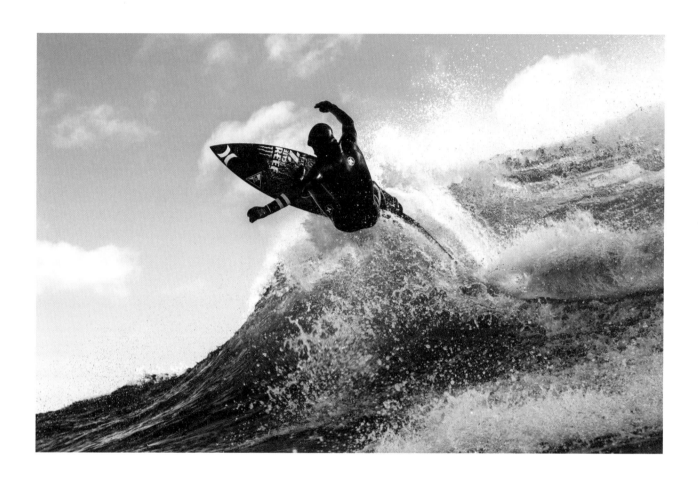

↑ I once rented a lens from a manufacturer to try it out before buying it. What better way to test out new equipment than to have Pete surfing over top of it?

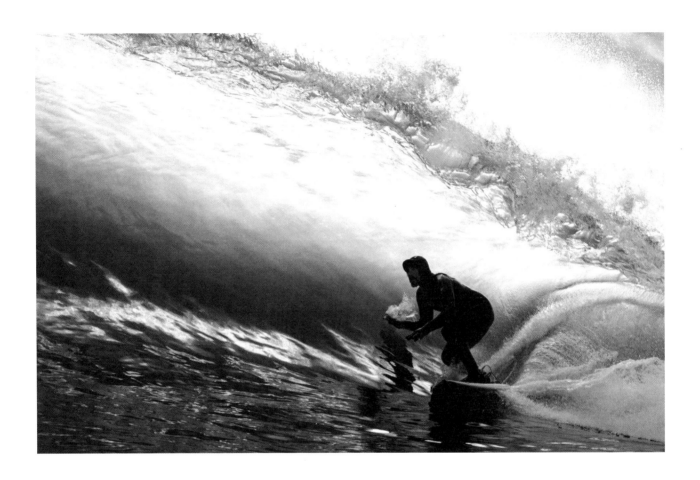

↑ Frequent heavy rainfall caused a surge of fresh water into the surf, transforming its colour into this murky, yellowish haze. Timmy Reyes didn't mind as he lined up to get covered by it as much as possible.

≫ We were blessed with perfect conditions on the first day of a ten-day trip. Our local guide told us this was definitely one of the top five days he'd ever seen at this spot.

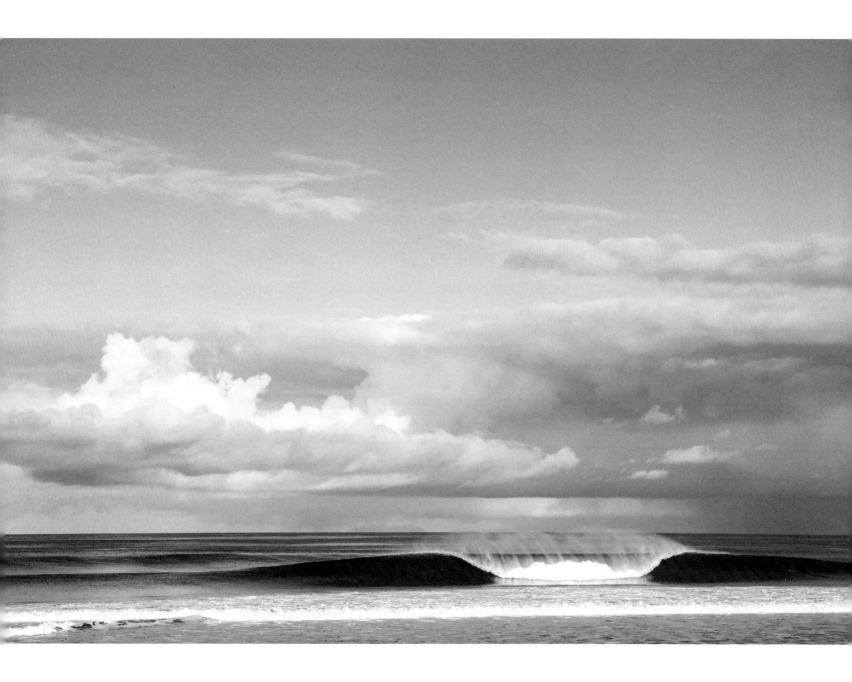

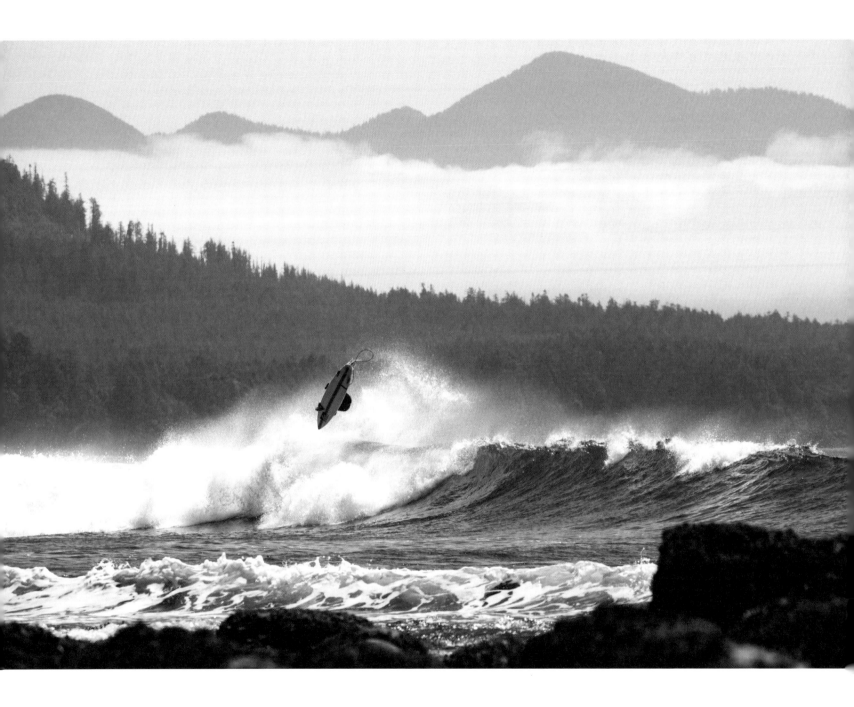

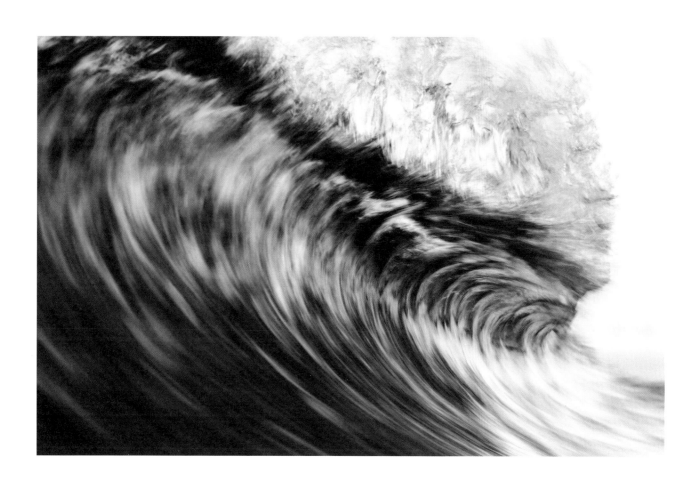

« Shannon Brown making good use of the lefts on a boat trip along Vancouver Island's coast.

↑ As a wave breaks along the shoreline, I brace for the impact in order to capture the perfect moment.

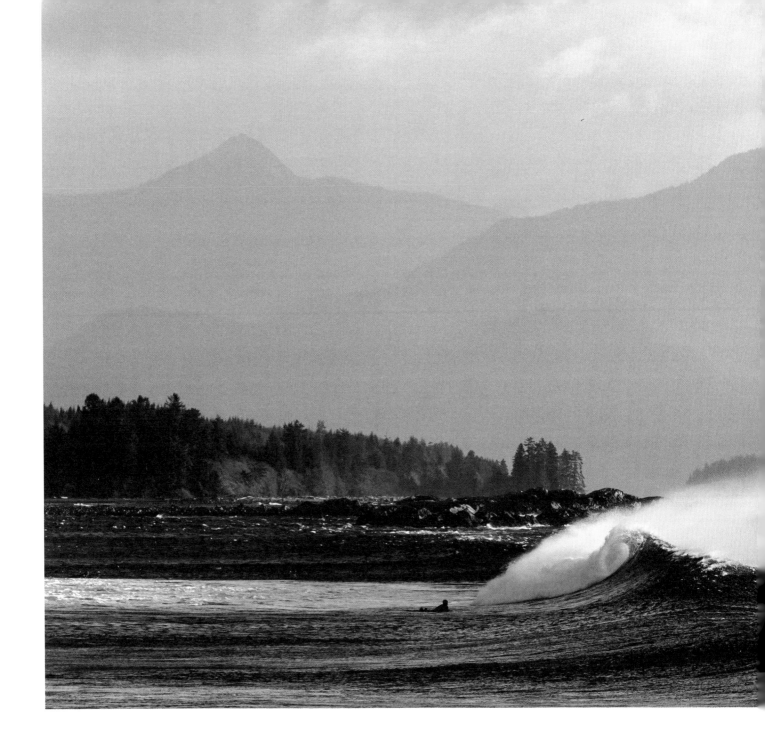

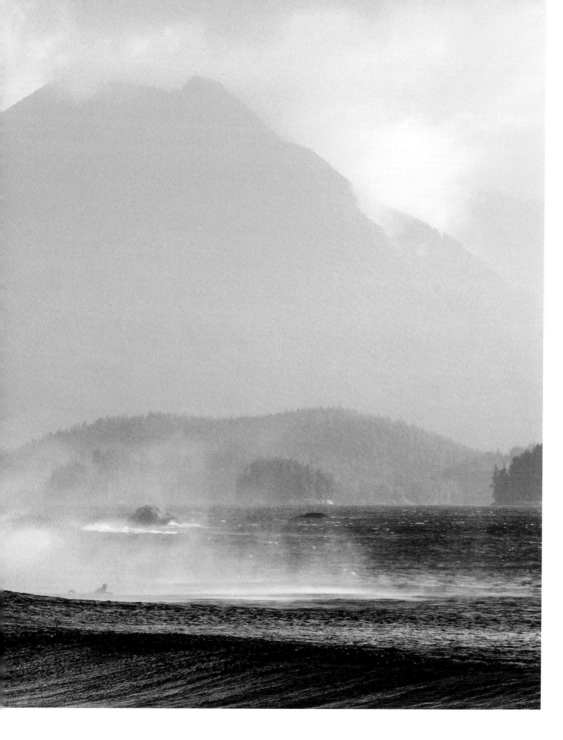

← This left-handed wave is a goofy-footer's dream. It often gets overshadowed by other waves in the vicinity but has become more and more popular over the years.

↓ Michael Darling and I love shooting together, even when the waves are flat. We've often spent days in the summer free diving and exploring the waters around Clayoquot Sound.

» Shannon Brown with a vertical snap at sunset during a rare summertime swell.

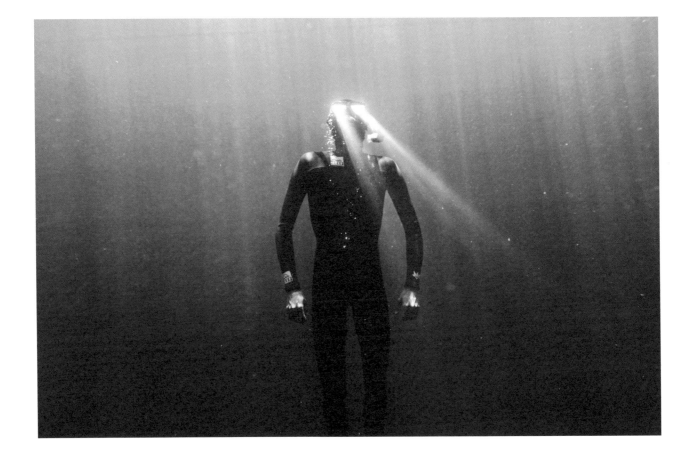

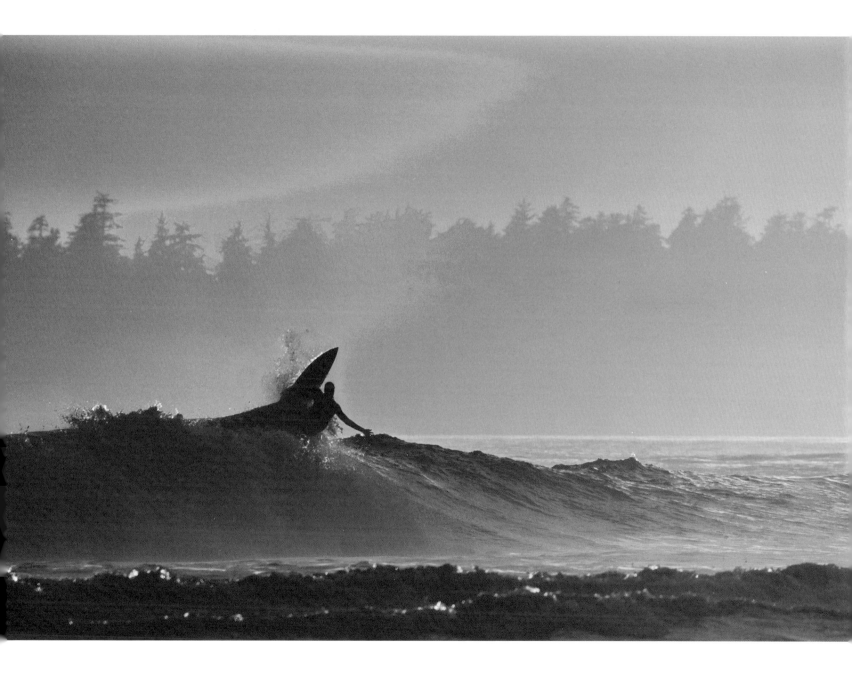

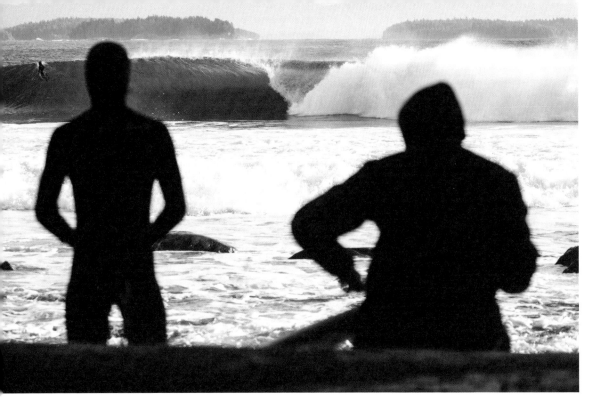

↑ After a long swim in the morning, I was debating whether or not to swim back out for the afternoon session. Once this set came through, the decision was made for me, so immediately after taking this photo I grabbed my wetsuit.

→ As the set of the day came through, Pete scrambled to get back in position after already catching a wave shortly before. He turned at the last second, and made the drop but missed the barrel. It was a wildly entertaining moment to watch.

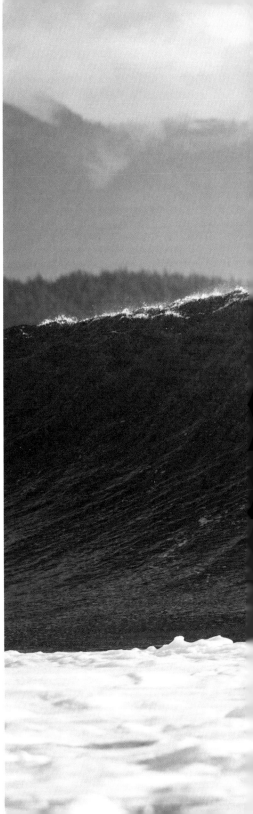

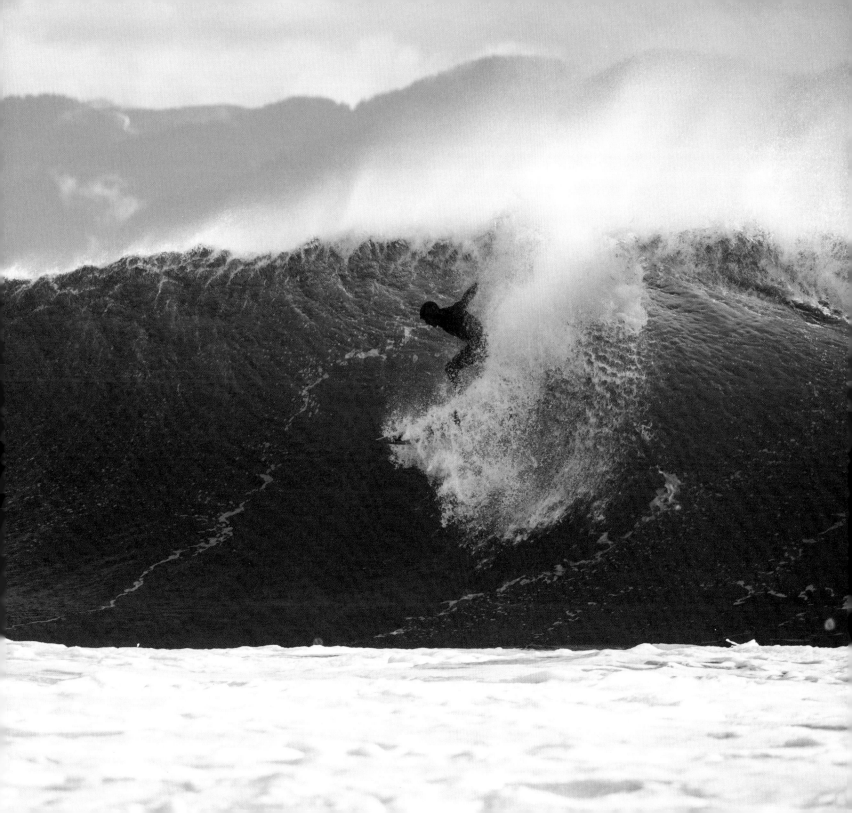

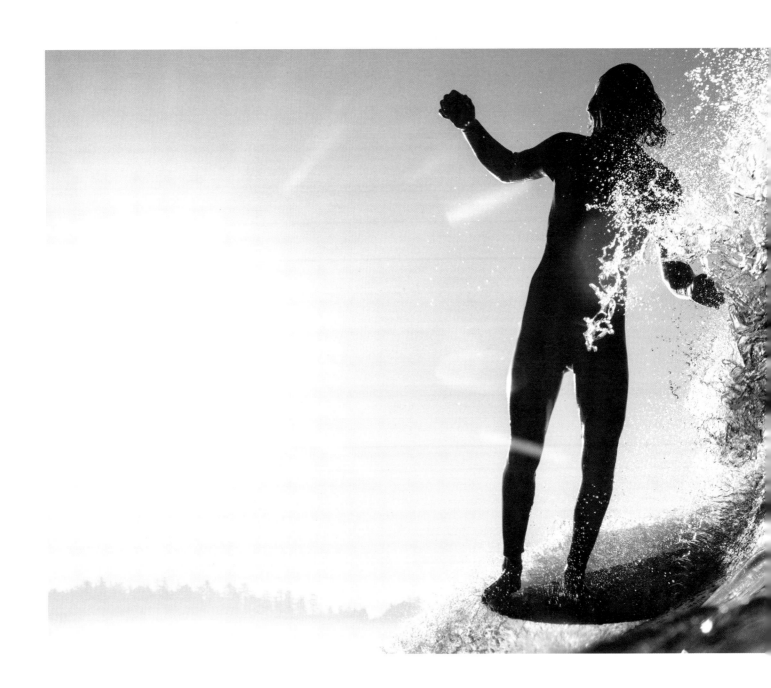

108

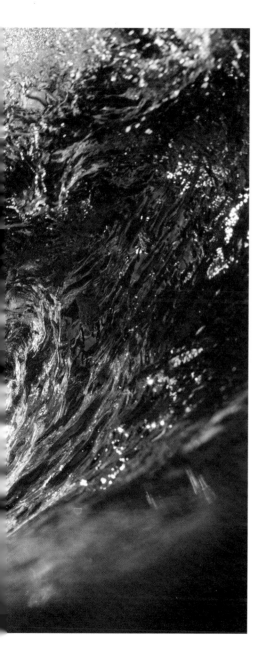

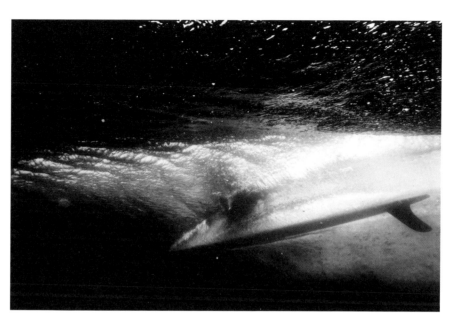

↑ There have been so many times I've thought about recreating this image of Andy Jones. Perhaps a different lens, a wider port, a better camera body, a sunnier day or cleaner conditions. But you can't mess with an original.

← Andy Jones spent this entire session going right, but then he caught this left as he was paddling back out and demonstrated a classic hang-ten.

↳ I woke up at 4 am to shoot just this wave at sunrise. Ironically this image was taken about 10 hours later... A for effort?

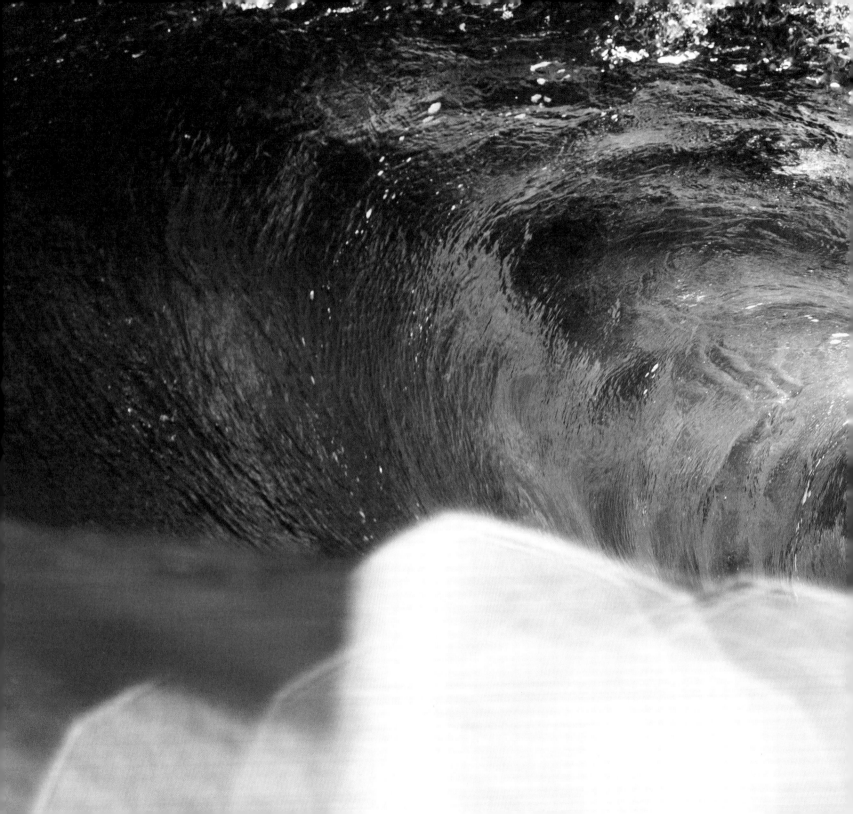

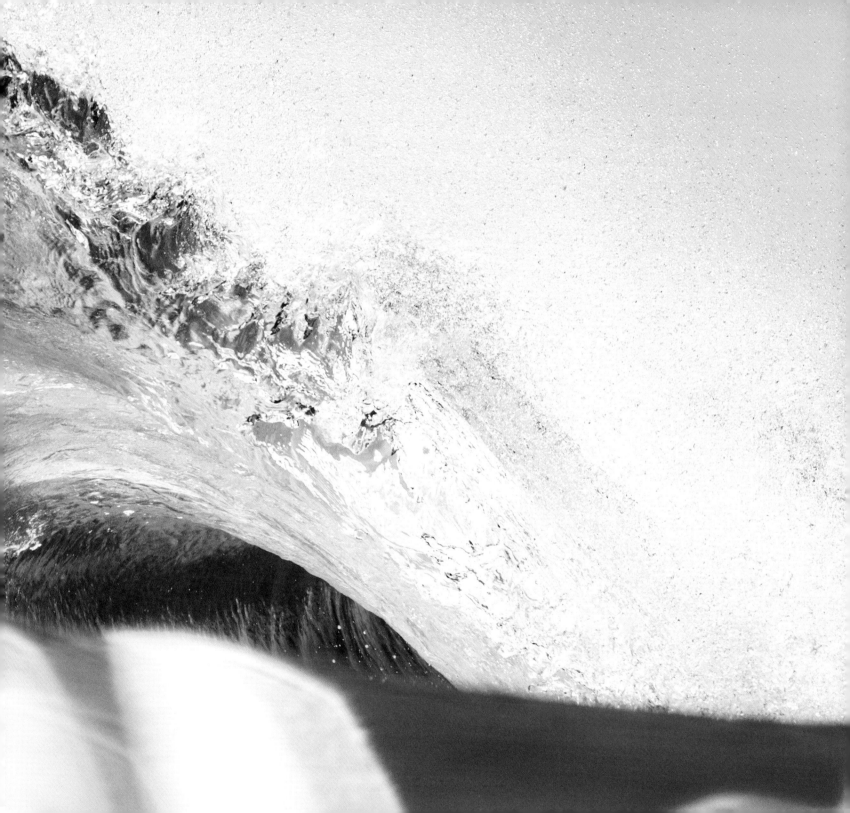

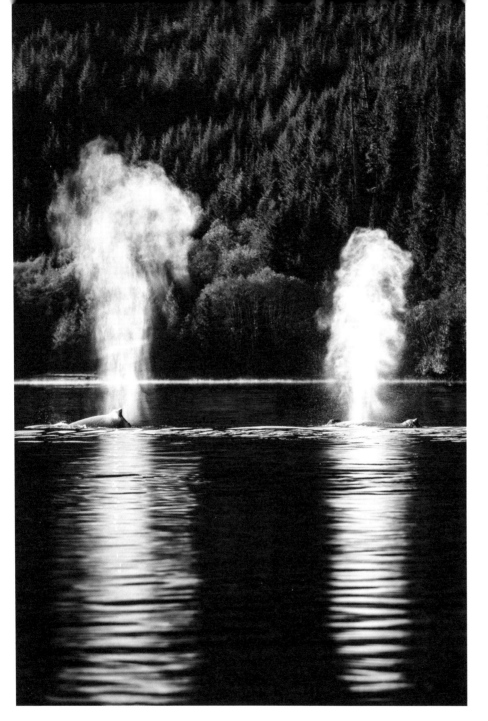

← I have the worst luck with whales. I've spent quite a bit of time on boats in the past few years, but I rarely see them and if I do they're gone as quick as they came. But luckily for me this morning was different. We slowed down and kept our distance as these beautiful humpbacks cruised by in calm water.

112

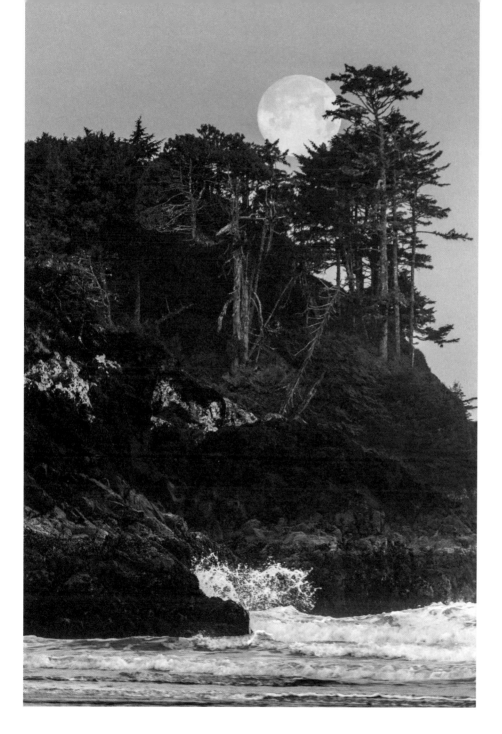

← The "Pink Moon" was rumoured to be the brightest and biggest super moon of the new year. It did not disappoint.

113

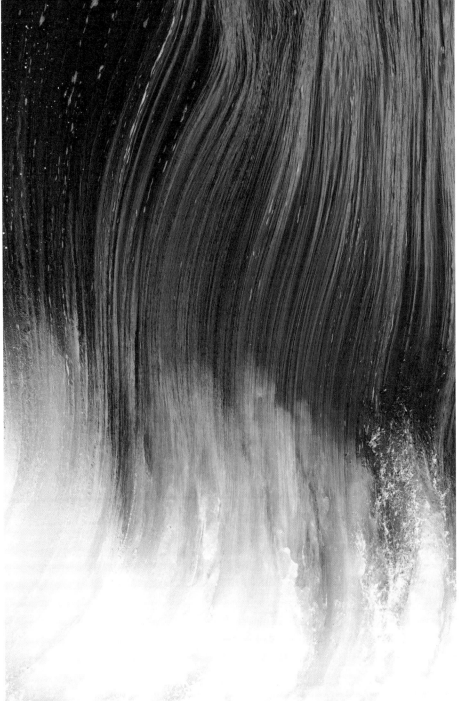

114

← A vertical perspective on the back side of a breaking wave along the shoreline.

→ An abstract underwater perspective.

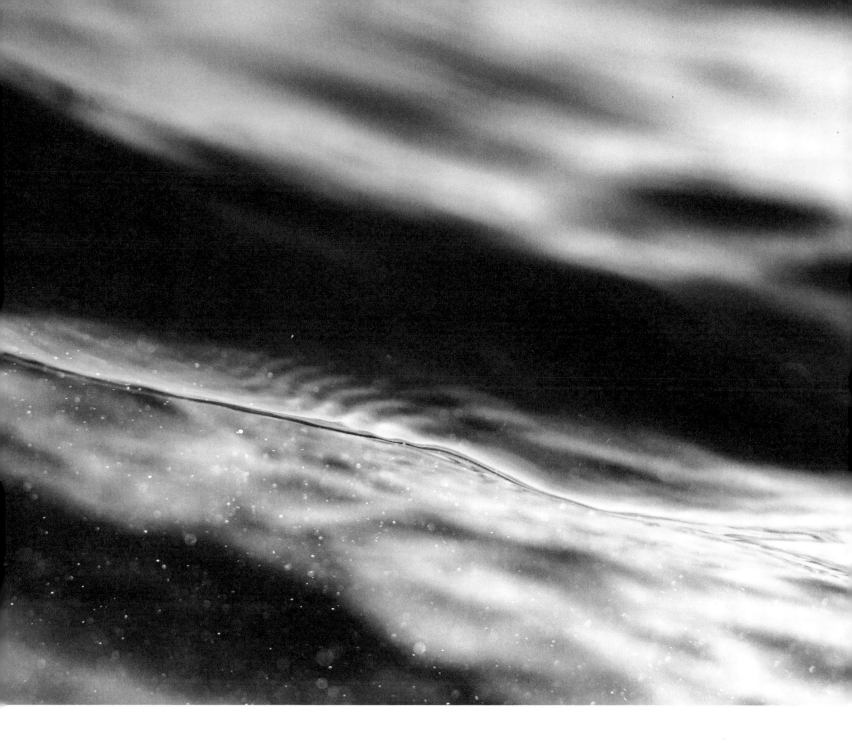

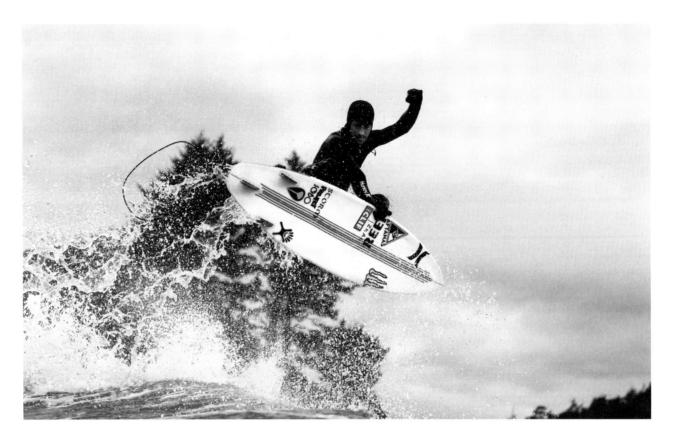

↑ I had just returned from Hawaii with fresh motivation from shooting on the opposite side of the surfing spectrum when Pete and I went out for a morning session. The current was unbelievably strong and I started getting sucked out to sea shortly after this photo was taken. I was told during my trip that "the ocean will always let you go... eventually." A very humbling experience to say the least.

≫ When I moved to Tofino, I lived in the staff accommodation at a beachfront resort, and Cox Bay was my backyard. When I finally got to see it from above, it was a nostalgic experience that is hard for me to explain. I have so many fond memories from this beach and its waters. It has shaped me into the surfer, photographer and person I've become.

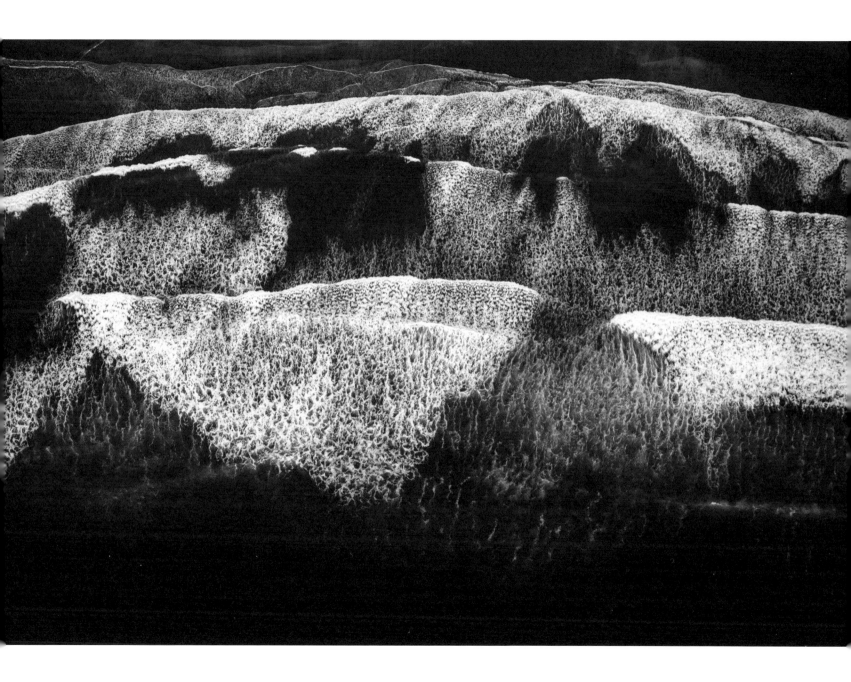

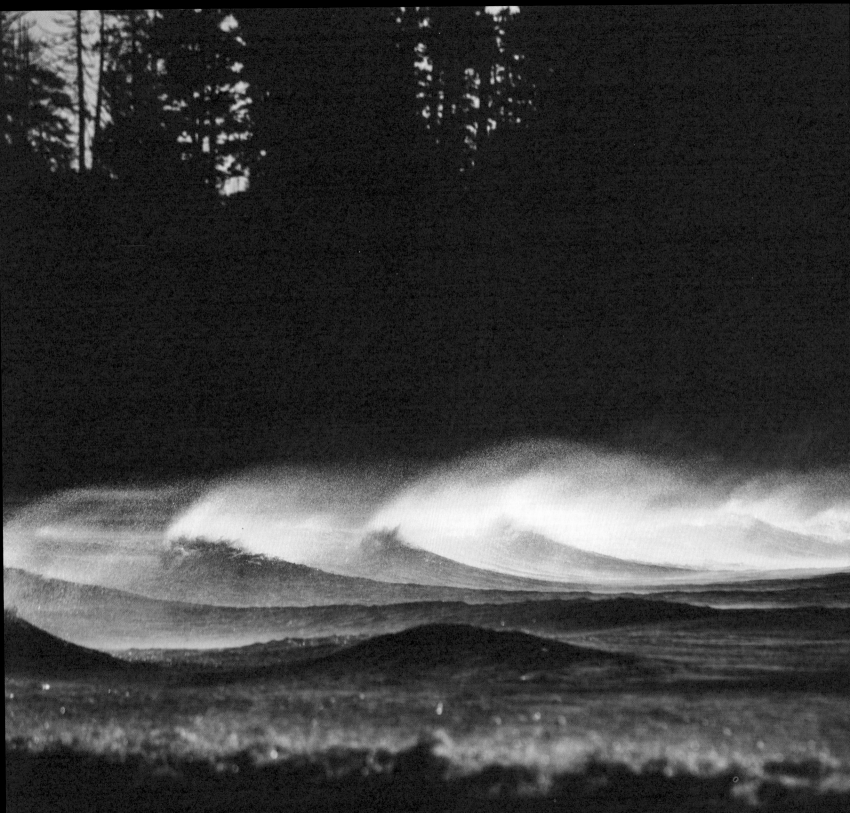

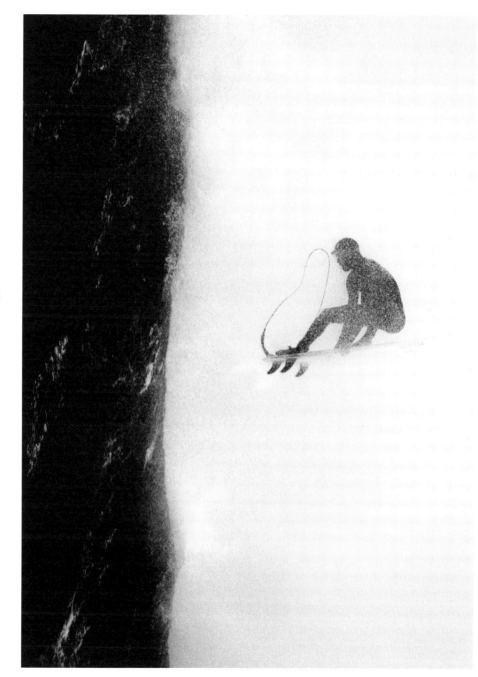

→ Michael Darling's new move. I inverted this image and edited it black and white to give it more of an artistic approach and to mimic the mood I felt in that moment.

← This small stretch of beach can get blasted with gale-force winds, and as they rip around the point they create extreme wind swell.

119

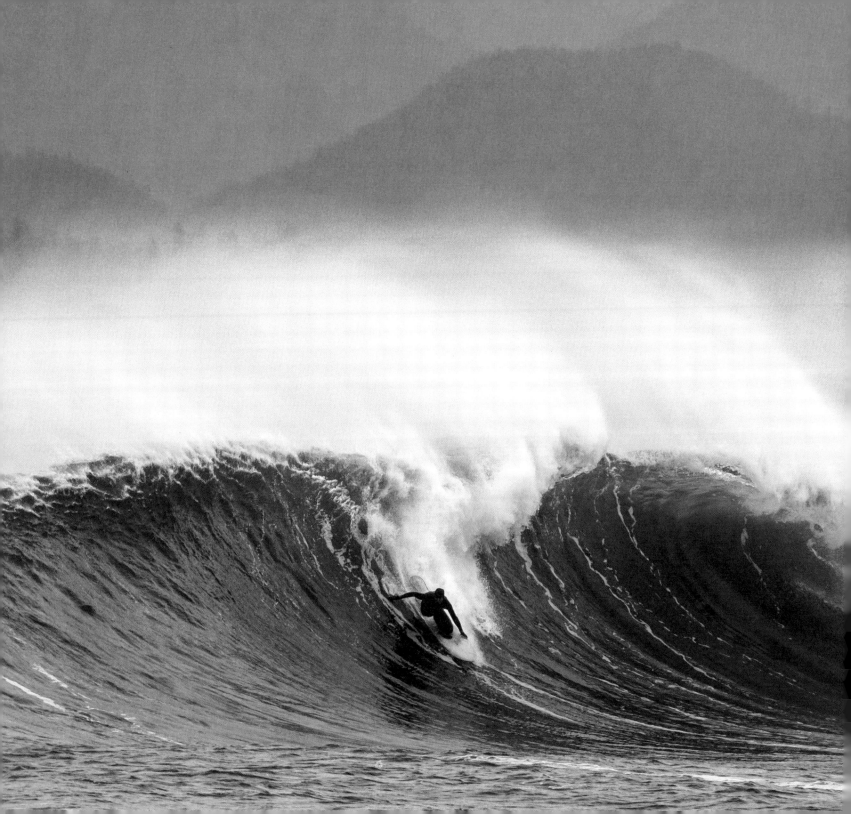

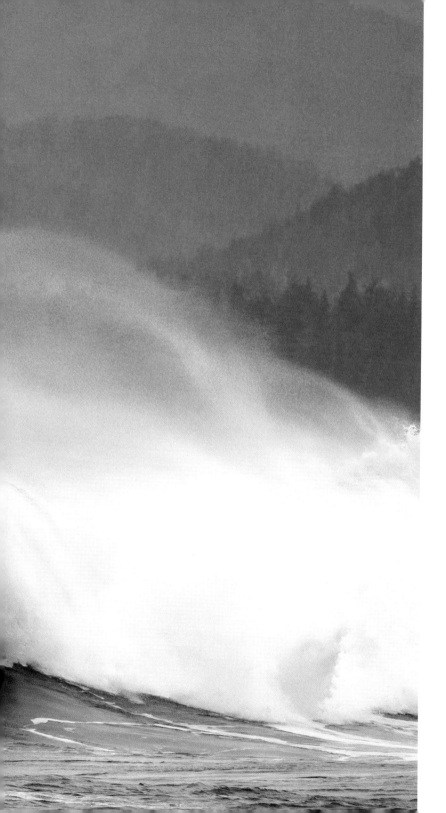

121

← Andy Jones, coming out of
quarantine and straight into a
slab. He's kept real low key since
the pandemic, and it's always
great to see him surfing more and
working less.

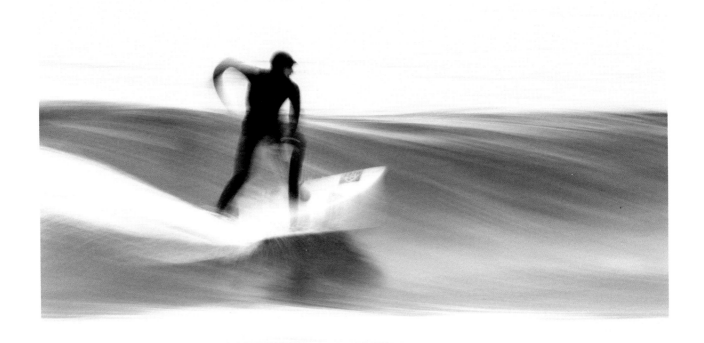

↑ Michael Darling was once claimed to be the fastest surfer on the West Coast.

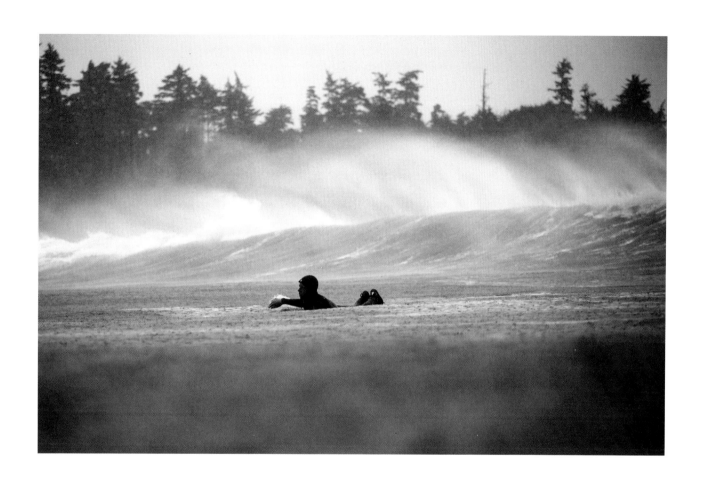

↑ Reed Platenius is growing up quickly. At the age of 15, he was surfing better than most locals could who were double his age. The future is really bright for this kid, and hopefully he will keep me right there to see it.

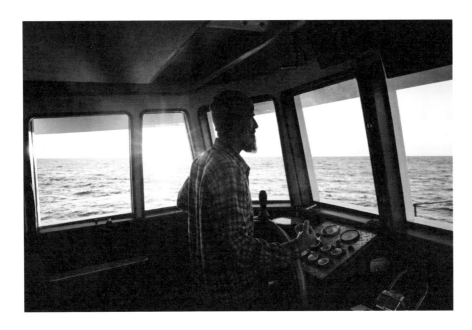

↑ First mate Doug Ludwig taking over the helm of SS *Pretty Girl*, a 75-foot YAG (Yard Auxiliary, General) vessel built in 1955. Formerly called the *Badger*, YAG 319 had been operated as a training vessel for the Royal Canadian Navy.

≫ Fall is my favourite time to shoot surfing here. The long-period south swells start showing up, the sun is out for most of the day and the water's not that cold, so you don't have to wear gloves yet. Noah Cohen was putting on a clinic at this populated point break, while shooting for his latest film project, *Transition*.

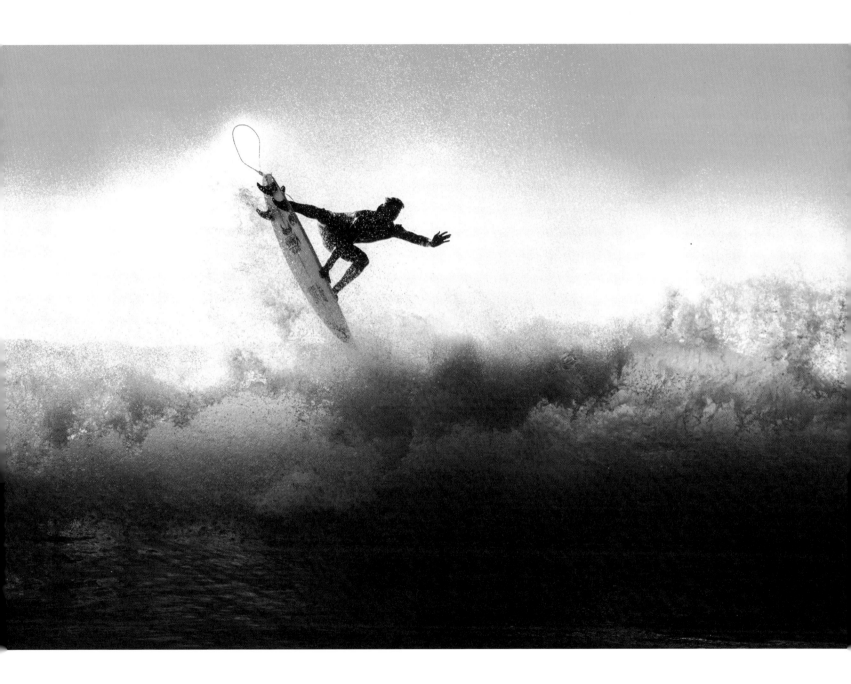

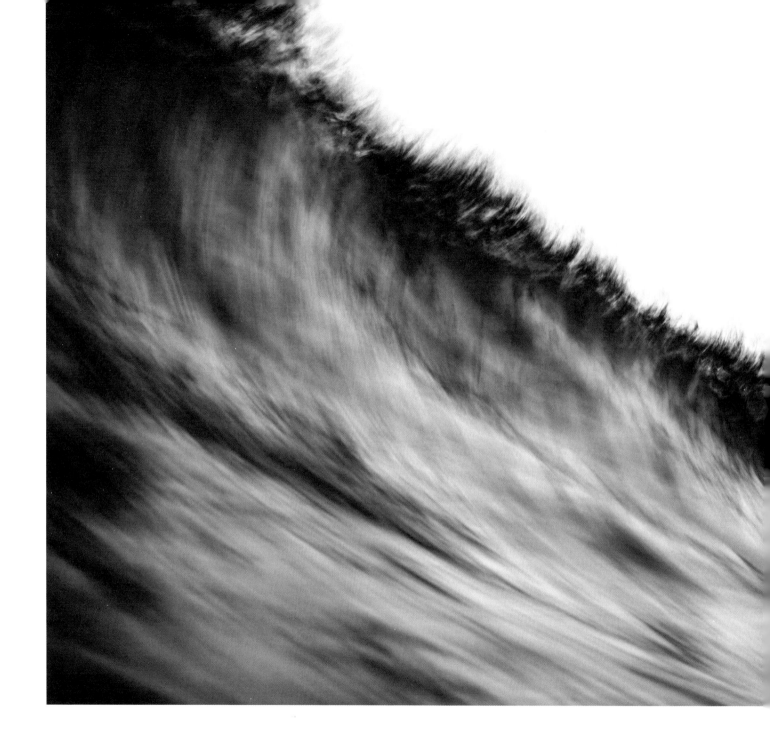

126

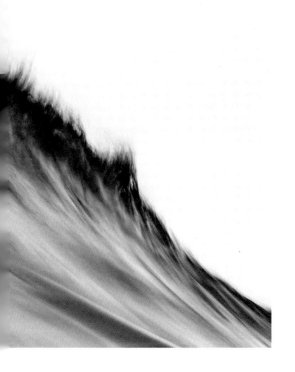

← I don't know what it is about this photo, but it feels like the best representation of myself. Whenever I look at it I start to get a bit teary-eyed. I have no idea why, it just resonates with me so deeply. That's when art has done its job, when people begin to see into their souls.

↑ I have always enjoyed trying to take at least one photo a day. That way I could continue to practise my craft regardless of conditions. I would go on a lot of beach walks by myself and see what I could come up with. Great advice from Jordan Manley comes to mind: "Walk slower."

» For a guy who prefers to stick to his forehand, Pete's ability to perform on his backside is incredible to watch. Even when he's at a right-hand point break, he can find a left and make it look second nature.

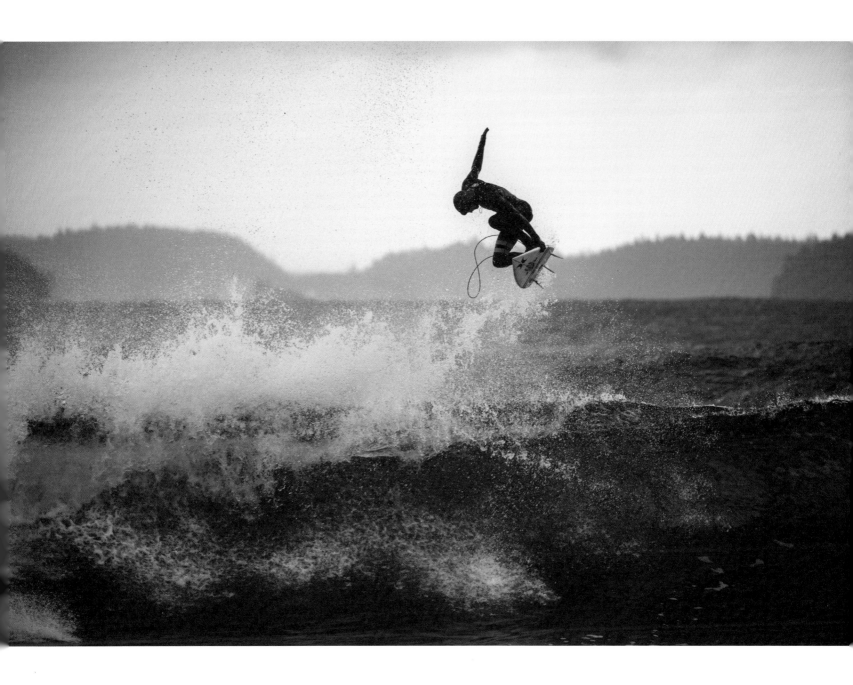

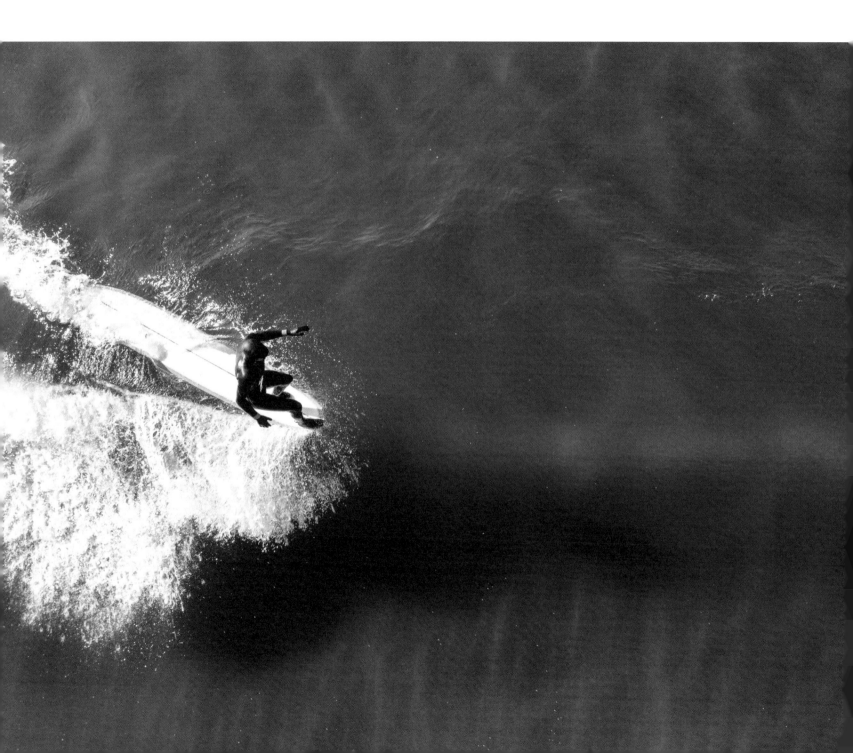

← Andy Jones walks the nose on a day when the weather looked like Hawaii but felt like Alaska.

↓ The last time we came here the waves were absolutely firing and there was no one else around. We came back on a hunch with the same anticipation but were stopped dead in our tracks.

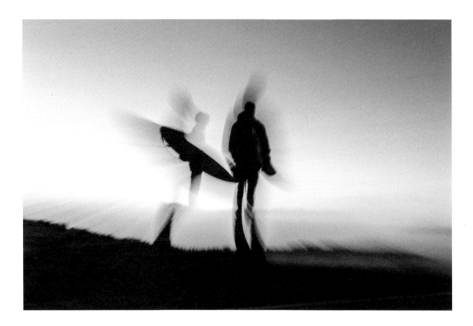

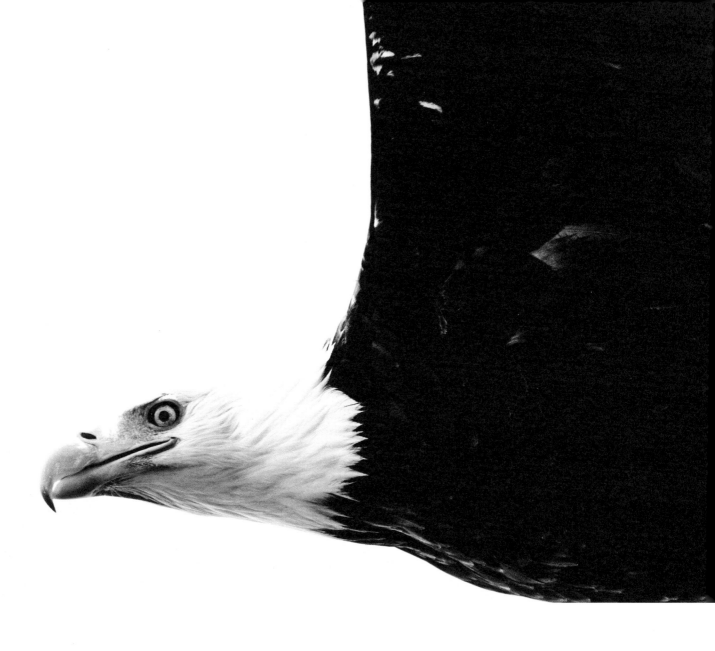

↑ This eagle circled our boat, continuously watching us closely while we were putting through Clayoquot Sound.

↑ Focusing on shooting waves over surfers is a completely different mindset. It's less preparation and more spontaneous.

134

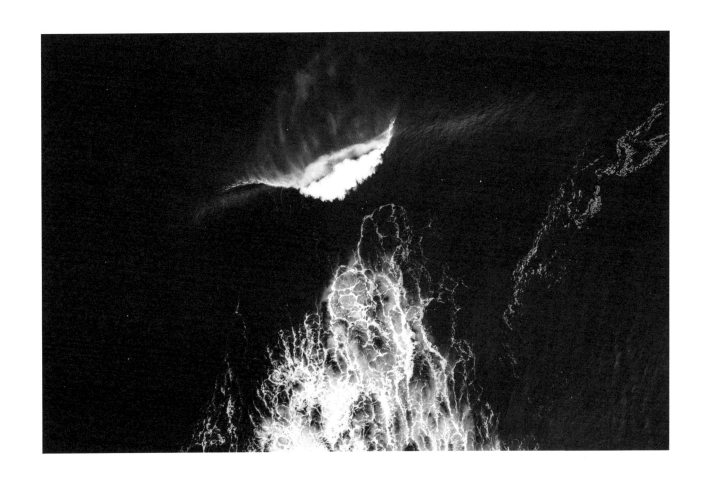

↑ I was actually assigned to shoot video from the water on this trip up the coast, but I managed to sneak off in the morning to grab a few stills from the air before everyone else woke up.

→ Peter told me that if something went seriously wrong out here, there's a lighthouse we could hike to along the coastline that's about an eight-hour journey one way.

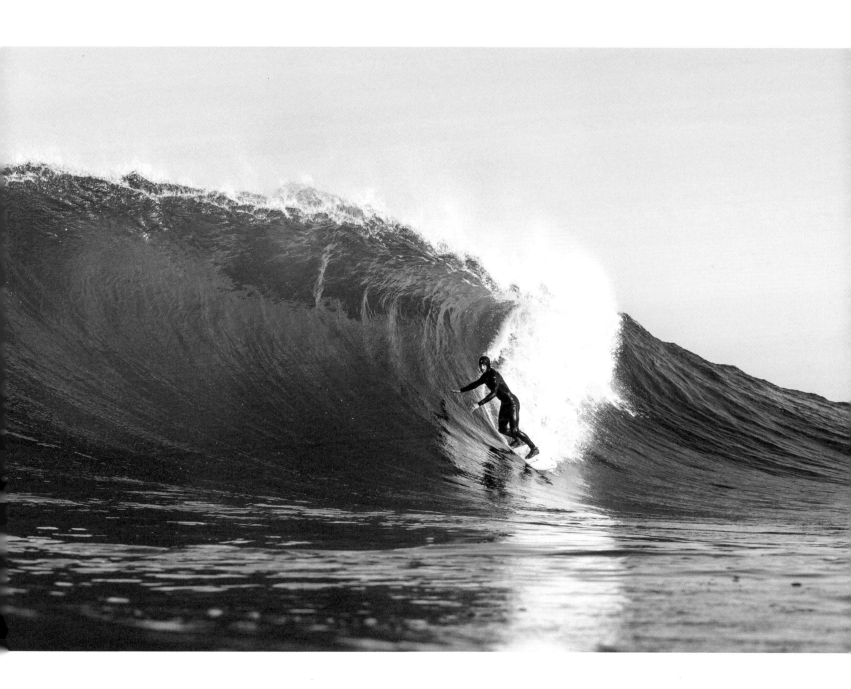

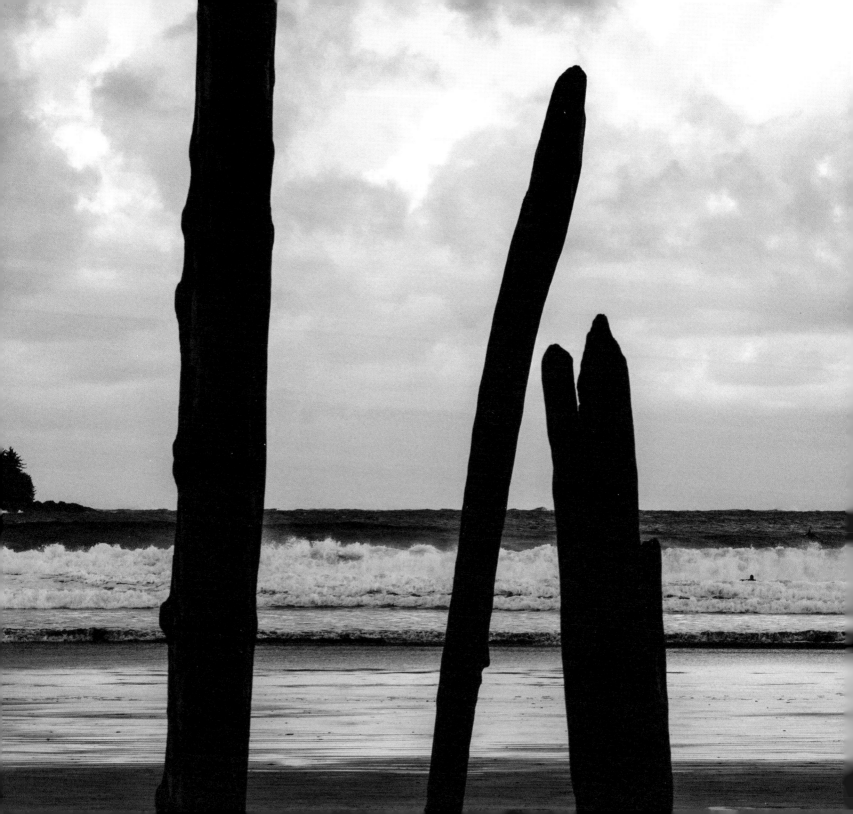

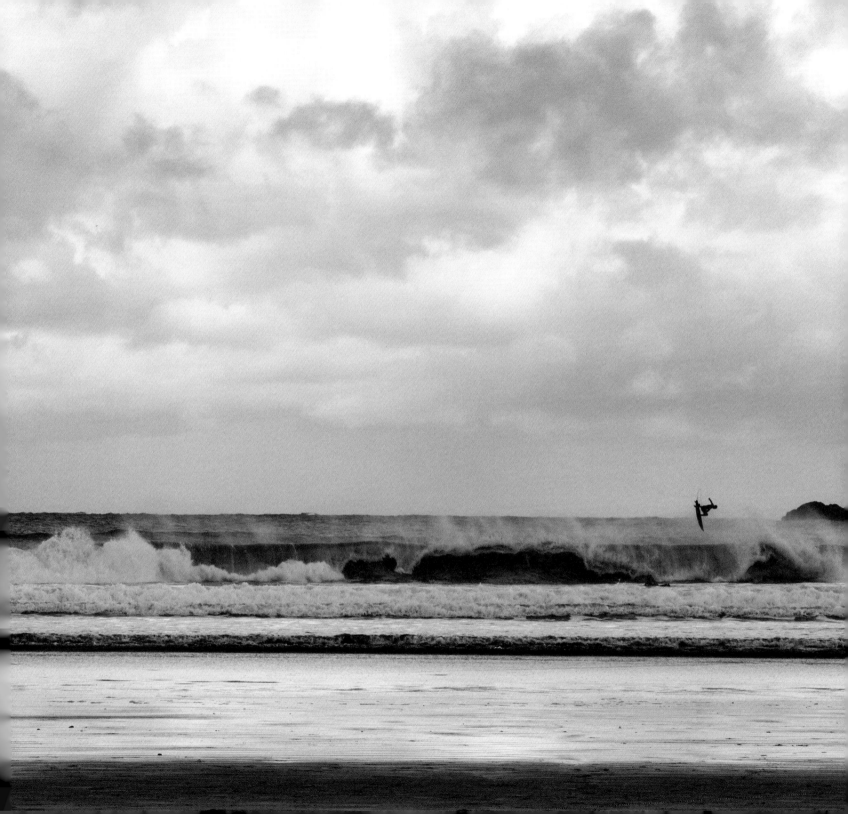

↰ I spent this entire day only shooting with my 50mm lens. I wanted to see if it was still possible to capture a quality surf image without a long focal length. The tiny speck of a surfer mid-air is Pete Devries.

138

→ As I swam back to our boat, I turned around to get one last photo of the wave. I kicked my fins as hard as possible, to stay above the surge of water breaking beneath me and keep the wave in view as it broke.

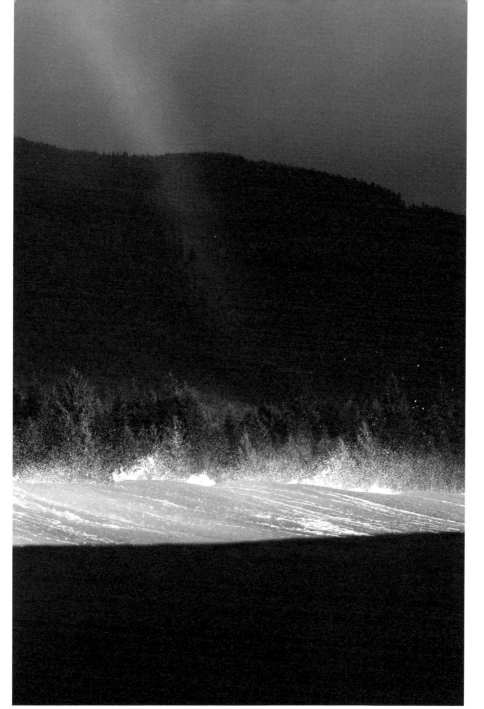

← I call this place the land of rainbows.

→ Simon Bauer dips into the wave of the day down the point. It's rare to see such hollow barrels here, but Simon really put in some work this past winter to make sure that when one came, he'd be ready.

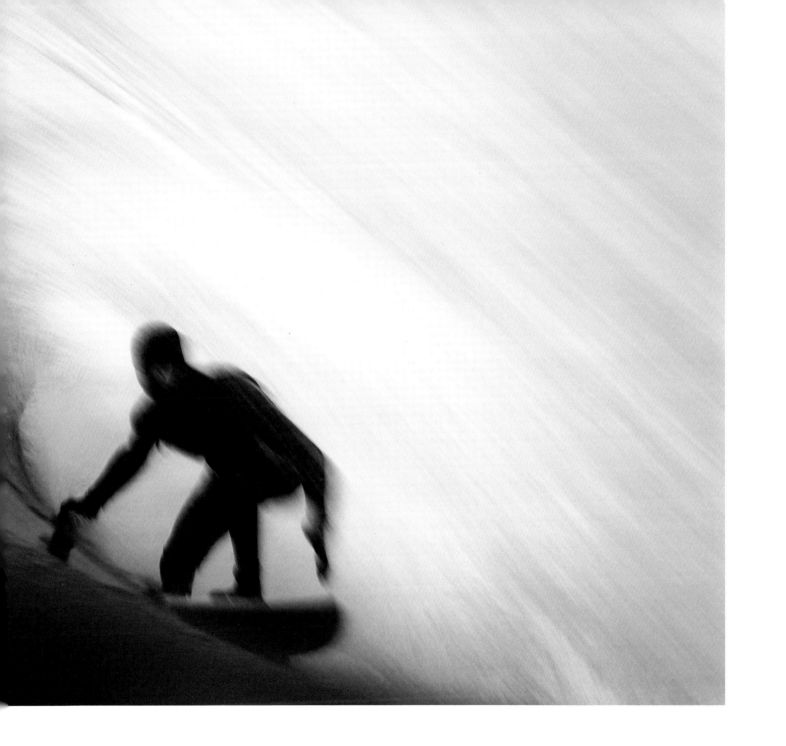

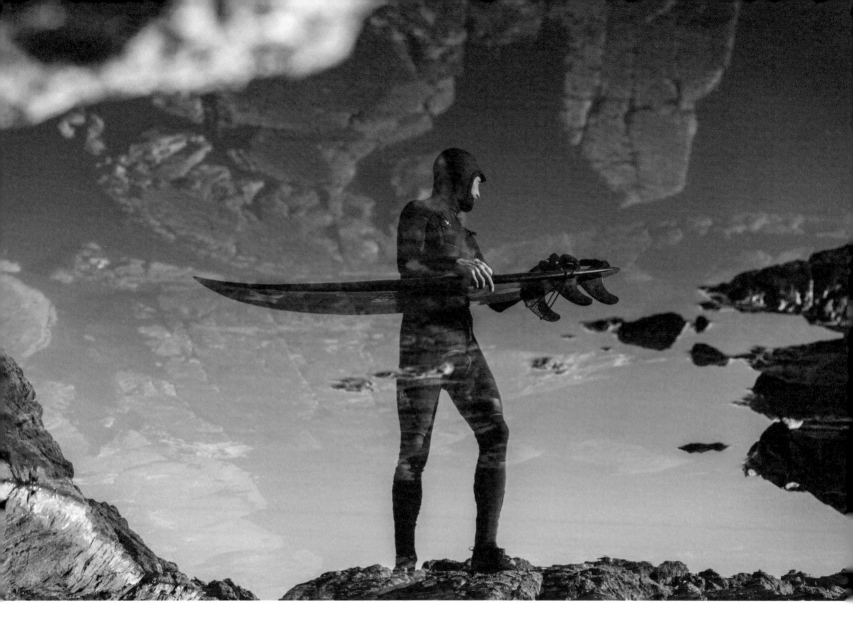

↑ Sometimes when Pete and I go on missions to find waves, the lifestyle shots end up standing out more than the actual surfing images. That's something I've really had to learn over time, to stay creative and look for angles before the shoot even begins.

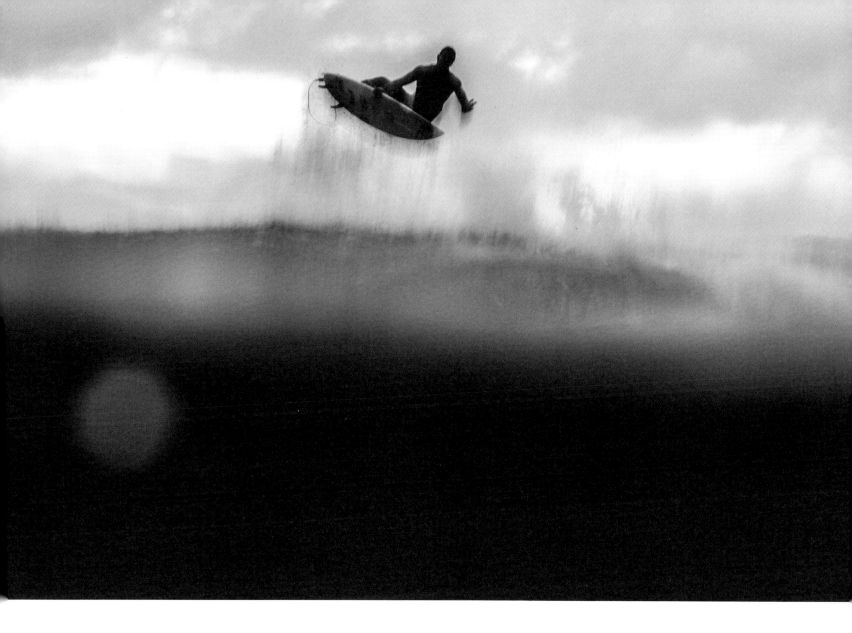

↑ One of the world's most renowned free-surfers was also in the water on this day, but local boy Noah Cohen still stood out among the best.

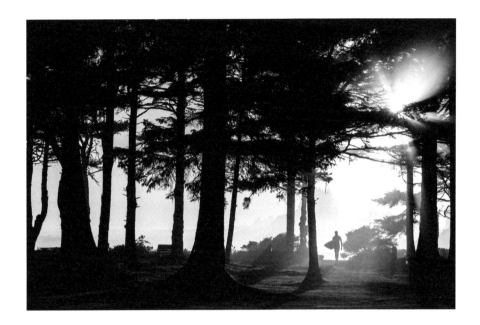

↑ Michael Darling finishing up a sunset surf at our local beach break.

→ A little moment of beauty and perfection as I prepare to duck under the wave. I love shooting from the water when the sun it out, as any moment can become *the* moment.

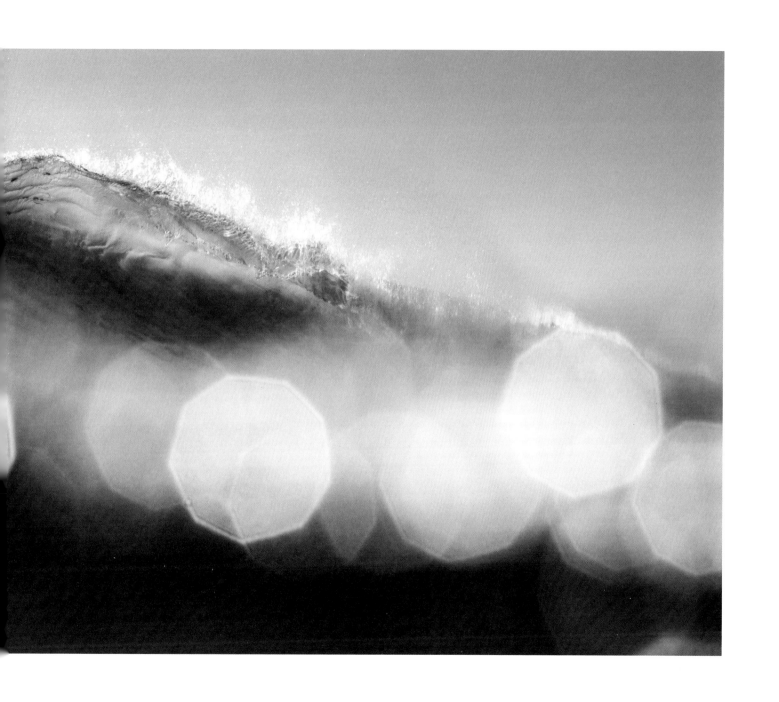

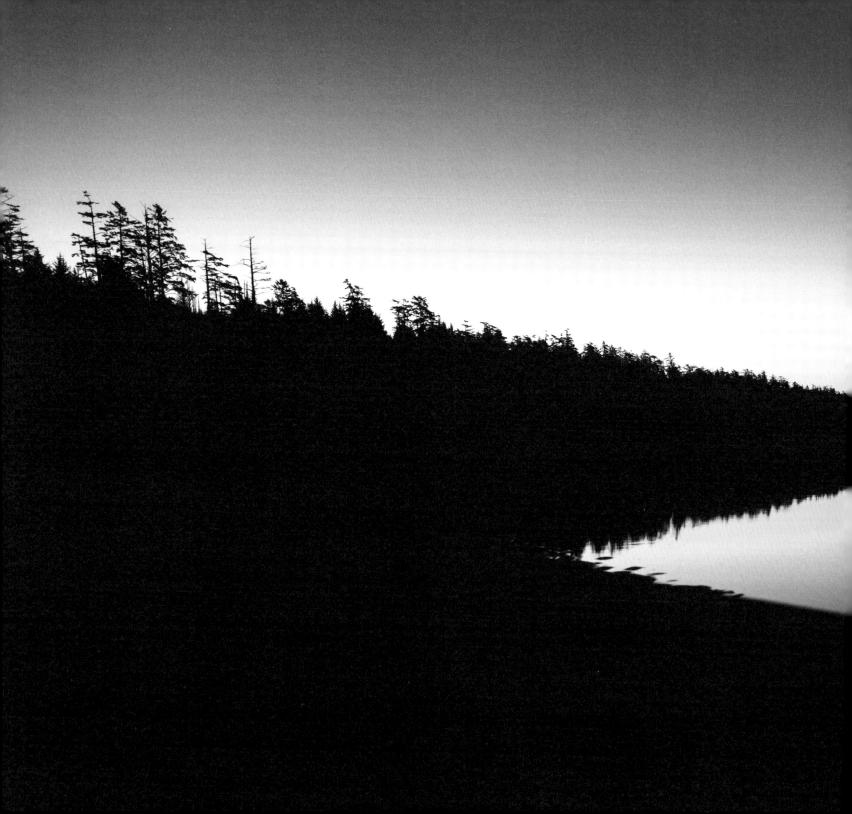

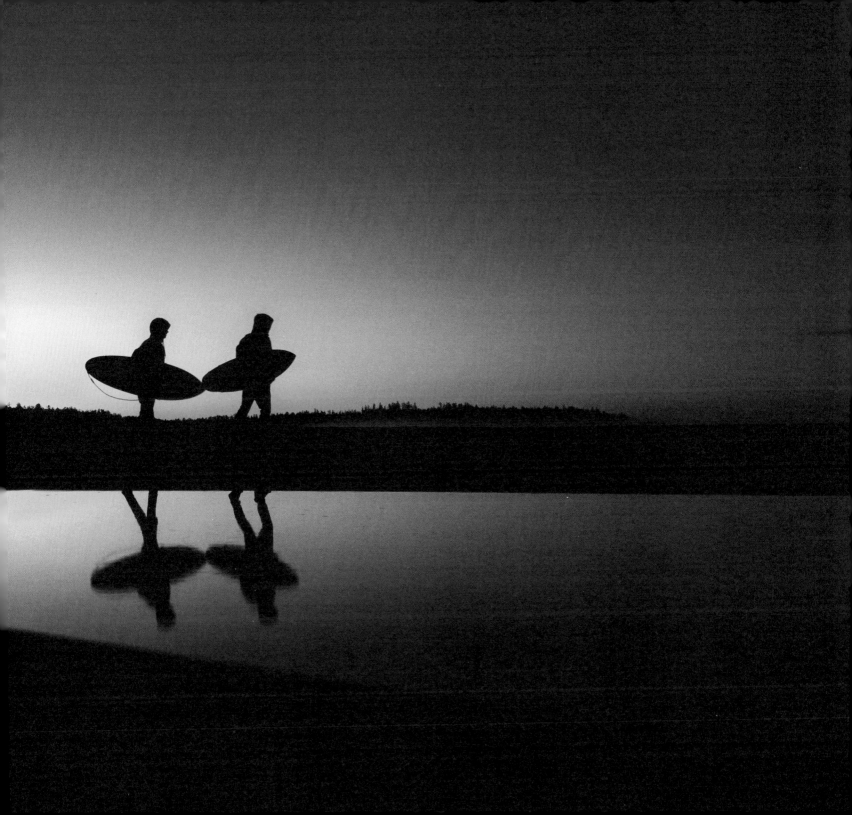

← After most of our surf adventures had been unfolding without much luck, Michael Darling, Malcolm Daly and I started to refer to ourselves as 'The Geese'. Even since, our trips have been nothing but wild goose chases.

↓ Four surfers waiting for their turn as a squall of rain slowly approaches from across the water.

≫ There is a lot of current around this point; I know from experience while surfing in close proximity. I've taken many mental photos of waves crashing on this rock. One morning, I swam out at sunrise and felt overwhelmed with gratitude to finally be able to capture what had been in my head for years.

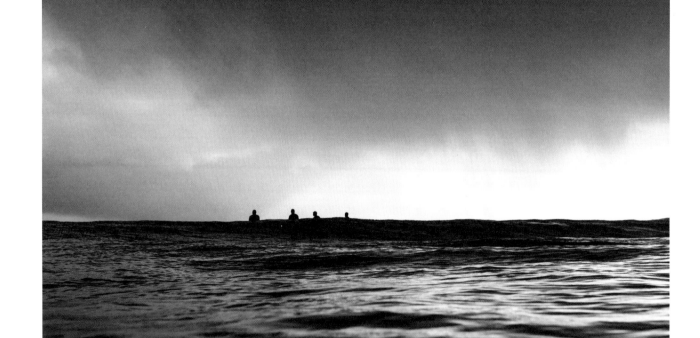

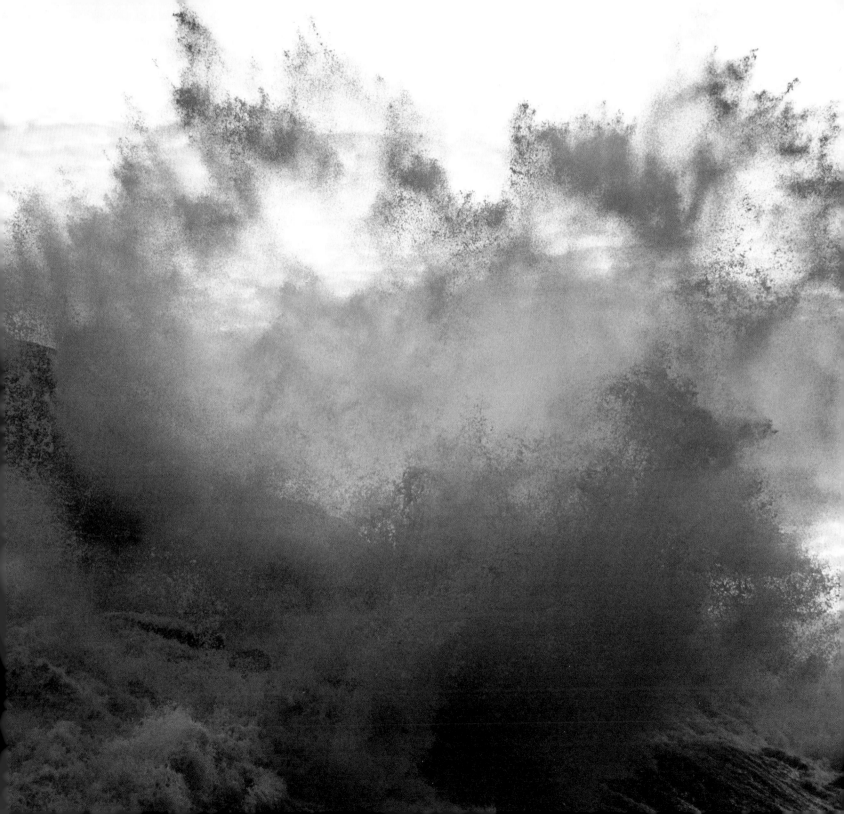

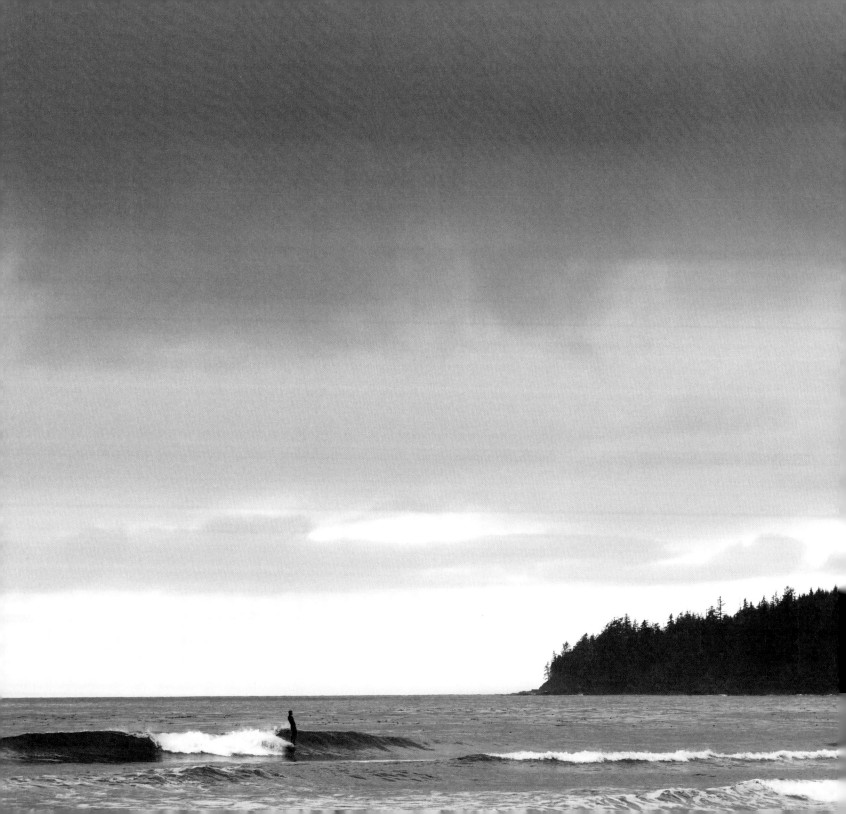

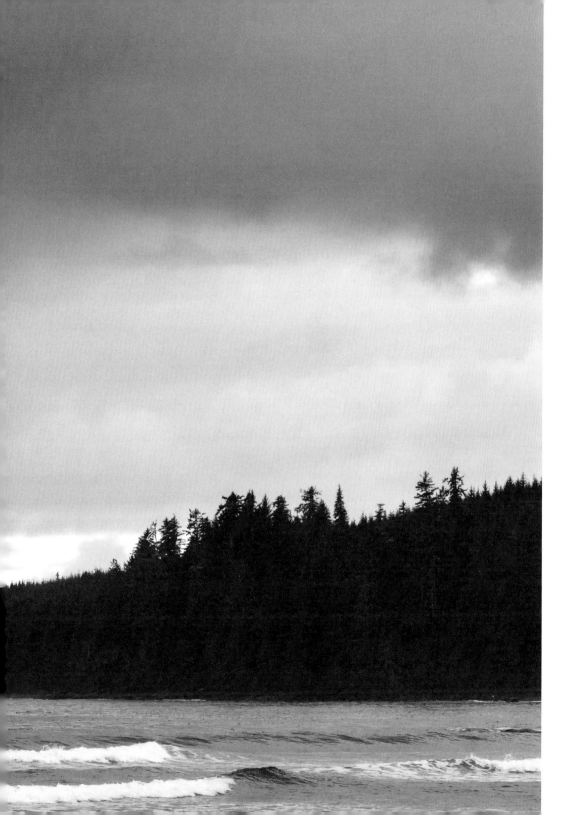

151

← Andy Jones left the hustle and bustle of touristy Tofino in exchange for a quiet life and isolation without cell service. It looks to me like he made the right call.

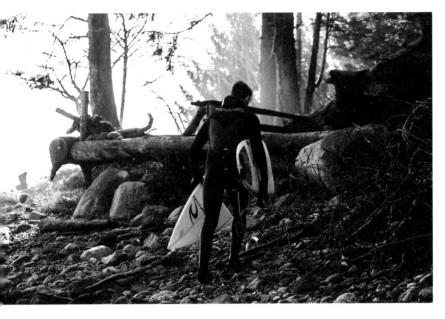

←When Noah came in with a broken board, I asked him to stand by the water, look out and wait for a set. Afterwards, I thanked him and he walked off. I turned around to say something else as he was walking away, and in that instant I realized that the best lifestyle photos are always candid. I don't always need to be creating moments, but simply capturing them.

➤ I was walking on the beach when I saw a group of birds eating away at something near the shore. I posted up and watched for a while until they all flew off from an incoming tide. This juvenile bald eagle and crow flew off together in perfect synchronization.

↙ I love shooting the lip of a wave, as it each time it creates a unique form.

↓ Derek Westra-Luney taught me everything I know about surfing, so it seemed only fitting that my first international surf trip was with him and a small group of friends.

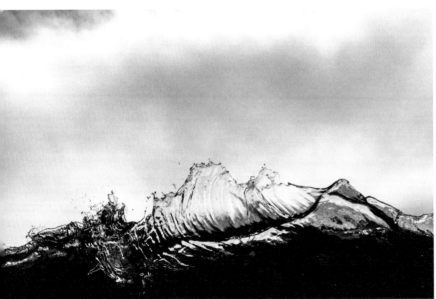

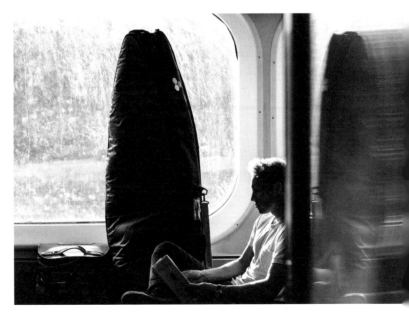

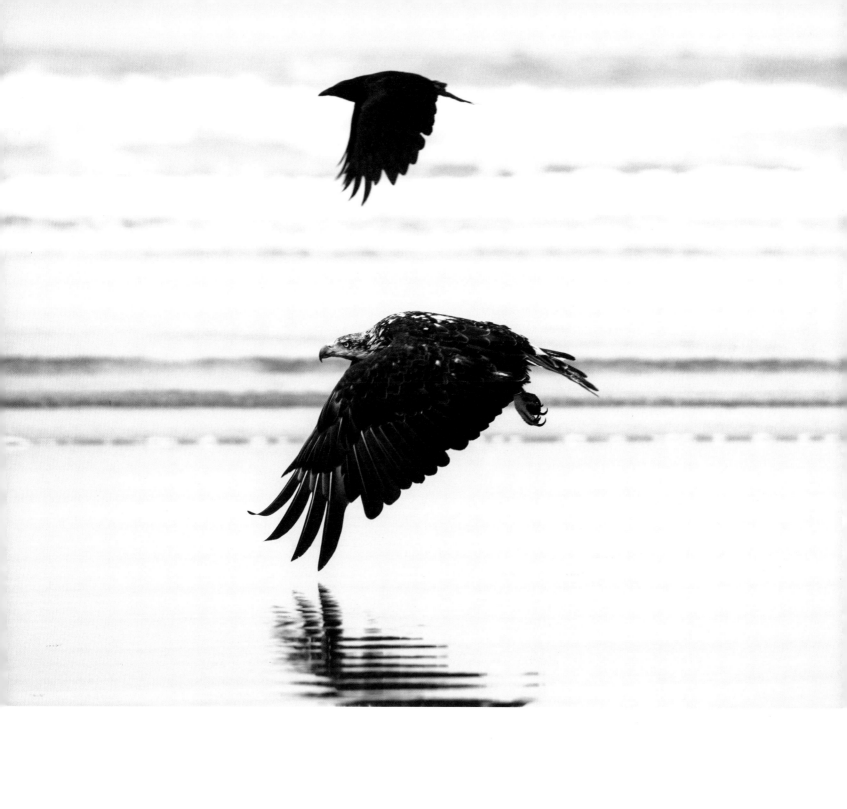

154

→ This was one of the best days of surf I've ever seen at this spot. I ended up shooting from the land for almost six hours straight. The conditions kept changing with the tide, but as time passed, more surfers and friends just kept paddling out. I had to call a friend who was getting ready for his second session to go buy me a sandwich from the gas station on his way because I just couldn't pull myself away.

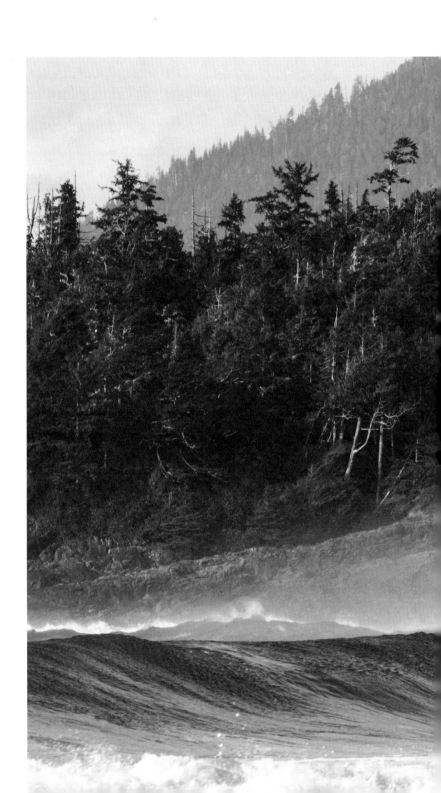

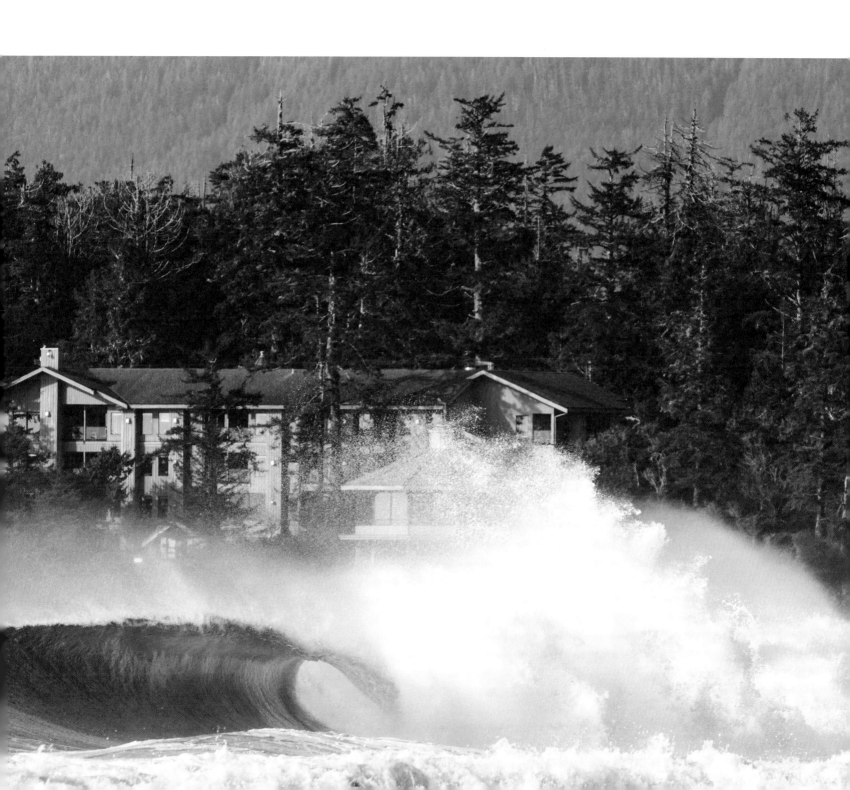

156

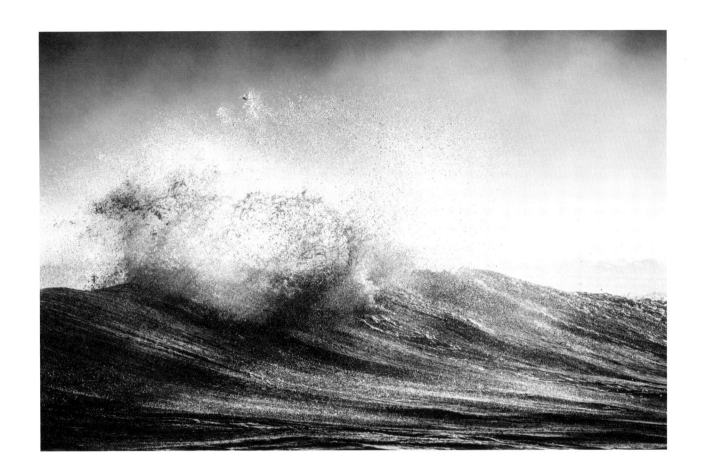

↑ Ryan Oke left behind this waft of spray from his turn during an early morning surf.

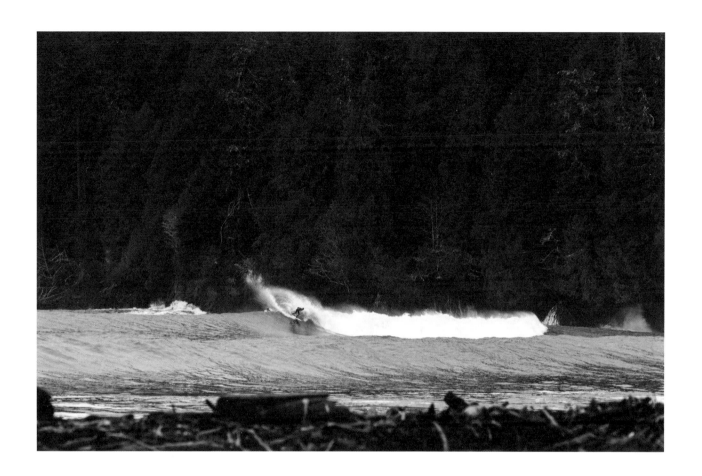

↑ Shannon Brown attempting to spray the trees on his backhand while on a road trip around Vancouver Island.

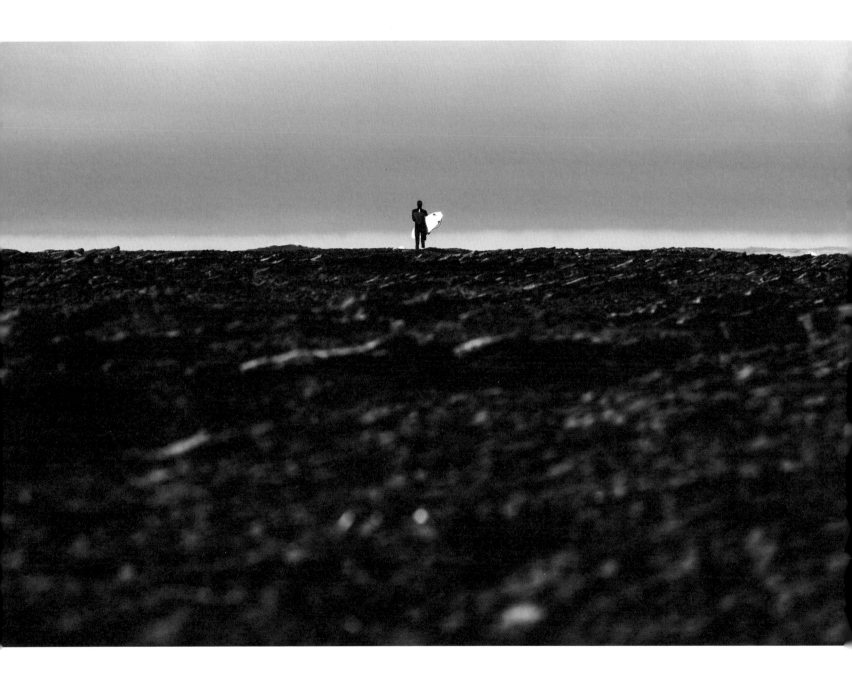

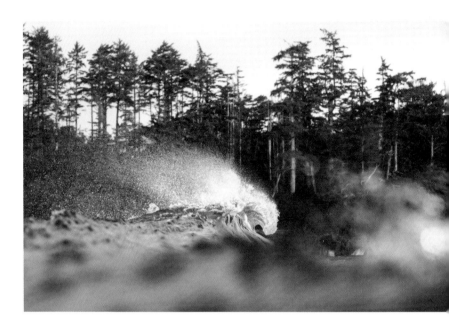

↑ Sometimes I plan to go out to shoot one thing, and end up completely focusing on another. Just like in the water, you've got to be willing to adapt to whatever circumstances you're given.

← This wave breaks so far from the beach, it takes almost 30 minutes to walk from basecamp to the end of the reef to get into the ocean. Here, Andy Jones is taking a final look before his paddle out.

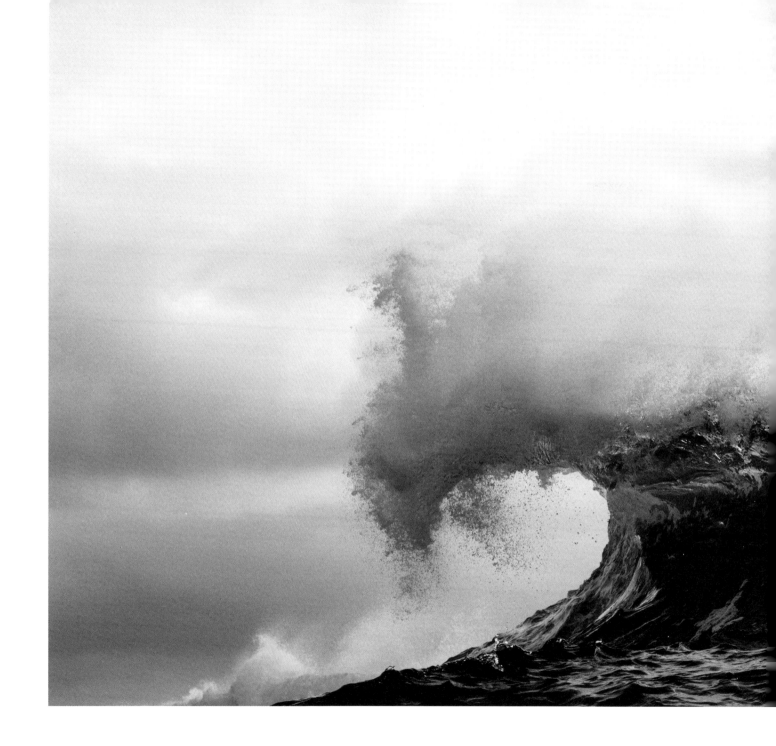

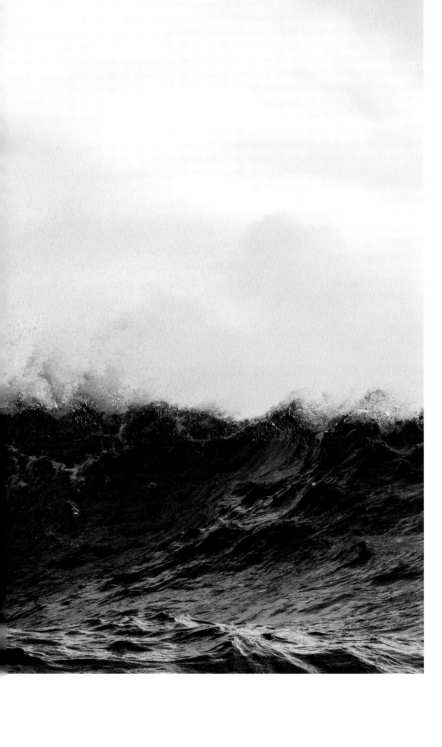

← As far as I know, I'm the only photographer that has ever swum here. I hope it stays that way.

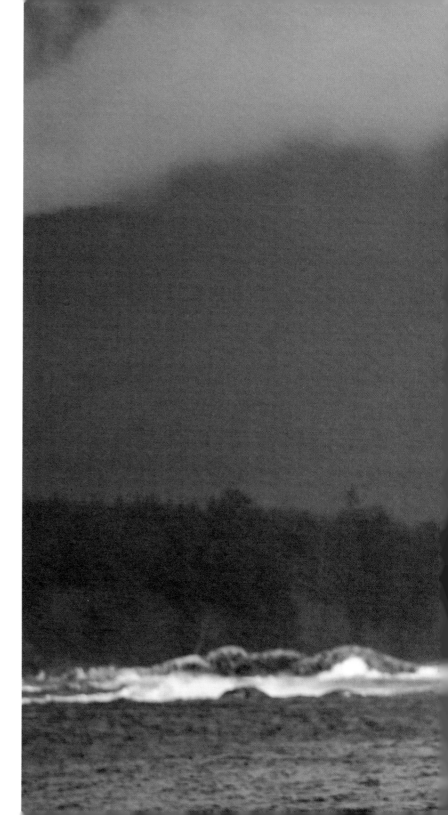

→ When Pete landed this air, I immediately heard a collective exhale from everyone watching from the beach. That's what his surfing does to people: it makes them subconsciously hold their breath in anticipation.

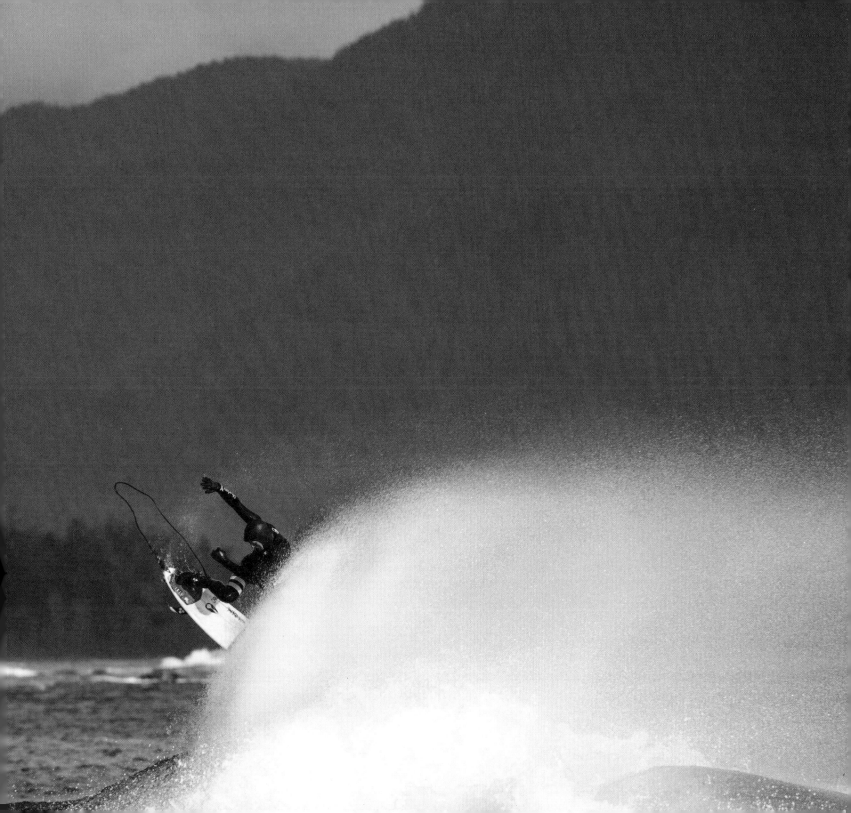

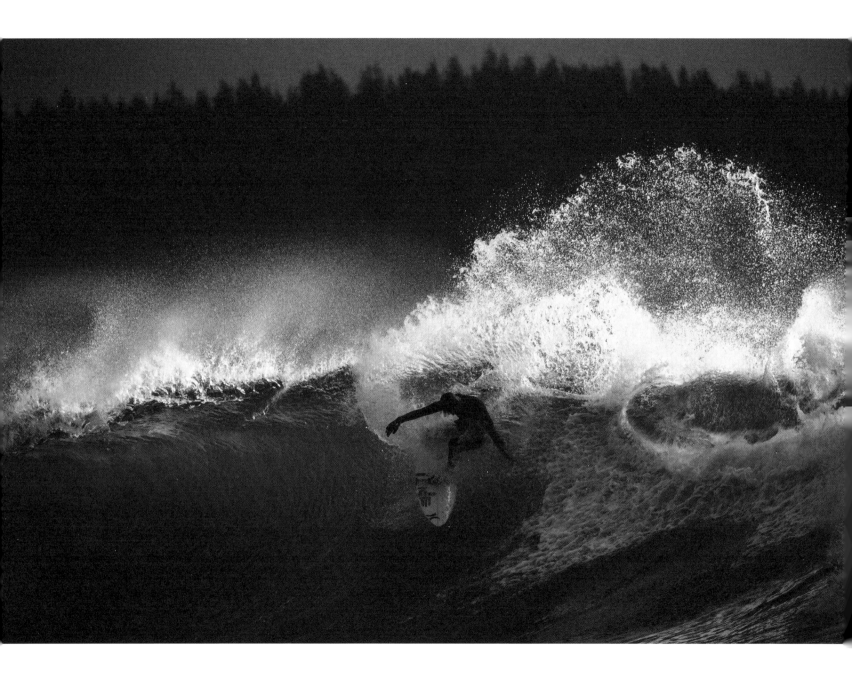

↑ I've always said that you can tell a lot about someone by their natural resting expression. Noah Cohen once described Pete Devries as being "simplistically complicated," a sentiment I've discovered to be quite accurate.

« Every time Pete and I talk about this photo, he apologizes, claiming he botched the turn and should have done a better manoeuvre with that brief morning light. It just goes to show how much of a perfectionist he really is, always looking to improve and push his abilities. I like to think his hard work and determination have rubbed off on me over the years.

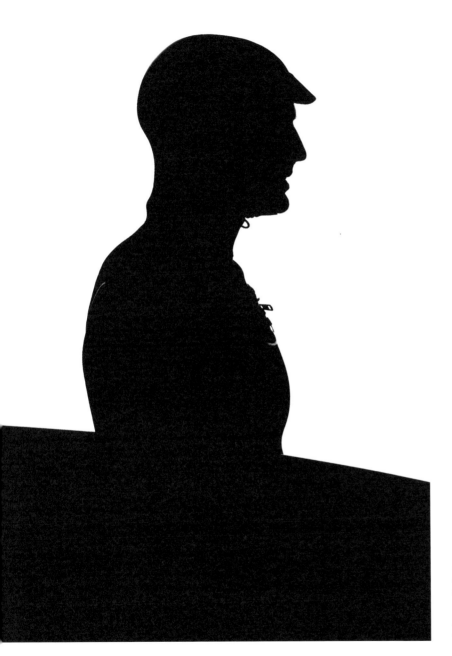

← While on assignment in 2019 for an *enRoute* magazine feature about Canada's hopeful Olympic surf team, I managed to capture this candid silhouette portrait of Pete Devries.

→ Is this wave 6 feet or 6 inches? When there's nothing to indicate scale, the answer is in the eye of the viewer.

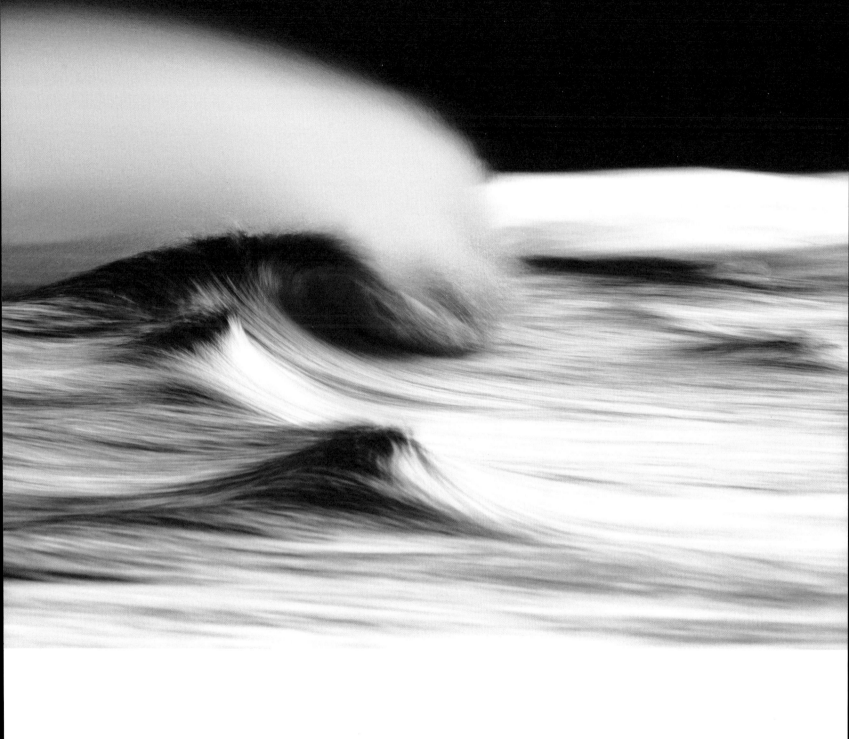

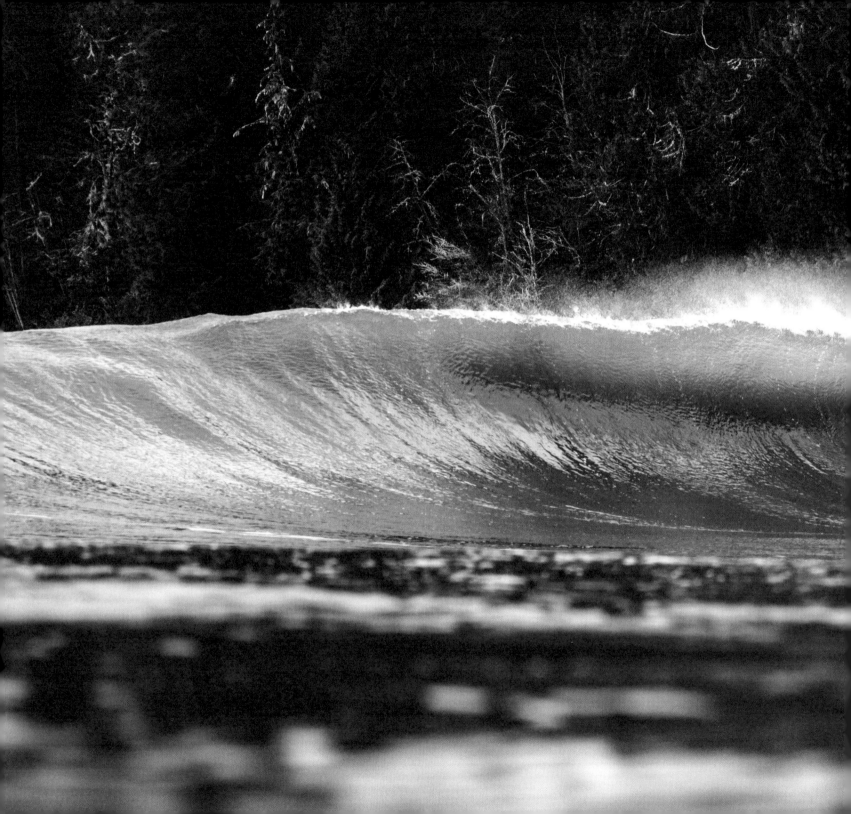

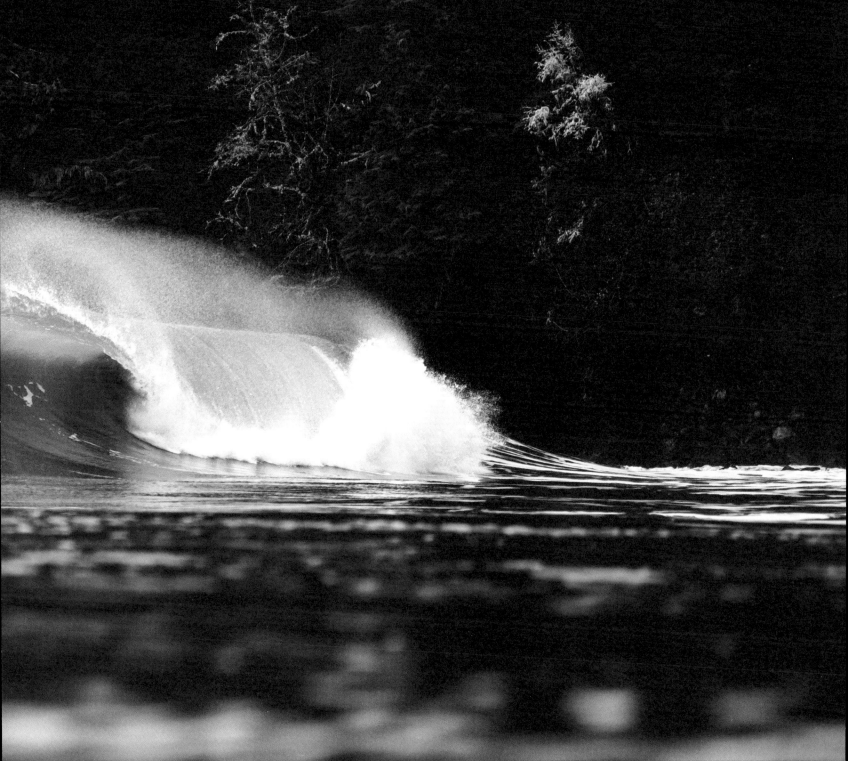

↰ Ever since the first time I surfed this wave back in 2012, I've wanted to swim here with my camera. This place has a gorgeous forest backdrop and at times an epic wave. Sounds perfect, right? The problem is it's a long drive away and has only a fickle window between tides. And to top that off, for the shot to work, there needs to be a specific and infrequent swell on the forecast.

170

→ There's no place in the world I would rather be to shoot the sunrise than this spot. From the first time I came here in 2012, this place has always been very dear to my heart. Despite how fickle the wave can be, I love shooting here any day of the year. Hanna Scott threw everything she had at this section, and it ended up on the cover of *SBC Surf*.

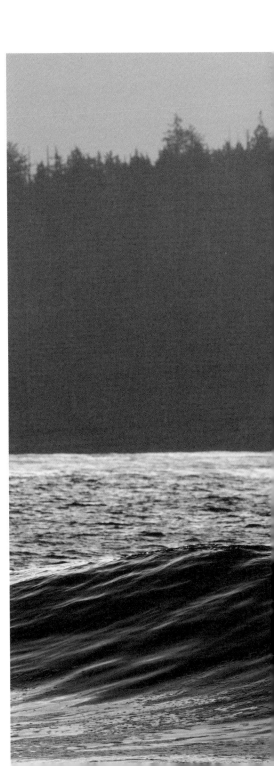

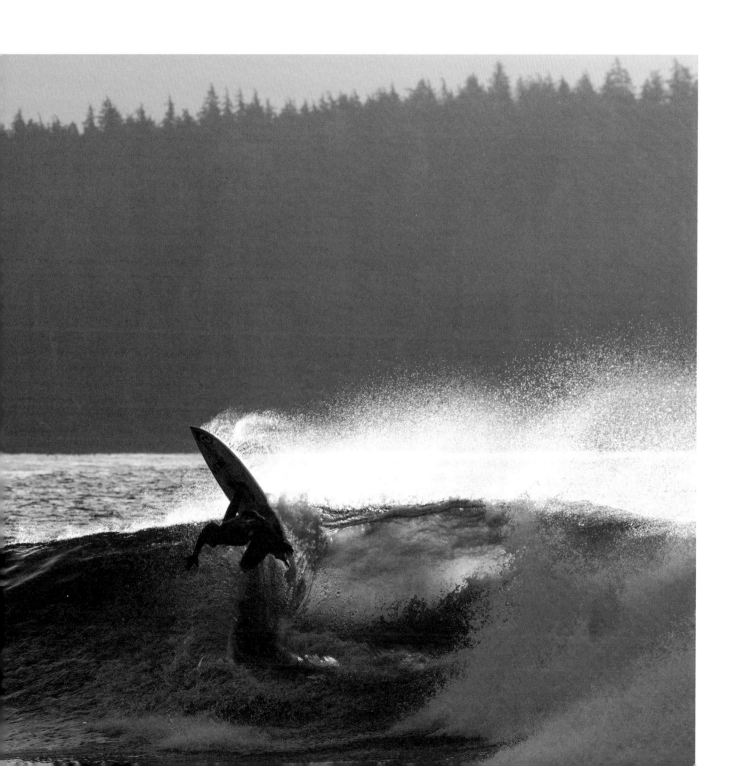

↑ I've sat on this rock and watched the sunset so often that I've lost count. It's become such a pivotal place for me. I know many good spots to sit and enjoy this show.

→ Pete Devries loves early morning surfs. It's one of the few opportunities to try and catch a few waves by himself before the sheep flock and start following him around.

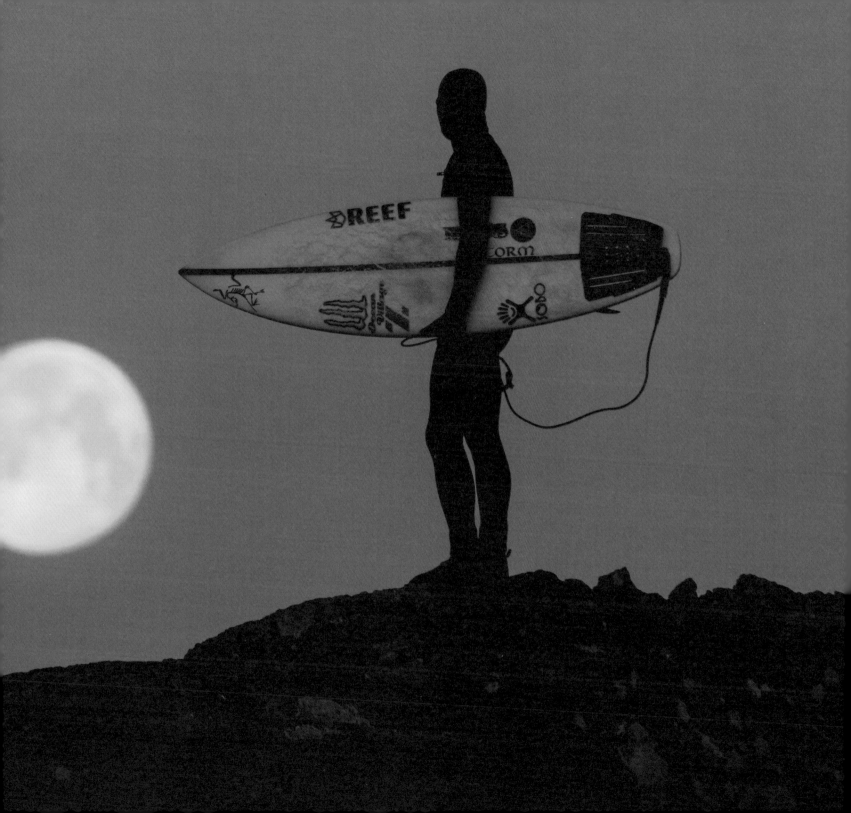

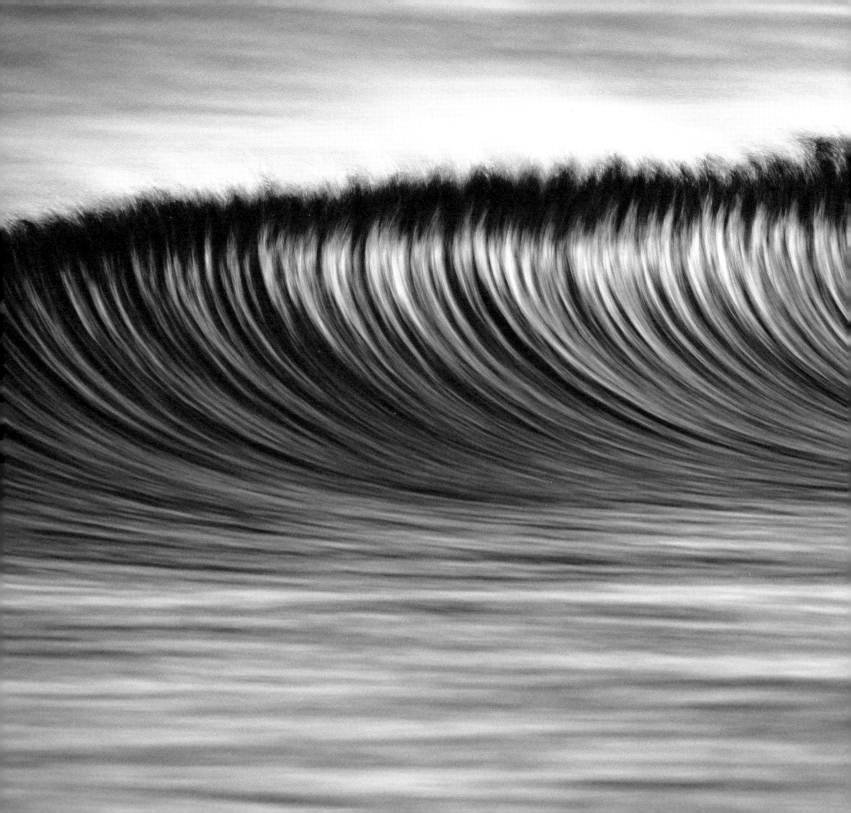

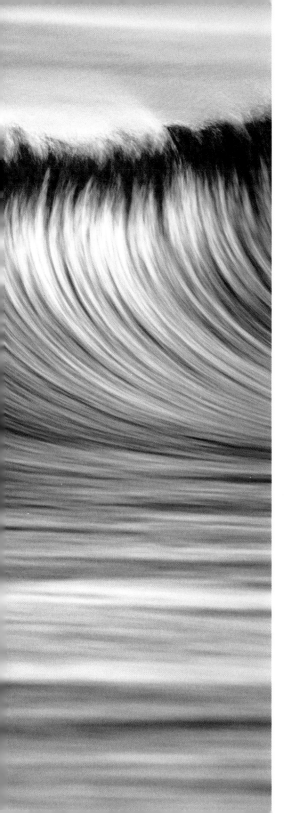

← I love adding a sense of movement to my images of waves. It creates a new dynamic to photography that forces the viewer to move in unison.

176

→ Timmy Reyes loves to make spontaneous visits from south of the Canadian border. Though in the case of this forecast, his excursion here was anything but random.

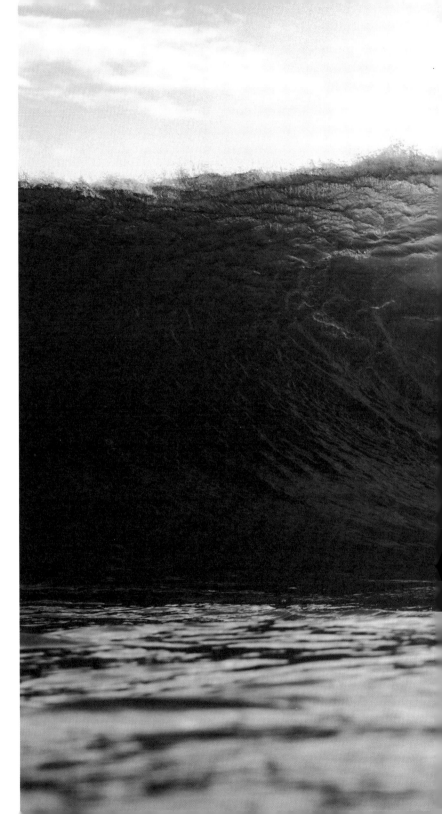

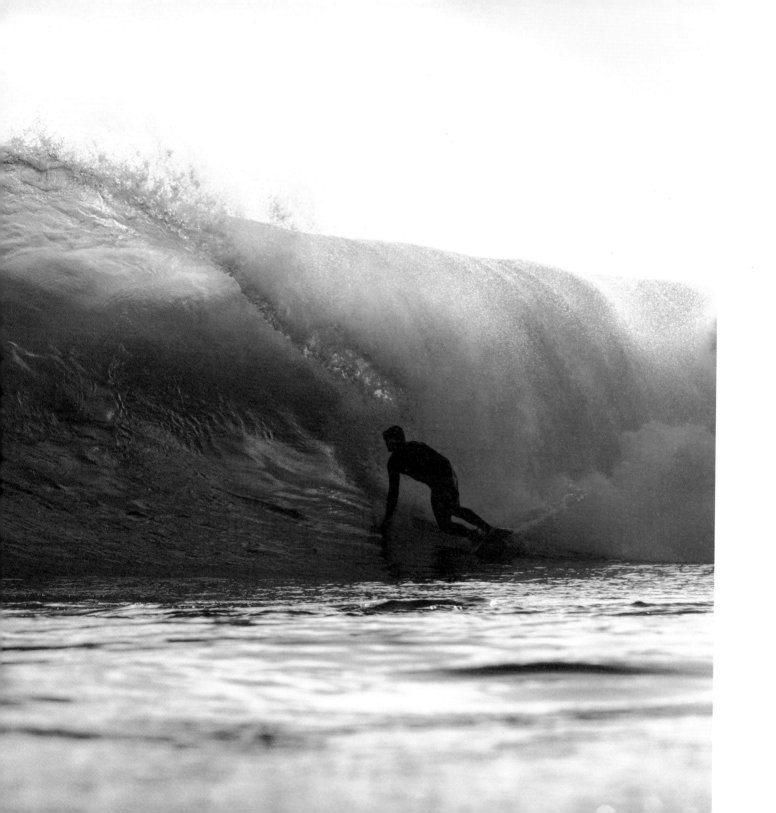

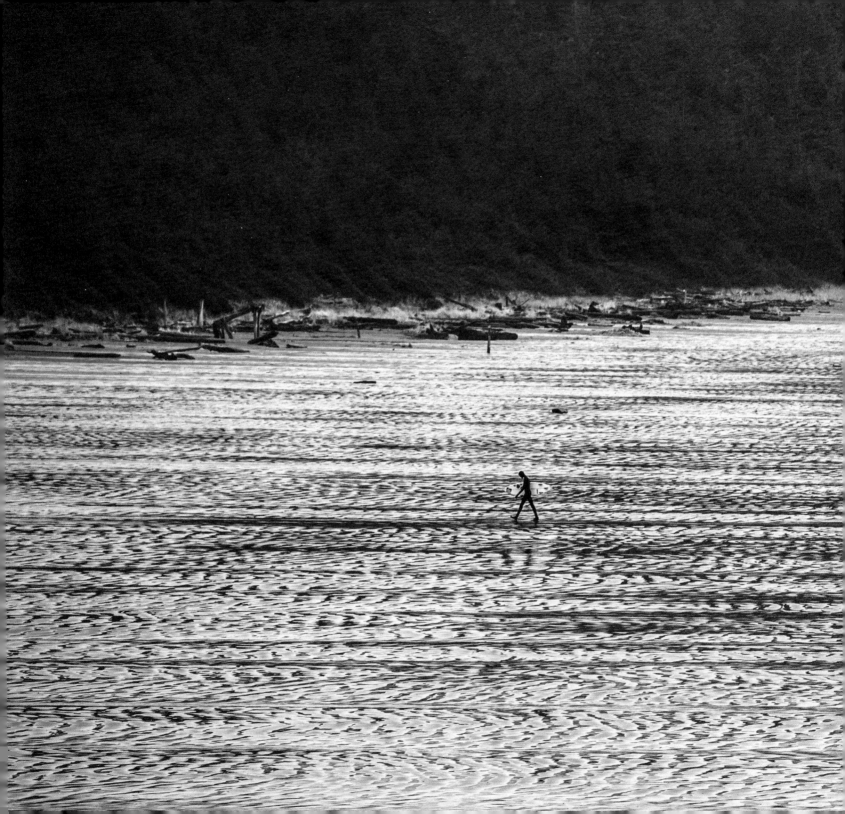

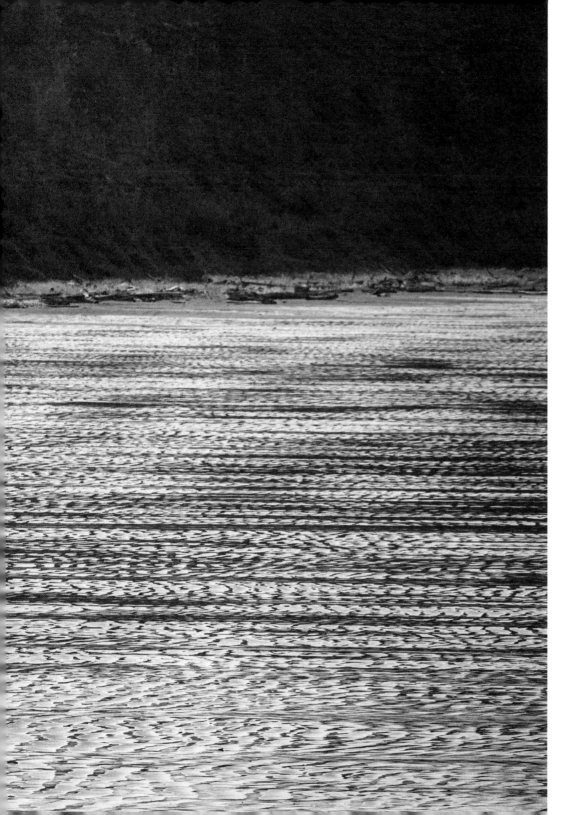

179

← Michael Darling told me that during this moment, he had just had one of the most challenging surfs of his life and was questioning his entire pursuit of professional surfing. Luckily he came around.

↓ Mathea Olin has to be the youngest woman to ever surf this wave. At only 17 years old, it didn't take long for her to be getting properly barrelled with ease.

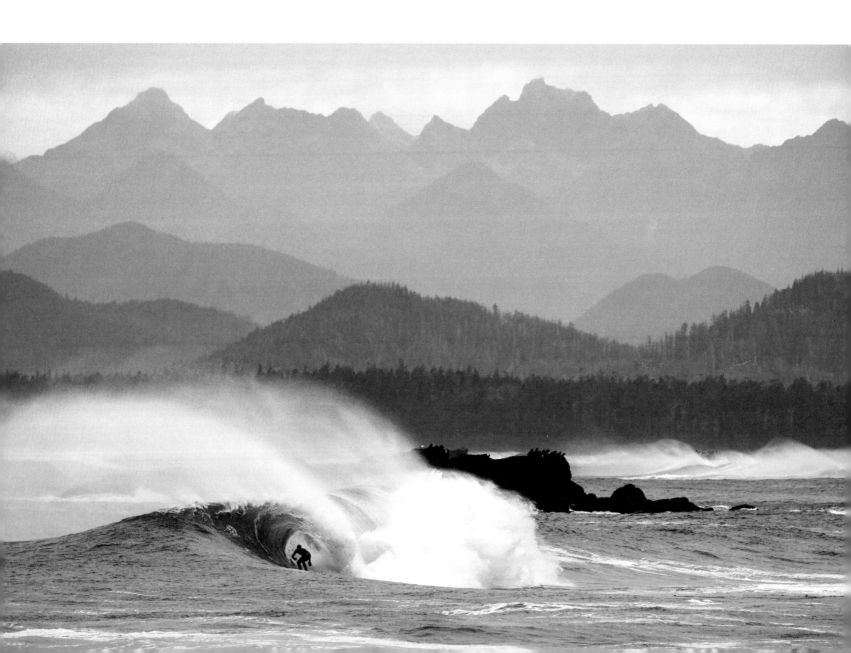

↓ With the wind at his back, Peter Devries takes a moment before heading back out.

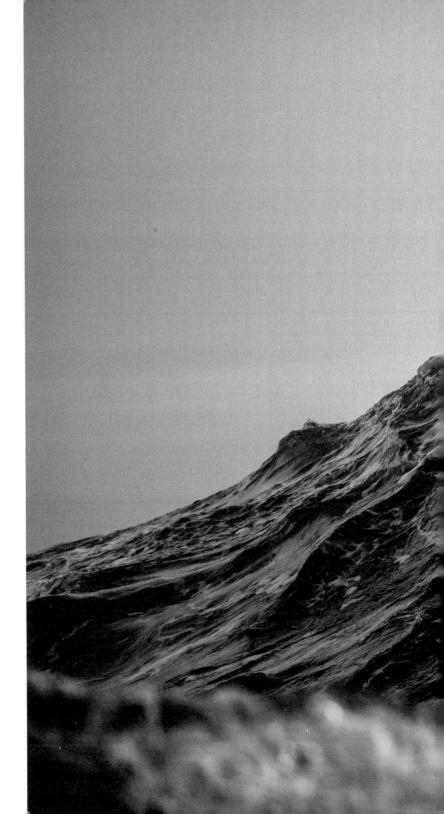

182

→ A mountain-like moment for a
wave as it forms various shapes.

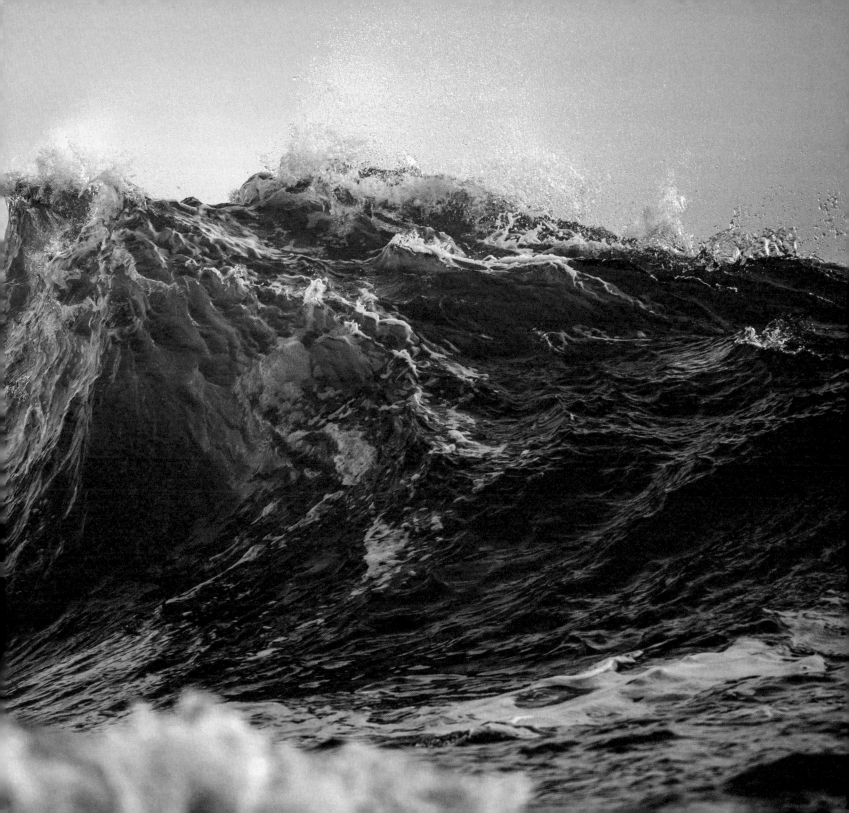

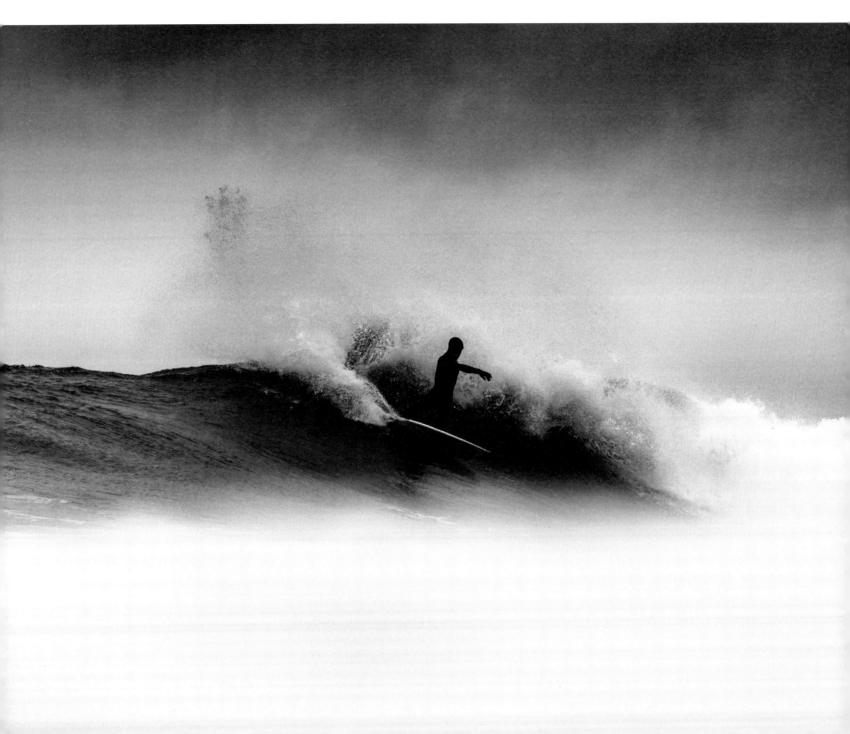

← Kalum Temple Bruhwiler has an extensive family history of Canadian professional surfing. You could say it's in his blood. He's been making a name for himself lately and has been carving his own path, whether it's through international contests or impressing his fellow surfers at the local beach break.

↓ The shore break was barely shin-high this day, though you'd get no idea of that from looking through this wave.

→ Before Pete and I started working together, I asked him when he was planning to surf, because I had a photo idea in mind. I brought two cameras, one on a tripod with a telephoto lens and the other in my hand with a 50mm lens. In a two-hour session, I only lined him up through the viewfinder maybe two or three times (though people still think it's Photoshopped). After I took this photo, we started shooting together pretty much daily.

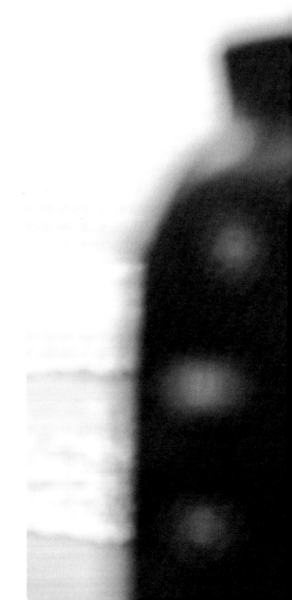

← At this point, I had lived in Tofino for over five years, and not once had it ever snowed enough to stick on the beach. This morning was different, as I looked out the window and immediately starting calling everyone I knew to go shoot. Thankfully Andy Jones picked up my call.

189

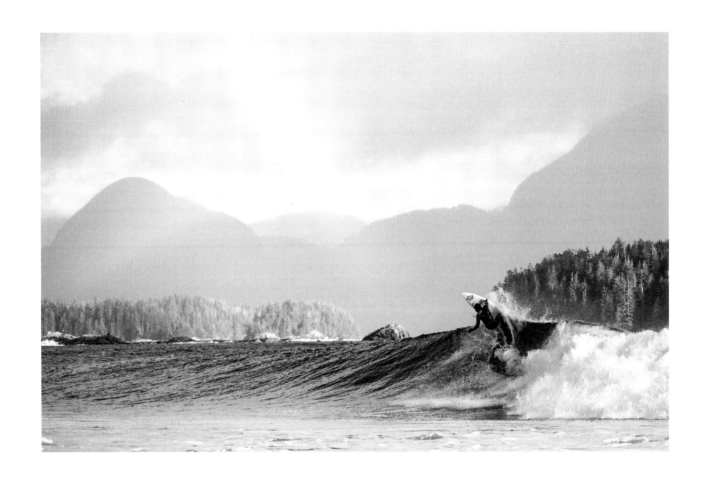

↑ In 2014 I started working for the local board shaper, Aftanas Surfboards. I was the team photographer/videographer and marketing manager. I shot so much during that time that most of those photos have been forgotten and are now dated and collecting dust on a hard drive. One image from that period has always stood out for me, though: this shot of Josh Mulcoy represents a true 'right place, right time' moment, as this rainbow came and went as quick as his forehand top turn.

» In my world there are lifestyle shots and there are action shots. I've been trying to bridge the gap between the two. Here, Michael Darling makes that bridge more accessible for me to cross.

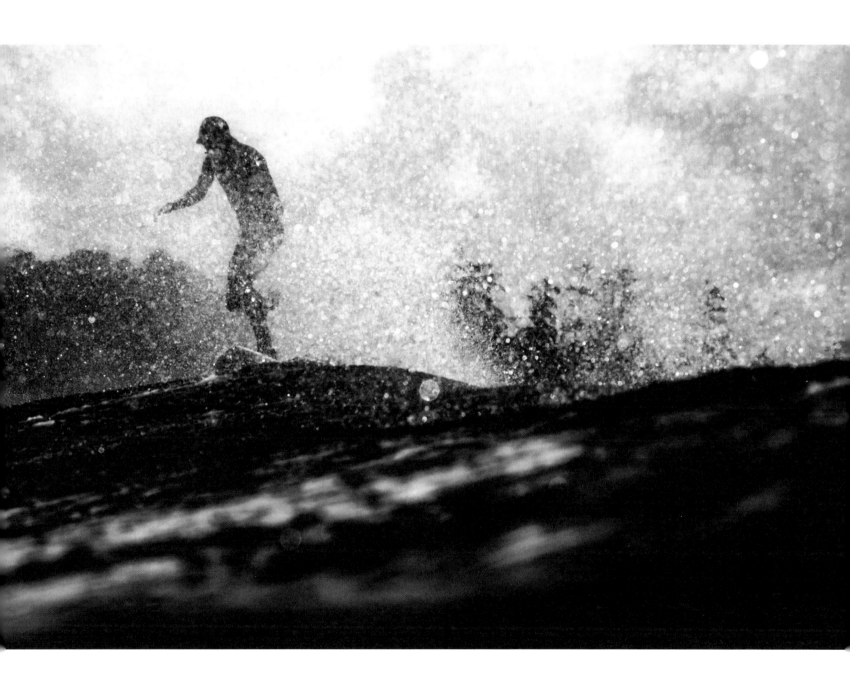

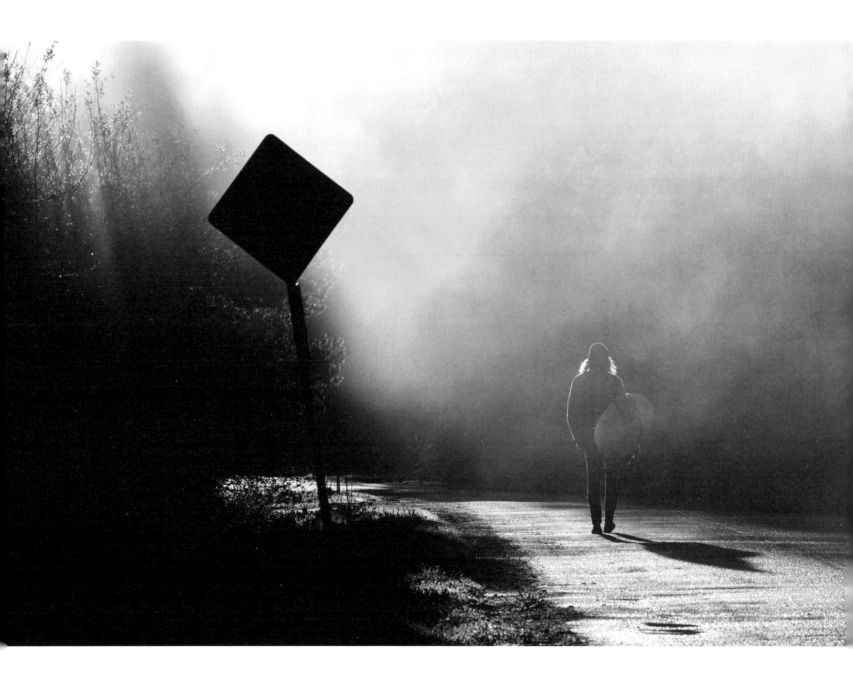

193

« There are people in life that as soon as you meet them, you become instant friends. Andy Jones is one of those people for me. Our friendship went from 0–100 in 2.5 seconds and quickly turned into working together as much as possible.

↑ Cox Bay is a swell magnet, which is great for surfing, especially in the summer when conditions are small elsewhere. The problem is that when the swell picks up in the winter here, the waves don't necessarily get bigger and bigger; they just start breaking farther and farther out.

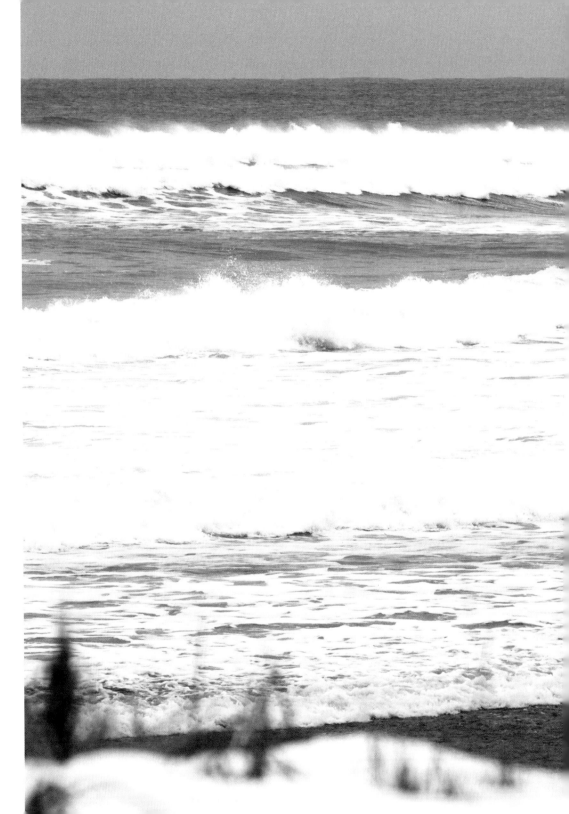

→ I never shoot this beach. I've always had bad luck here despite how good the sandbars are rumoured to be. But with fresh snow on the ground and a fresh surfboard under his feet, Noah Cohen took flight, and in that moment my negative streak was broken, hopefully for good.

194

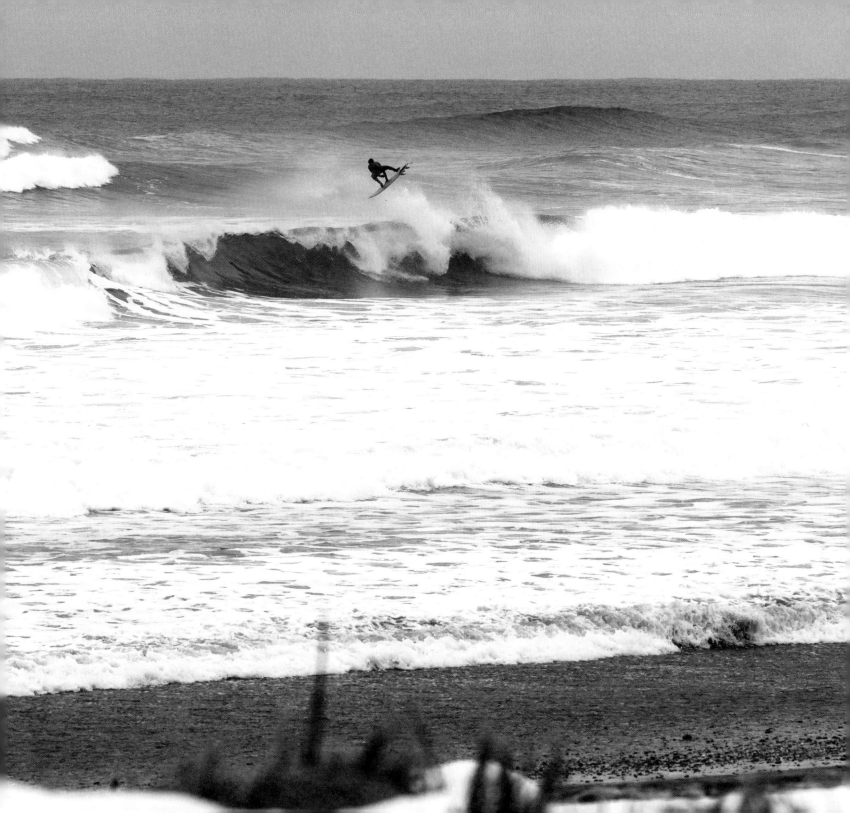

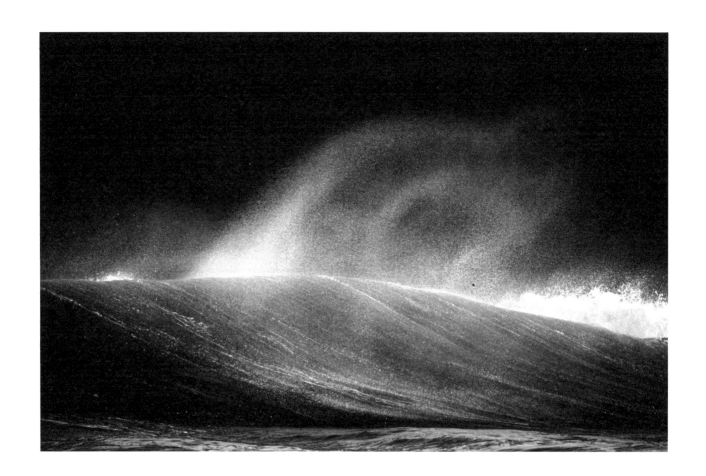

↑ Some surfers can tell exactly how good a wave is just by looking at it from behind.

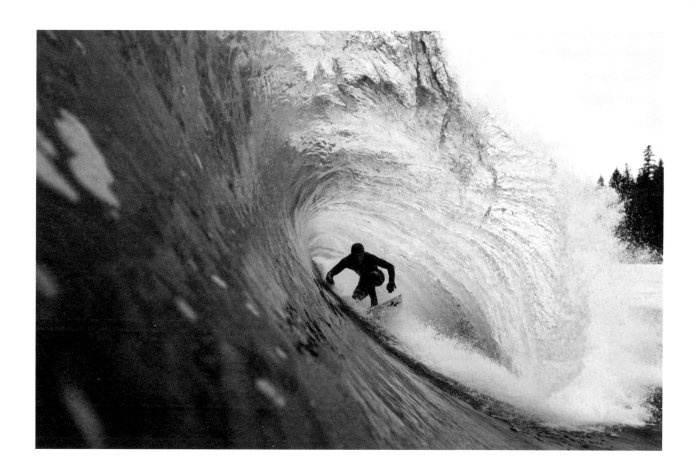

↑ I swam for almost four hours before I had to force myself to go in because I couldn't feel my hands/feet anymore and was shivering uncontrollably. I was so tired and cold, swimming frantically to get out of the water, that I attempted to go in at the worst possible spot. I quickly learned to never try and come in this way at high tide, because I ended up getting scraped along the rocks while trying to protect my camera housing from getting smashed. When I finally got to the beach, I rushed over to my bag and that's the last thing I remember. I blacked out and eventually came to sitting on a log with a bunch of empty food containers and water bottles around me. This was the only good photo I got that day, and I still have the scar on my back.

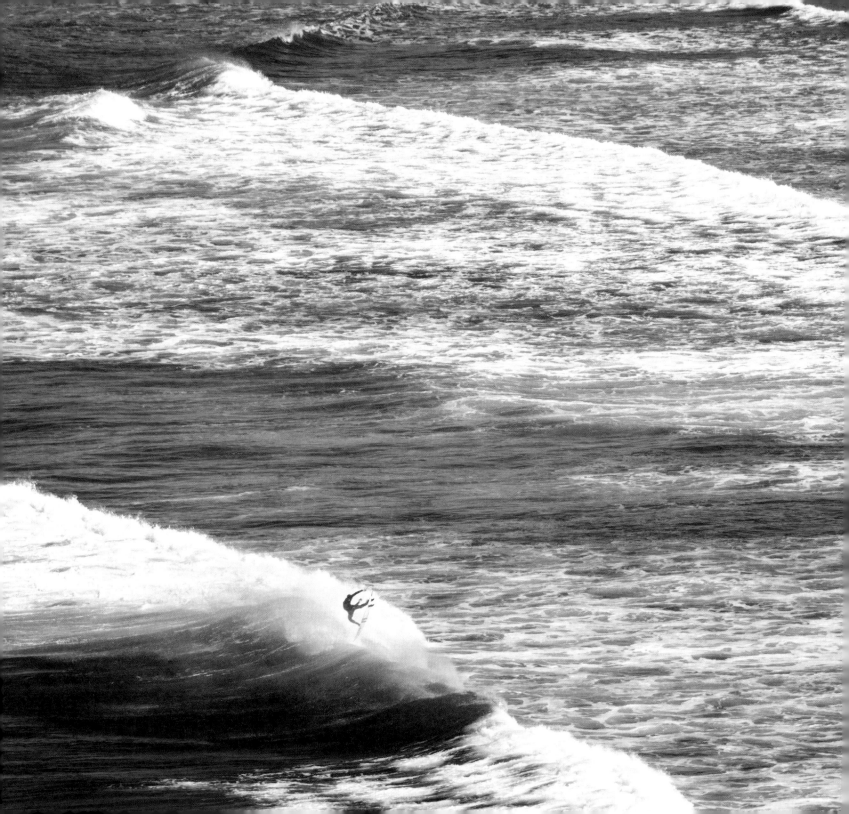

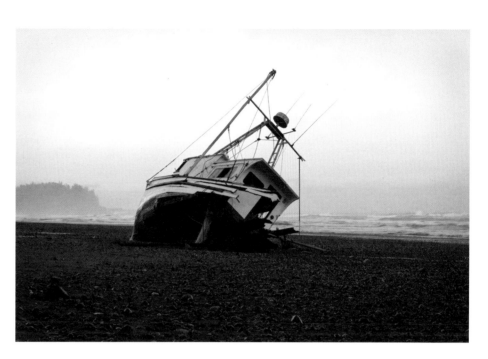

↑ Rumour has it that this old boat was purchased for $1. As it was being towed, it started taking on water, so the line was cut. It ironically washed up at "Shipwreck Cove" and remained there until it was removed by Parks Canada. When I first saw it, someone was inside sawing off the steering wheel.

← I couldn't afford a helicopter, and in the days before drones became so easily accessible, I hiked up a mountain adjacent to the beach and shot the action from 100 metres above sea level.

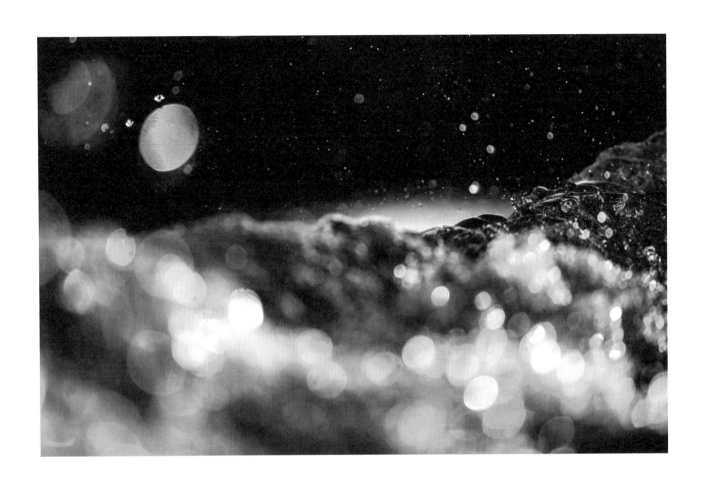

↑ Little details left over from a previously broken wave.

≫ When Malcolm Daly got the call for this trip, he was sitting on the floor of his shower trying to break the fever of a 24-hour flu. Unfortunately, it is not common for a seat on a boat to open up before a big trip, and even less common for the photographer to make the call of who is getting the invite. Malcolm knew that, so by the time we suited up, he was ready to hop on.

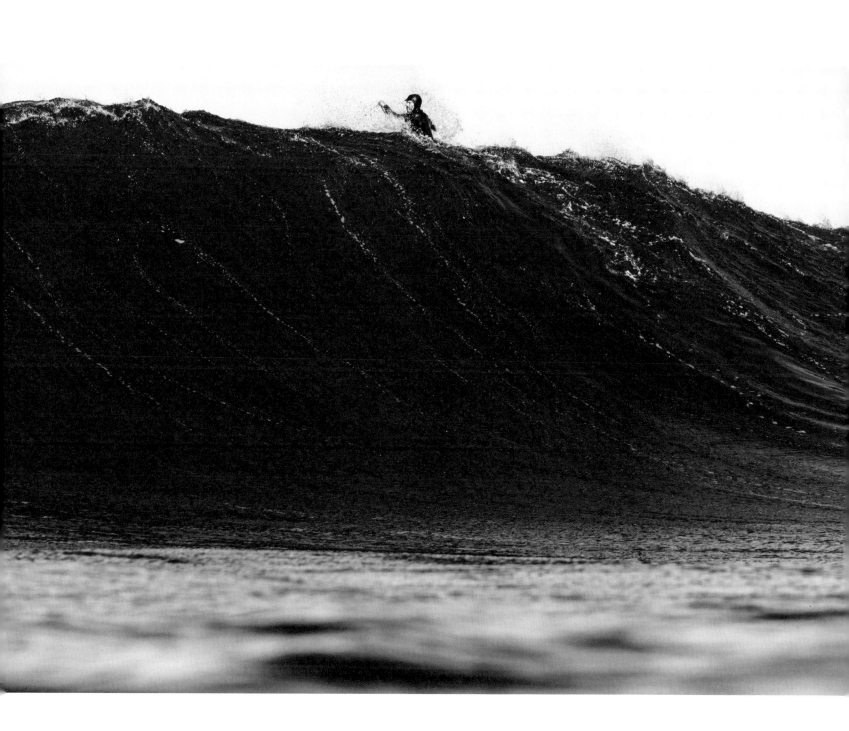

→ Small waves and cloudy skies, a perfect excuse to put down the camera and go surf myself. Just as I was putting my board in the car, I got a text from Pete Devries. He said the waves looked bad but he was going out if I wanted to shoot. I figured I already had my wetsuit on anyway...

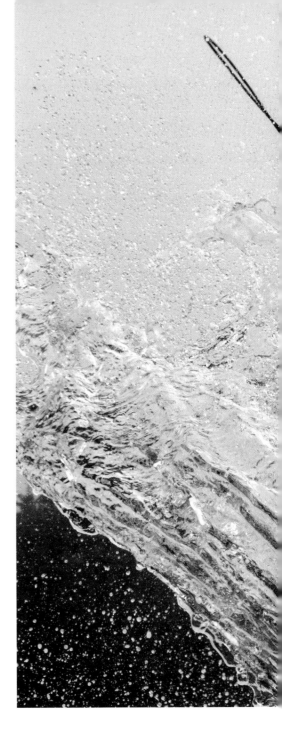

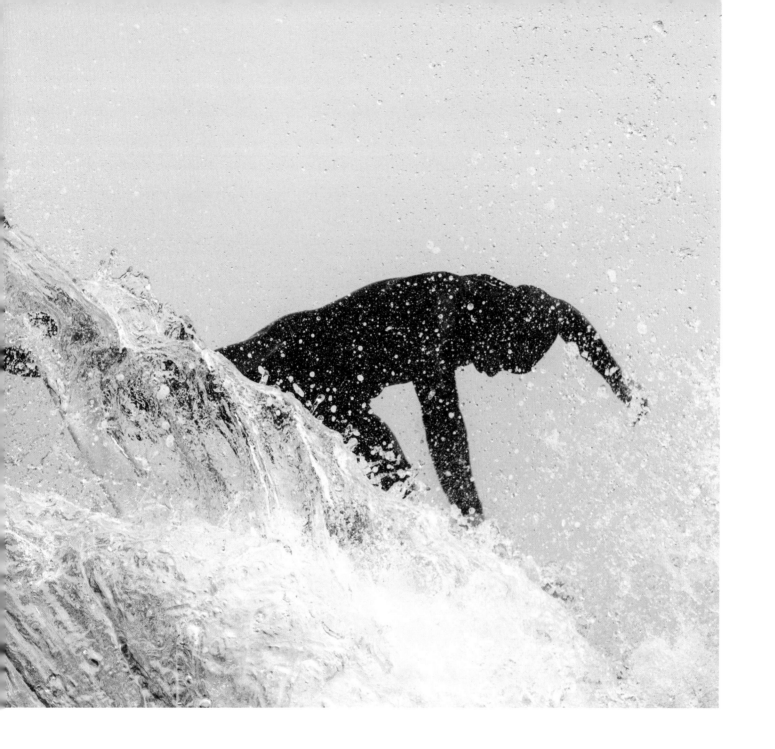

203

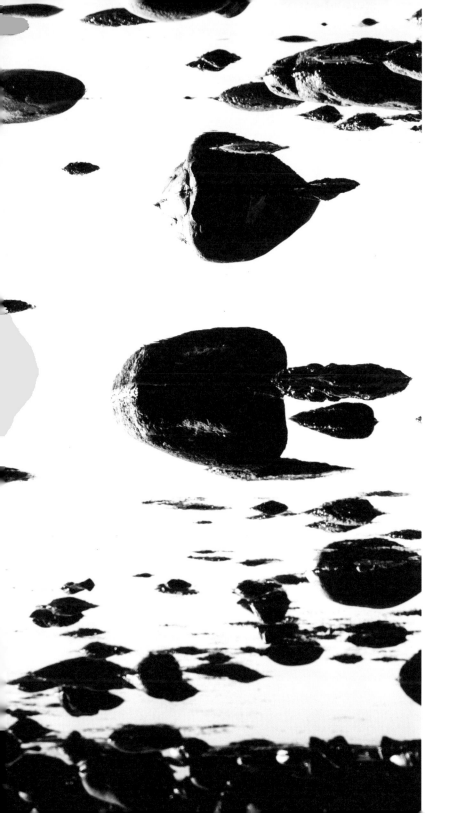

← Ground control to Major Tom...

205

→ While swimming in the lineup
with several other photographers,
I couldn't help but notice all the
wind howling off the wide sets
pushing into the shore.

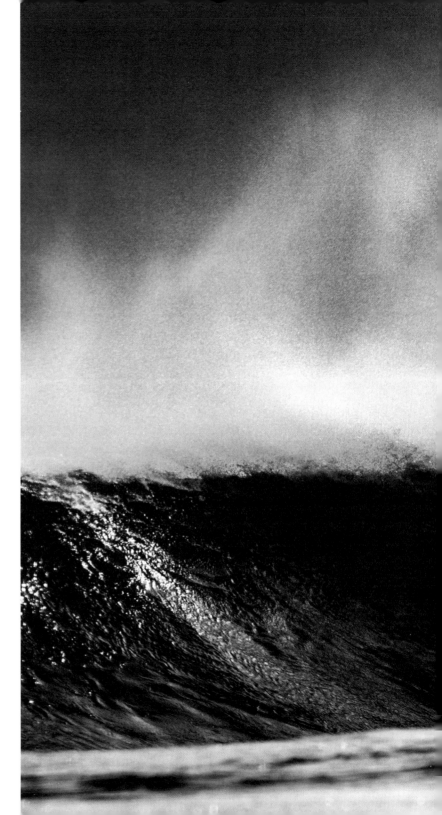

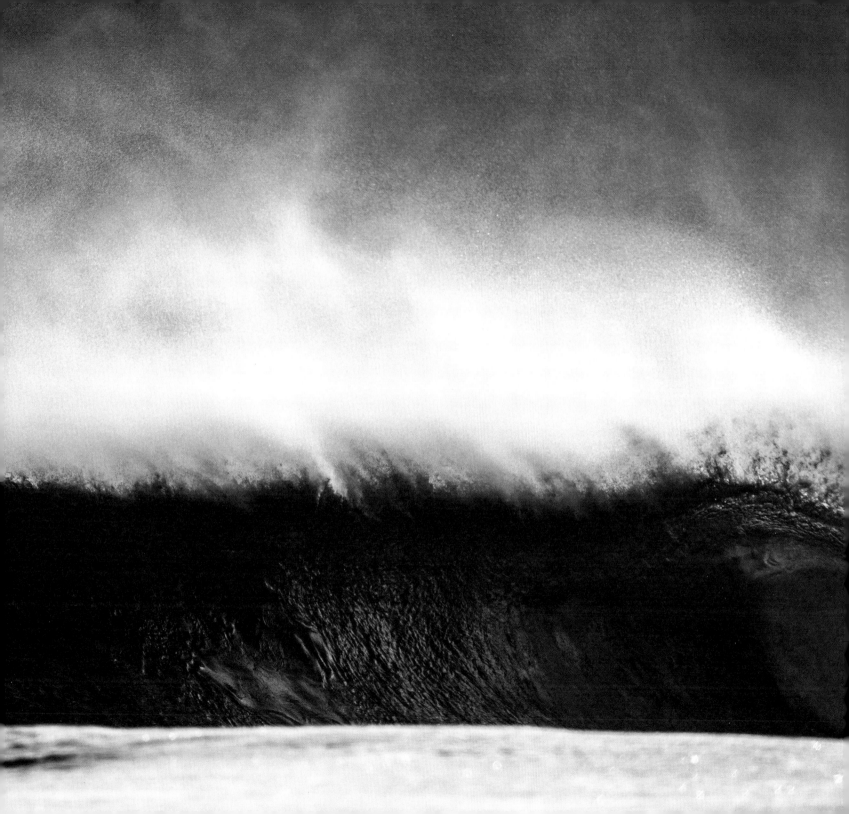

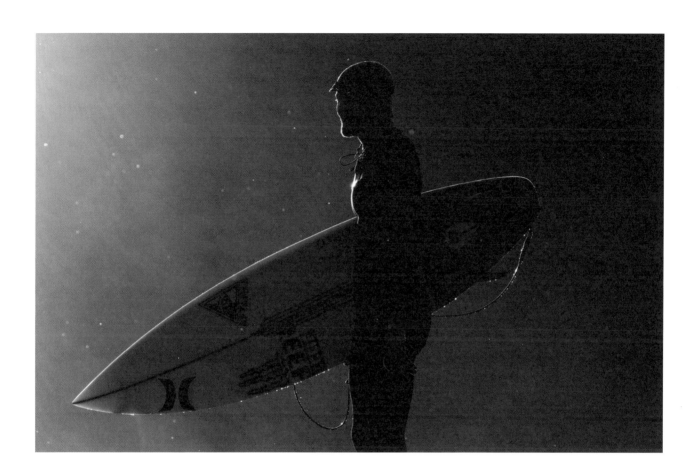

209

« It's not often that in-between manoeuvres – like this floater – really stand out enough for a quality action image. But when they do, you know it must be something really special. I don't think we could ever get the light this good again, with dark clouds all around us from the morning rain and the sun beaming through just enough to illuminate the wave as it breaks.

↑ While we were hiking back after a long day of surfing, the light got incredible and I convinced Pete Devries to suit up and go back out for a few more waves.

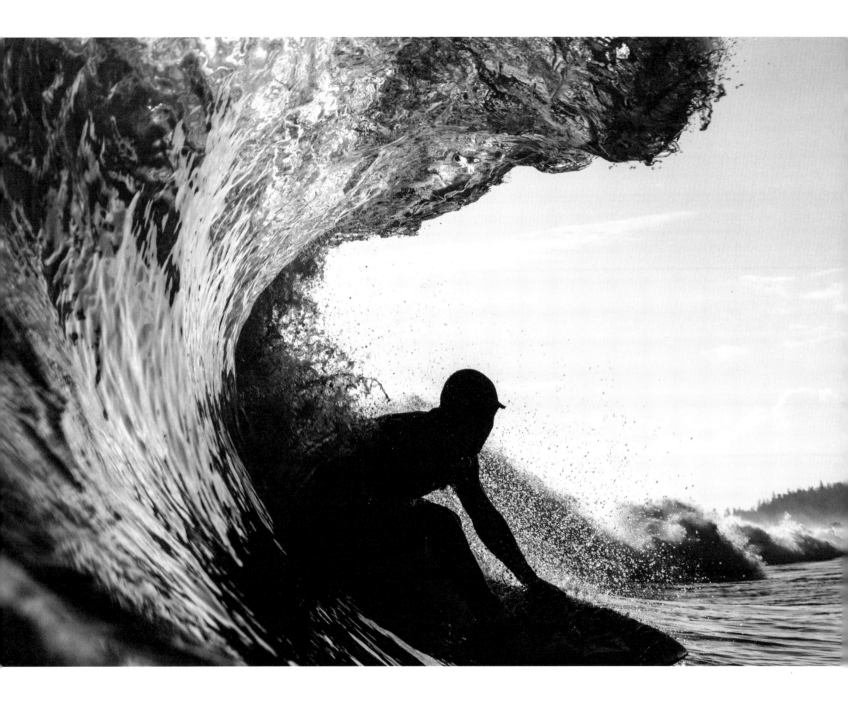

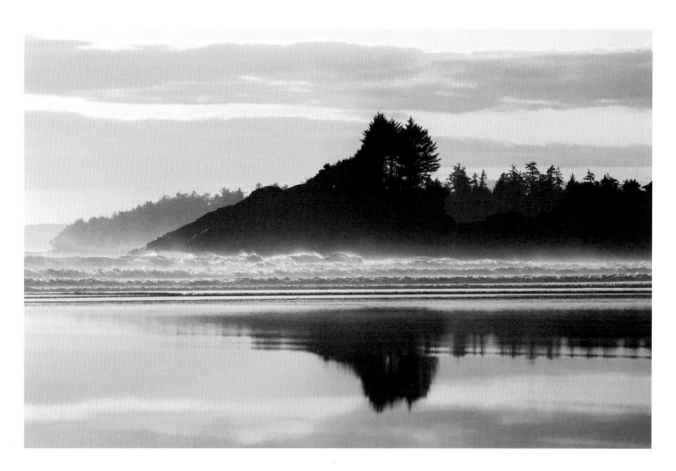

↑ Sunset Point, as it is so accurately nicknamed.

« New York's own Balaram Stack traded his board shorts in Hawaii for a 5mm neoprene wetsuit in Canada with less than a day's notice. I love the willingness of so many surfers to drop whatever they're doing and get on a plane just in time for a swell. Balaram ended up flying back to the North Shore a few days after being in Canada, just in time for another swell.

212

→ We all got out of the water at the end of this day claiming it was just too small and too low of a tide to work properly. While we were taking off our wetsuits this bomb of a set came through and had us second-guessing our decision.

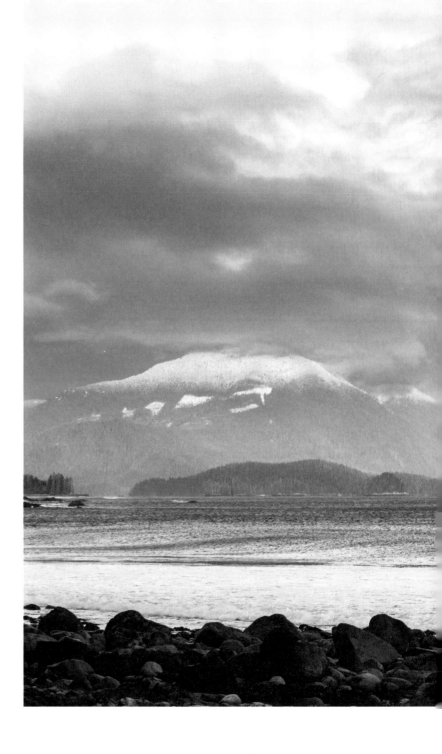

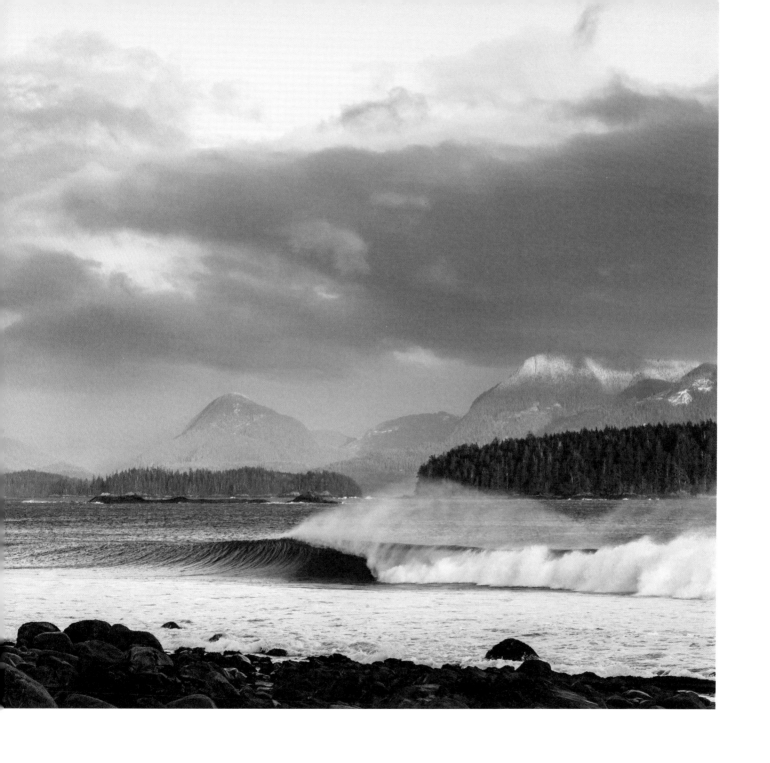

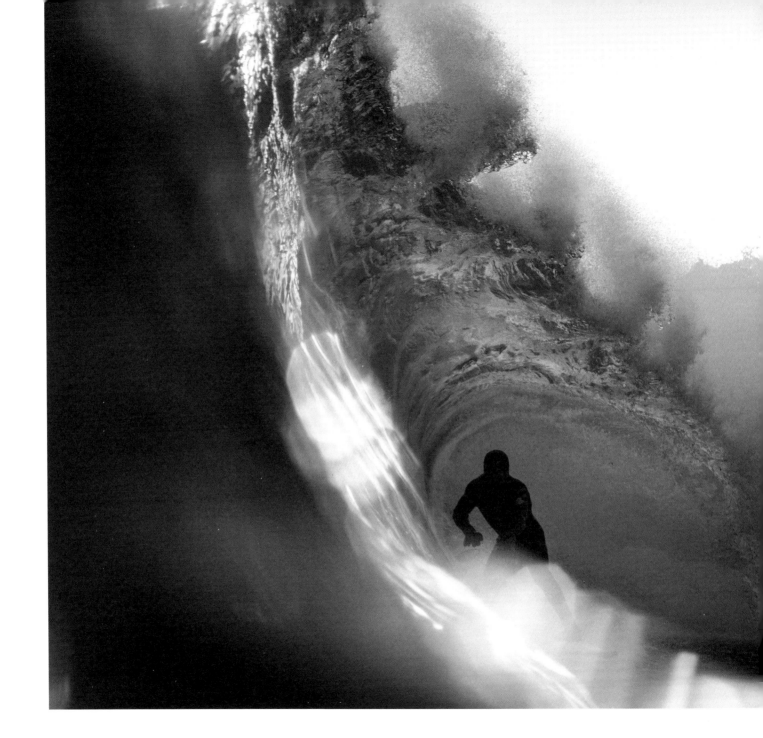

← Noah Cohen survives this barrel as the sun sets on one of the best days of the winter.

215

↳ A wave breaking inside of a wave breaking. This is the norm at a spot made famous by bodyboarders that has been deemed "unsurfable."

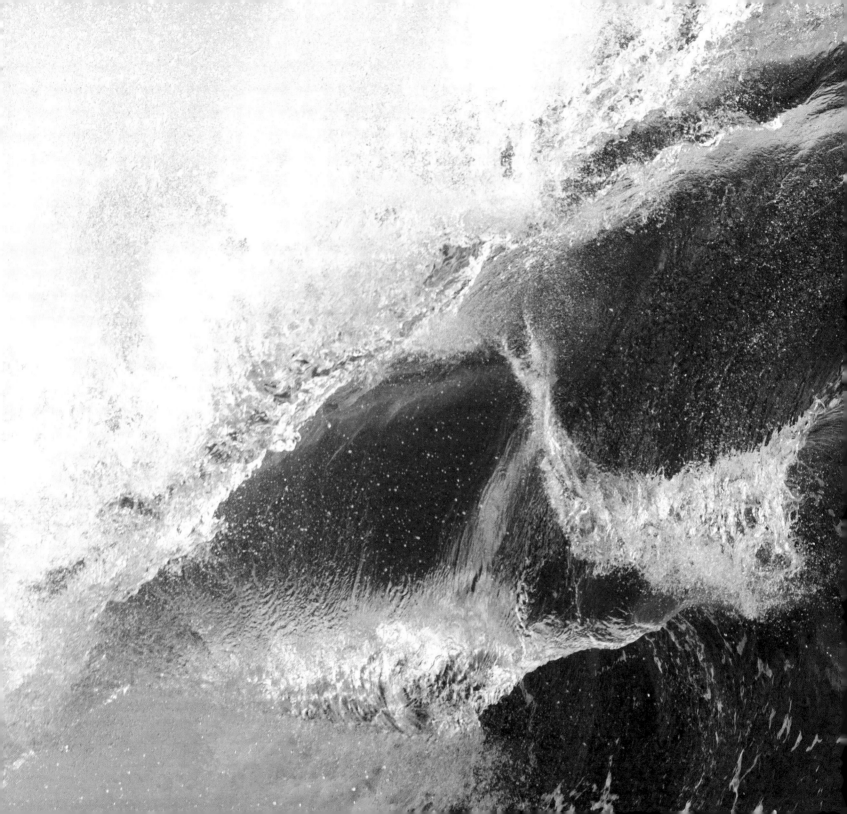

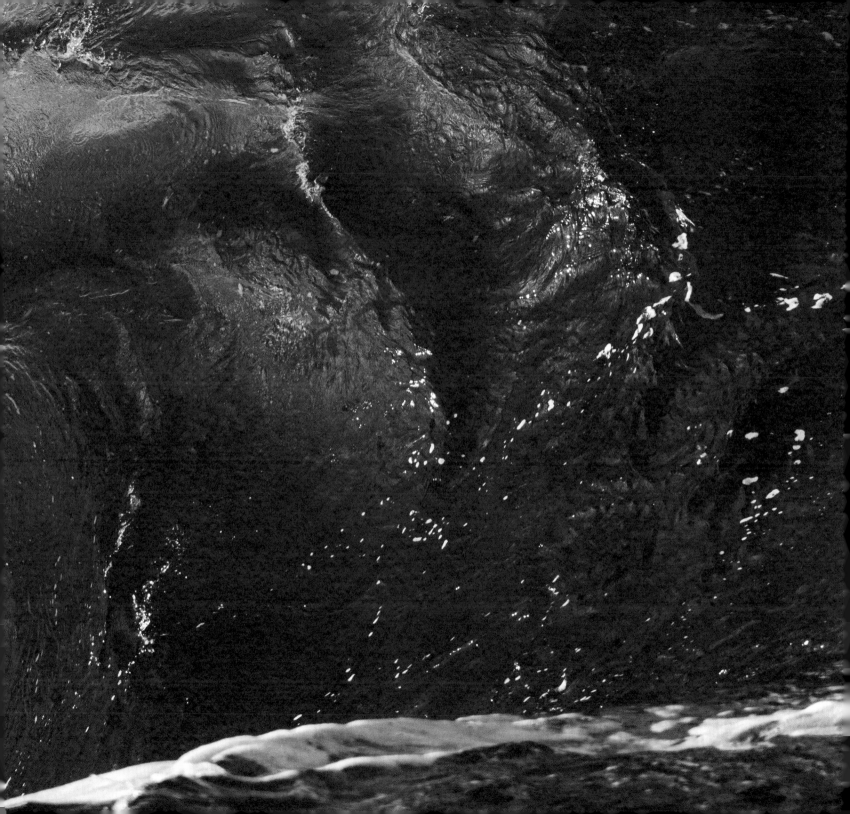

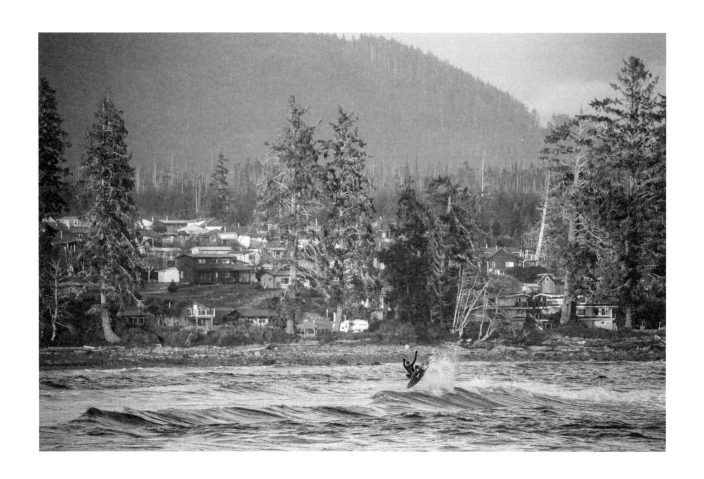

↑ Noah "Waggy" Wegrich has to be one of the nicest guys I know. He is always excited and positive about everything. It must be a California thing. I am always happy to spend time with him when he ventures north of the border.

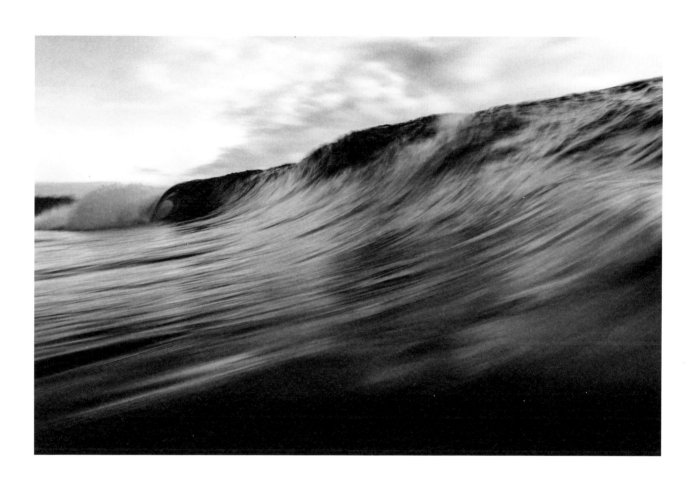

↑ This wave is probably only knee- or waist-high, but it was the most perfectly peeling left I'd ever seen at this local beach. With only a handful of friends out on longboards, we all swore we would never tell anyone about 'Spot X'.

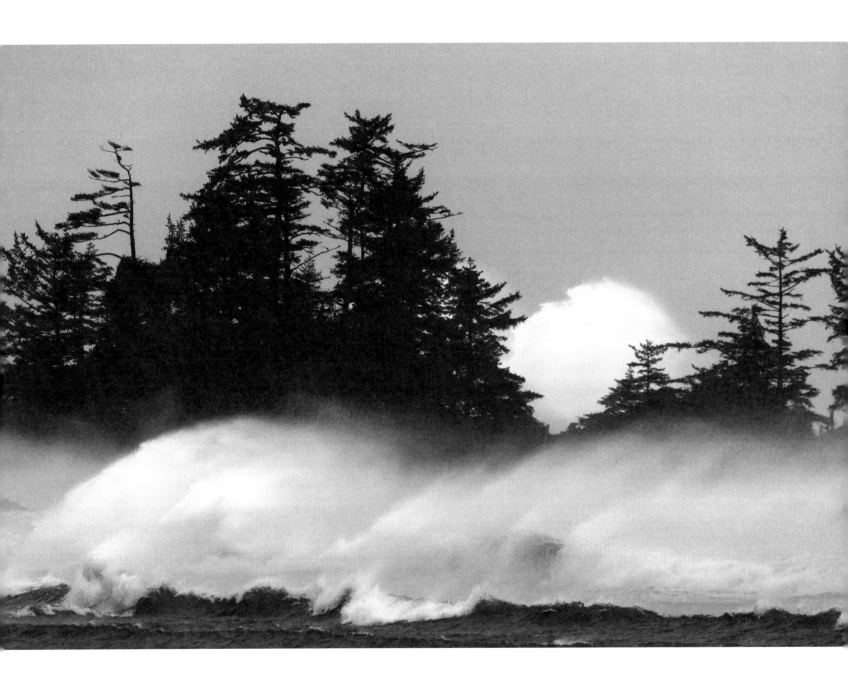

↑ Shannon Brown is a high-performance surf coach and an integral part of the Canadian Olympic surf team. His competitive nature and acute attention to detail (with everything) runs deep.

« For surfers here, it's always exciting when such large swells pummel the beaches, because it moves the sand below us around and (hopefully) creates new sandbars for waves to break on when conditions calm down again.

222

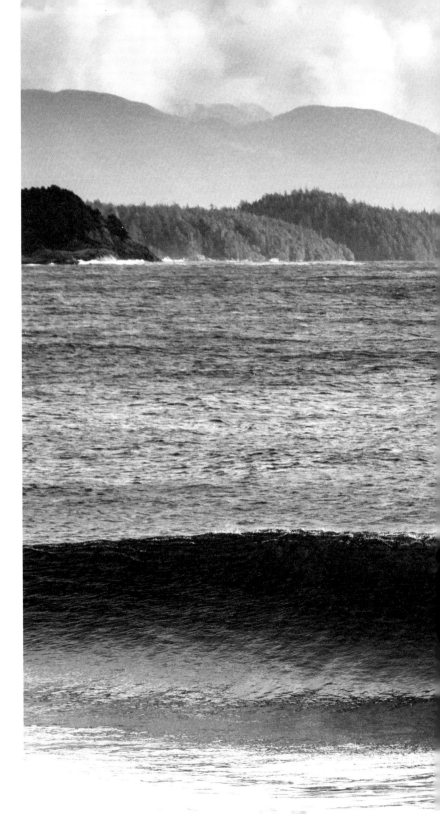

→ Josh Mulcoy has probably been surfing this wave since before I was born. He recently told me this was his favourite photo he's ever seen of himself, which is an incredible honour from someone who has graced the cover of numerous international surf magazines.

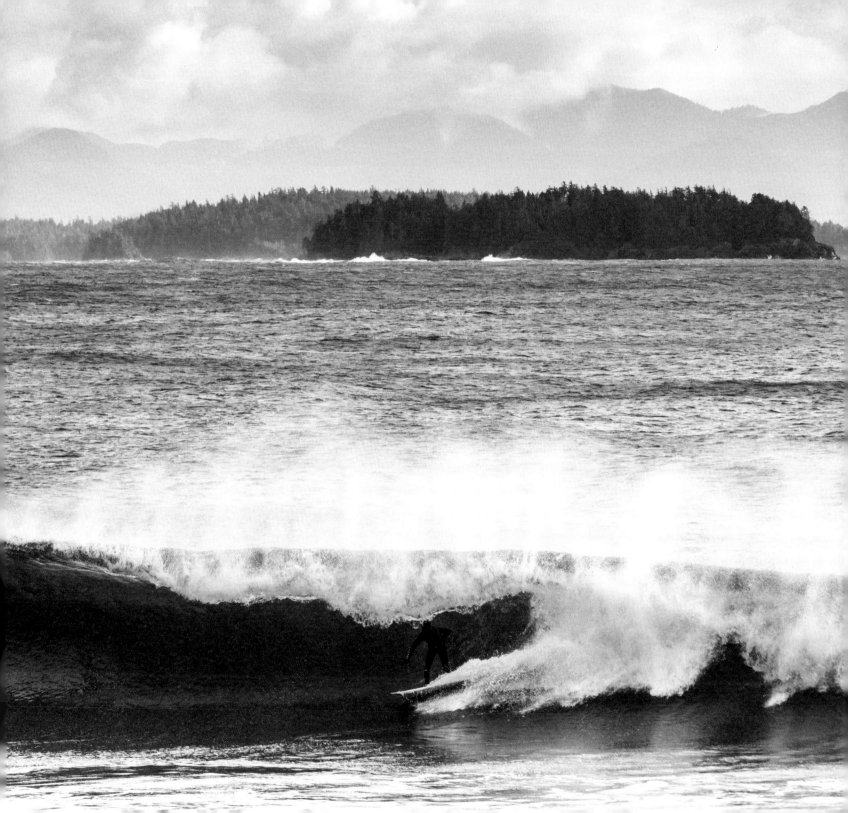

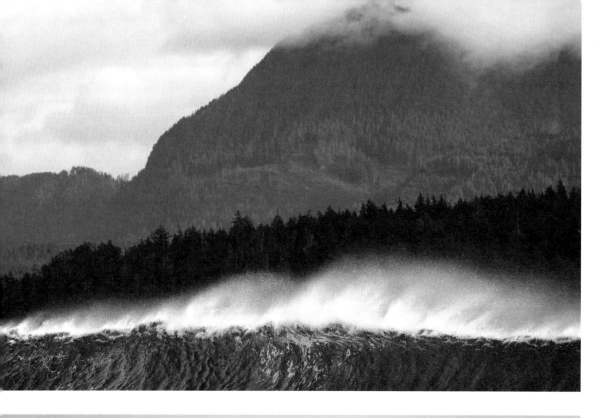

← I've always called this photo 'Just A Peak', for many reasons.

← I spent so much time trying to line up this shot and it still didn't turn out quite what I was hoping for. But it's an image worth keeping in a unique, yet unplanned, way.

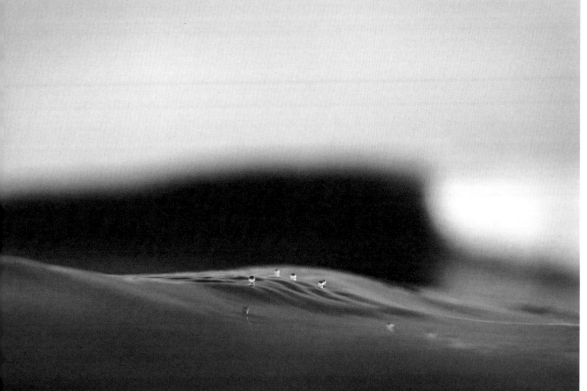

↘ No wave is ever the same, which is what makes shooting the ocean so addicting. These quick glimpses of moments that only exist for a split second, only to be gone and never return again.

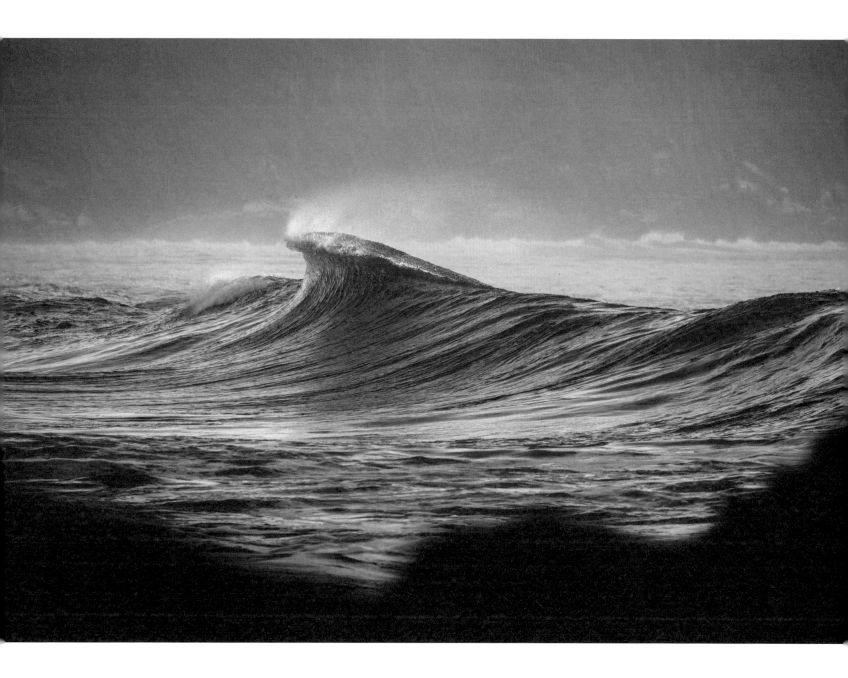

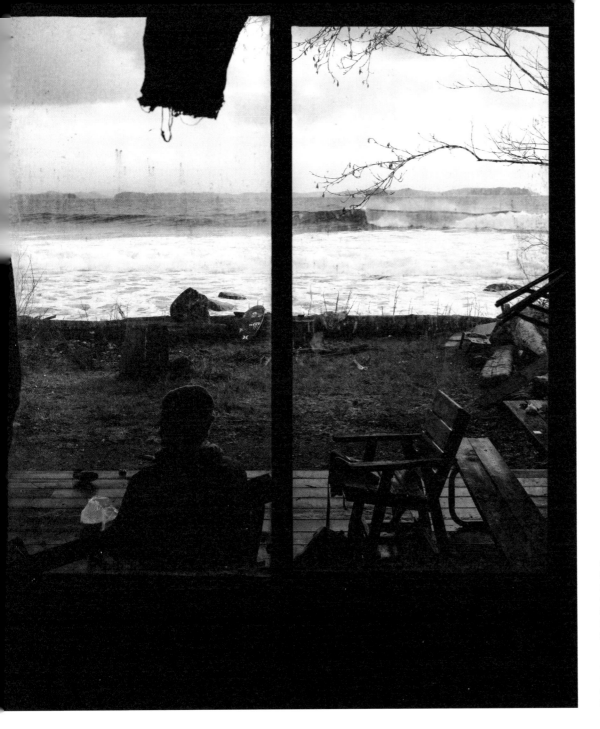

← Leasing a piece of property at this spot is like finding the golden ticket. If you're lucky like I know myself to be, you'll be friends with one of the select few who have found those golden tickets, and you'll be set up for the winter.

→ A beautiful sunrise, with no one out, and perfect waves with a good friend by your side. What more could you want?

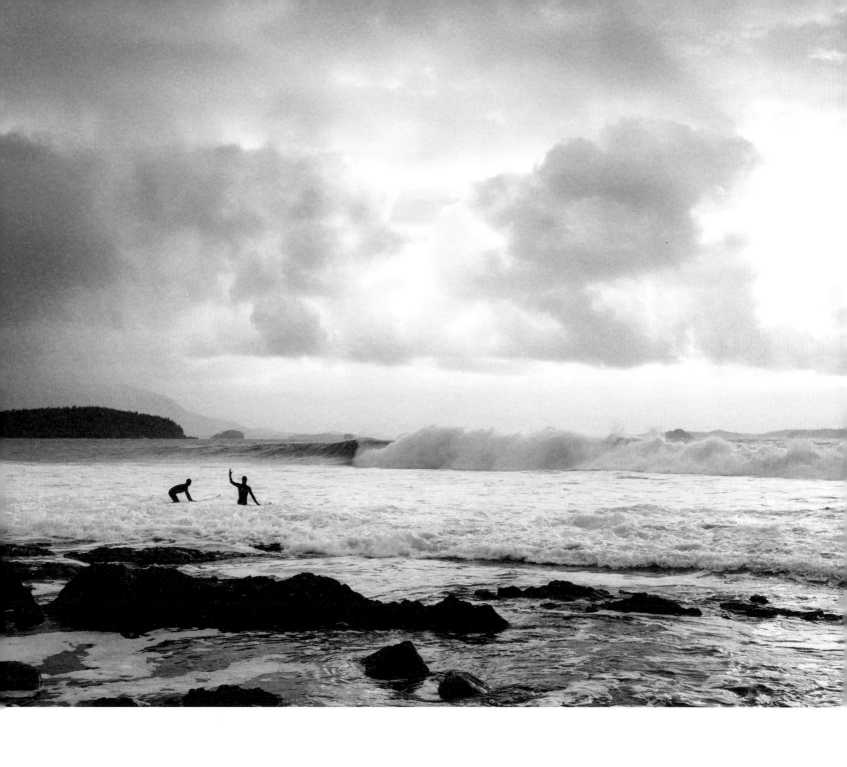

228

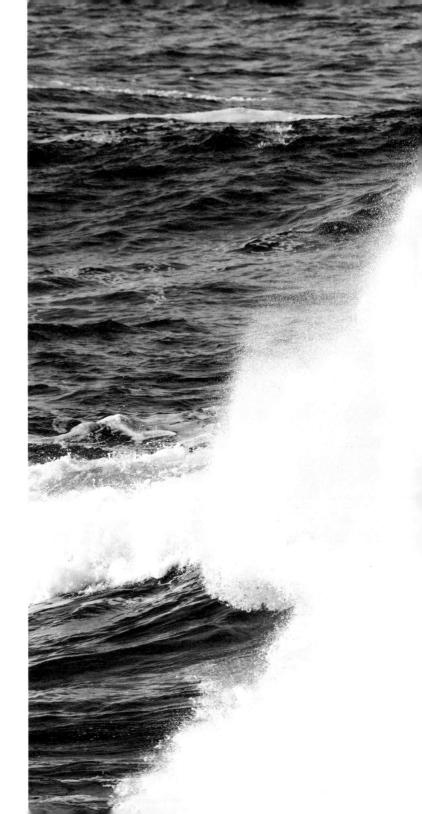

→ I got some intel from a friend about the specific conditions required and then did some investigating on Google Maps to find out how to get here. This was my first time seeing this wave in person, and I've been completely obsessed ever since.

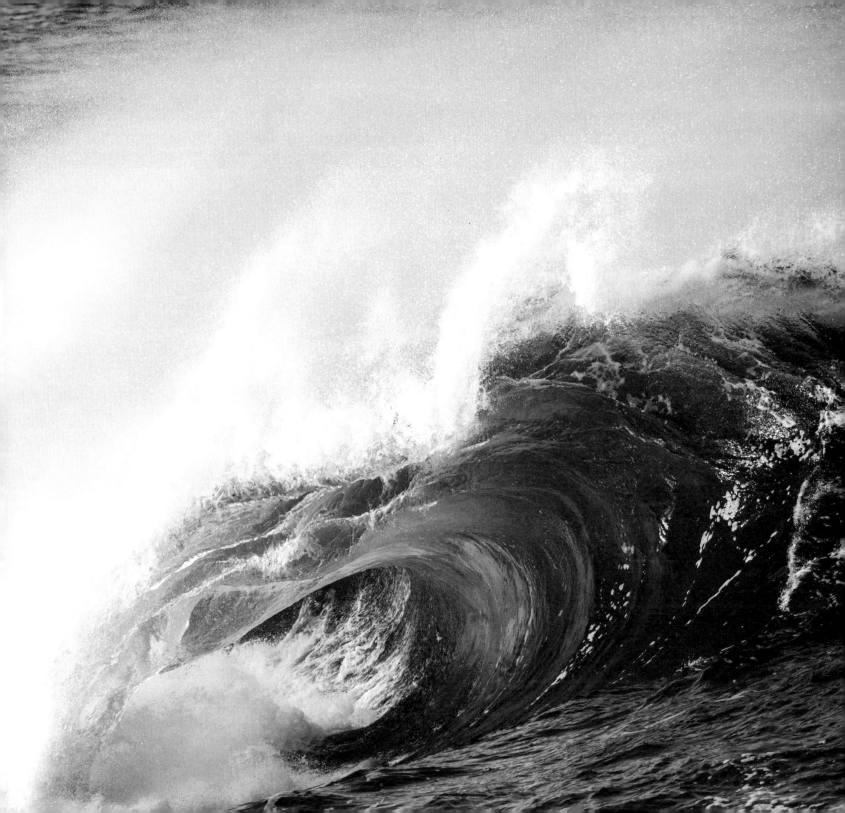

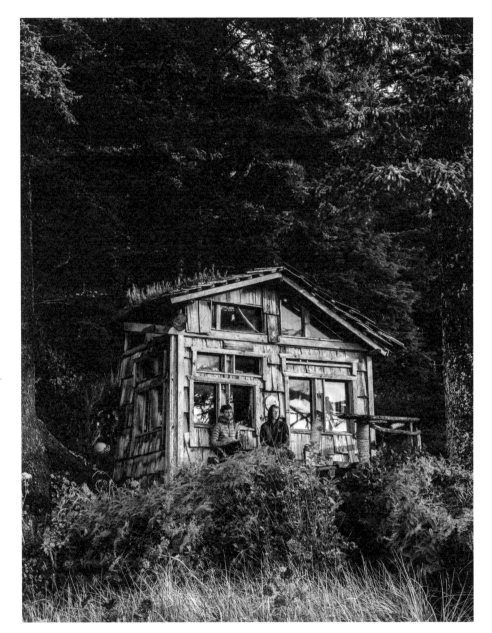

← This cabin is an emergency shelter practically in the middle of nowhere just off a logging road along the coast. No cell service and no civilization for at least a couple of hours. Written on the front door reads "Please keep this beautiful place OFF social media." This makeshift home is now (secretly) open to the public and there happens to be a heavy slab a few beaches over. These two surfers are sitting outside watching the swell building, after getting up at 4 am to get here, hoping the slab will be worth it at the right tide.

» Most Canadian surf photos have a reputation for being so pulled back that you could cover up the surfer with a dime. To follow that trend, here's Noah Cohen looking larger than life as he sends this air to the flats.

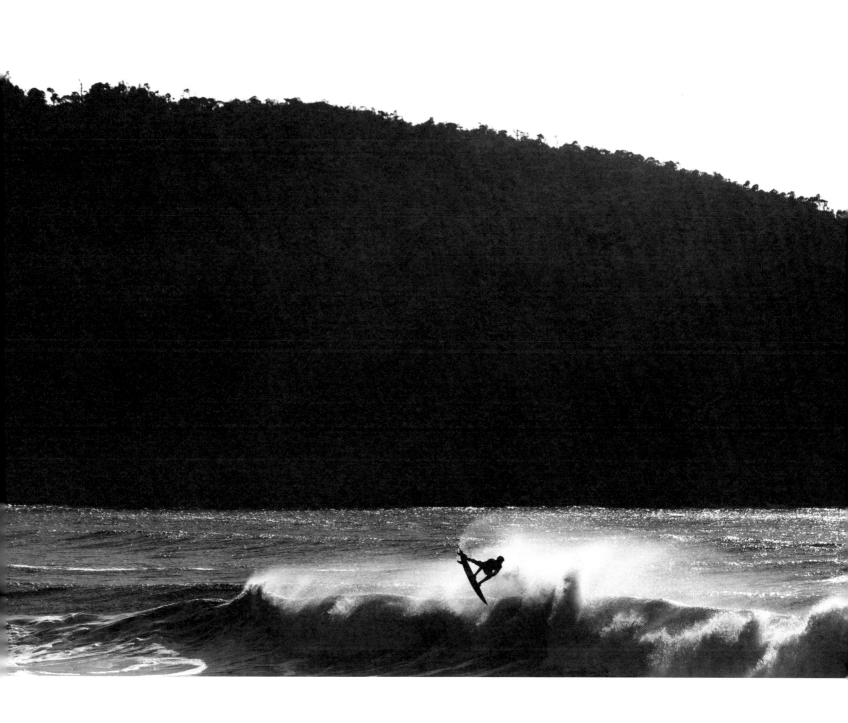

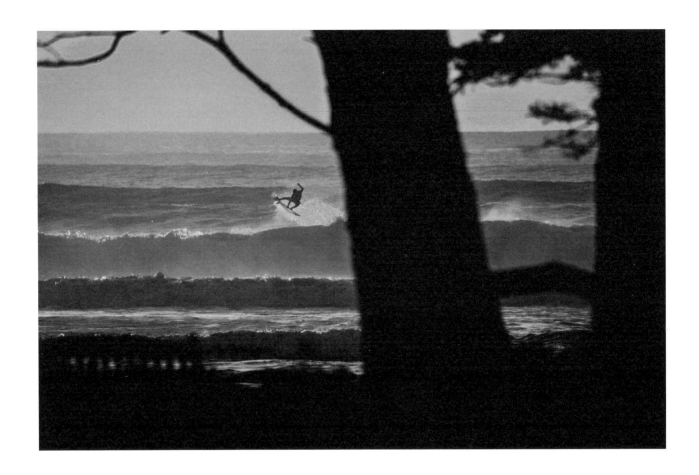

232

↑ I was shooting a beachside elopement and I couldn't help but watch the surf from the corner of my eye the entire time. As soon as our session ended, I immediately ran down the beach and started capturing the last glimpse of light. That's when I realized that wedding photography was not in my path, regardless of the money.

↠ I'll always remember the first time I (successfully) swam at this favourite slab on Vancouver Island. When I got home it felt like I was still in the water. I felt my whole body was moving and surging in intervals, and I would twitch and brace for impact every so often. It was so surreal. I still love getting out here and am just as excited and anxious to shoot as I was the first time. Here, Pete Devries makes it look too easy, but believe me, it is not.

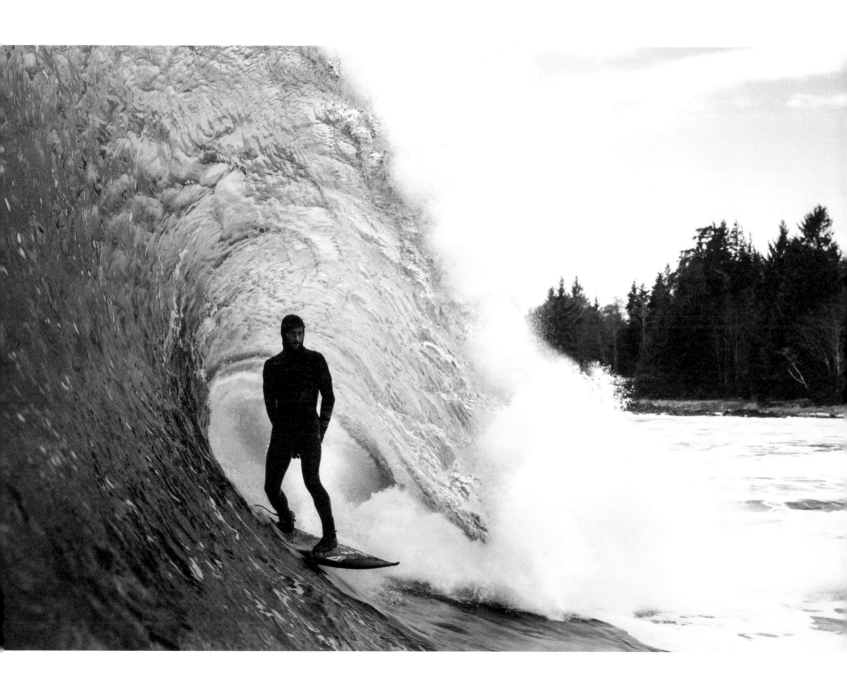

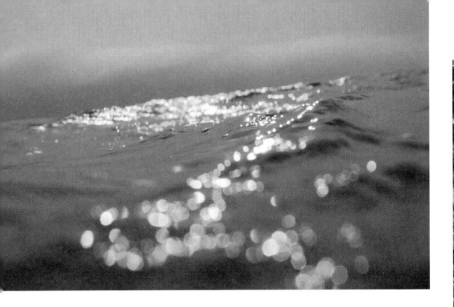

↑ Behind me is one the most dangerous slabs on the west coast of Canada, but I couldn't help but be enamoured of a glimmer of light in the corner of my eye. Everything in life has a risk–reward analysis.

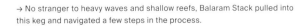

→ No stranger to heavy waves and shallow reefs, Balaram Stack pulled into this keg and navigated a few steps in the process.

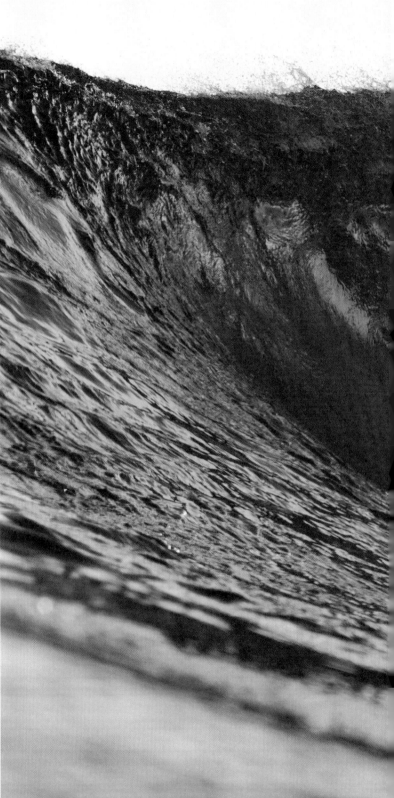

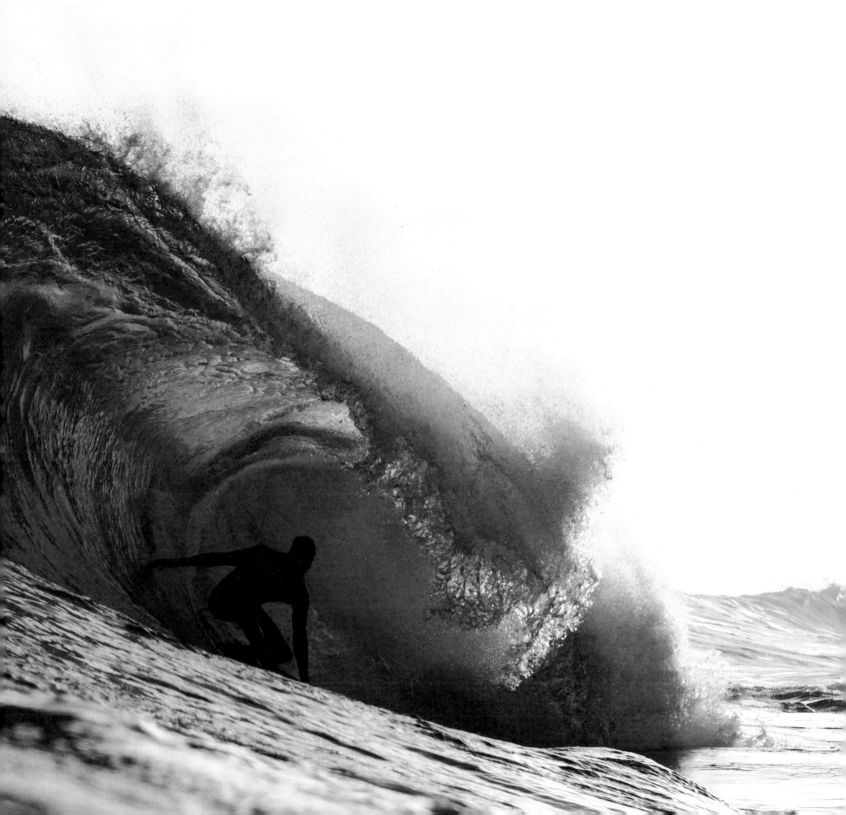

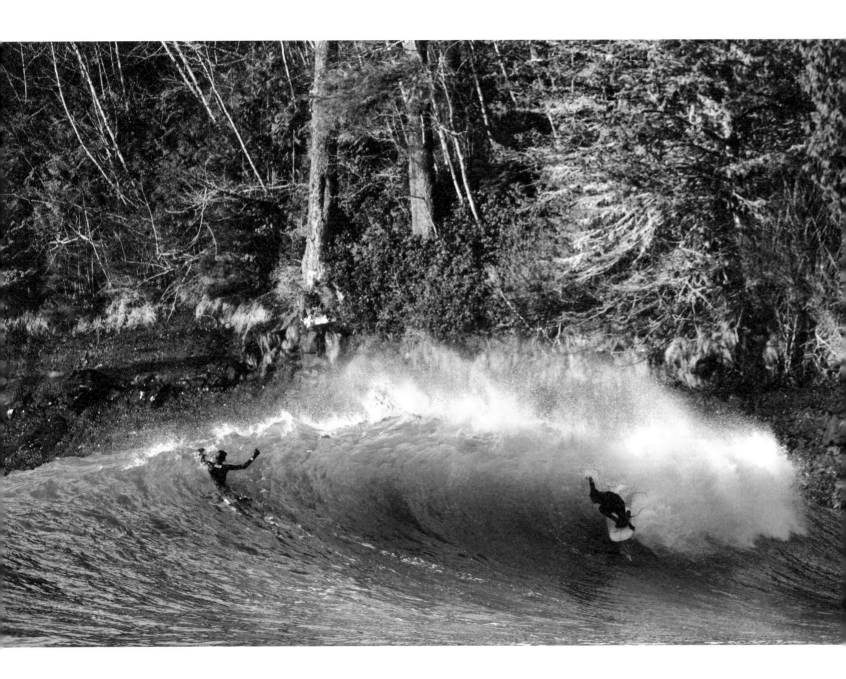

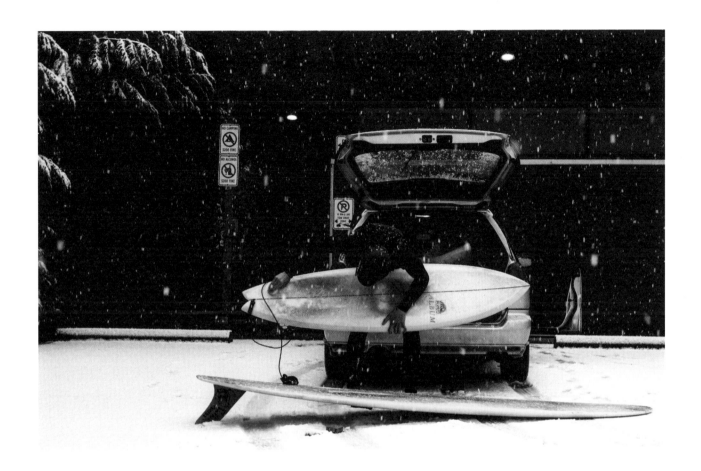

« When we arrived, everyone was already leaving. Apparently, we missed the tide and the surf was no good now. Since we had travelled quite a long way, we decided to try it out anyway. Here, Michael Darling is cheering on Andy Jones as he pig-dogs into the wave of the day. The conditions seemed just fine to me in this moment.

↑ Andy Jones surfs everything. From small peeling points on a longboard, to messy beach breaks on a mid-length, to heavy stabs on a twin fin. I'm constantly impressed by this Canadian-born, Australian-raised, one of a kind gentleman that people refer to as 'Disco'.

↑ Waves were constantly breaking all around me as I continuously scrambled to stay in position for the next set. I get distracted easily, and couldn't help but notice these bubbles that day.

→ I assumed it was going to be small and messy, and boy was I wrong. Never trust the forecast.

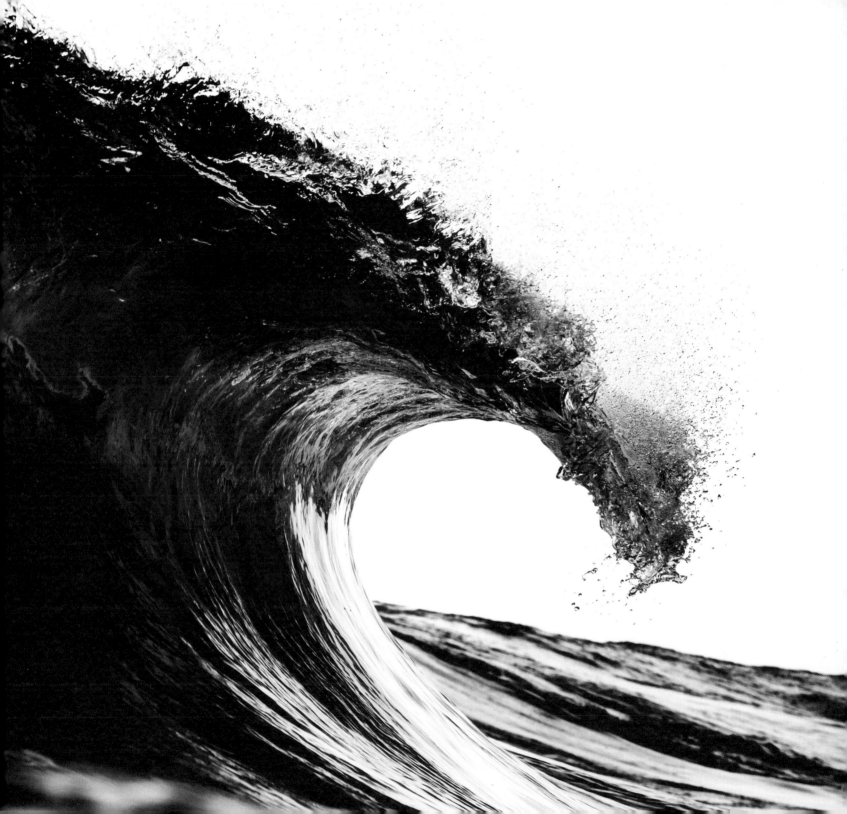

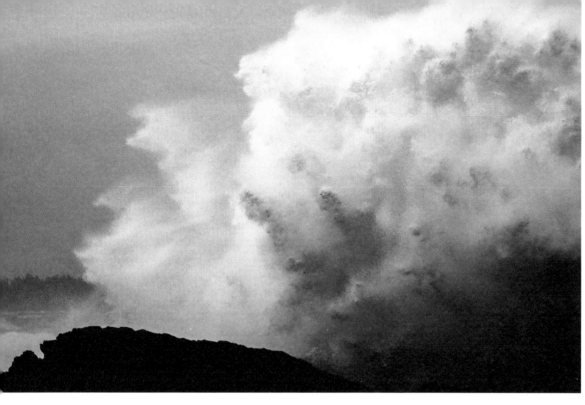

← Before accurate surf fore-casting, people around here would figure out which direction the swell was moving based on whether waves would crash against specific rocks.

← The top half of a wave breaking has always seemed the most interesting to me. Everything about a wave is unique, but when the whole thing rolls over and smooths out, for that short moment it takes on a completely different form.

→ Pete Devries has taken me to this wave a couple of times and I'm still not sure if it's a legitimate spot or not. The reef is so dry that you're basically standing on it while shooting, and there are so many bumps and steps in the face that if you fell in the wrong spot on the takeoff it would be disastrous. I am looking forward to coming here to try again on a bigger day. Maybe I will finally see what Pete's talking about.

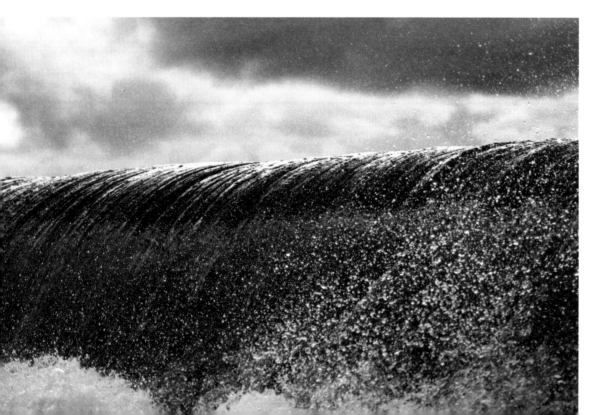

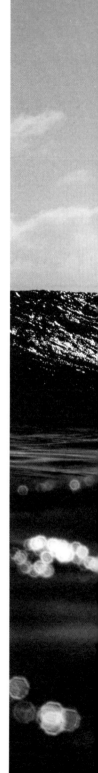

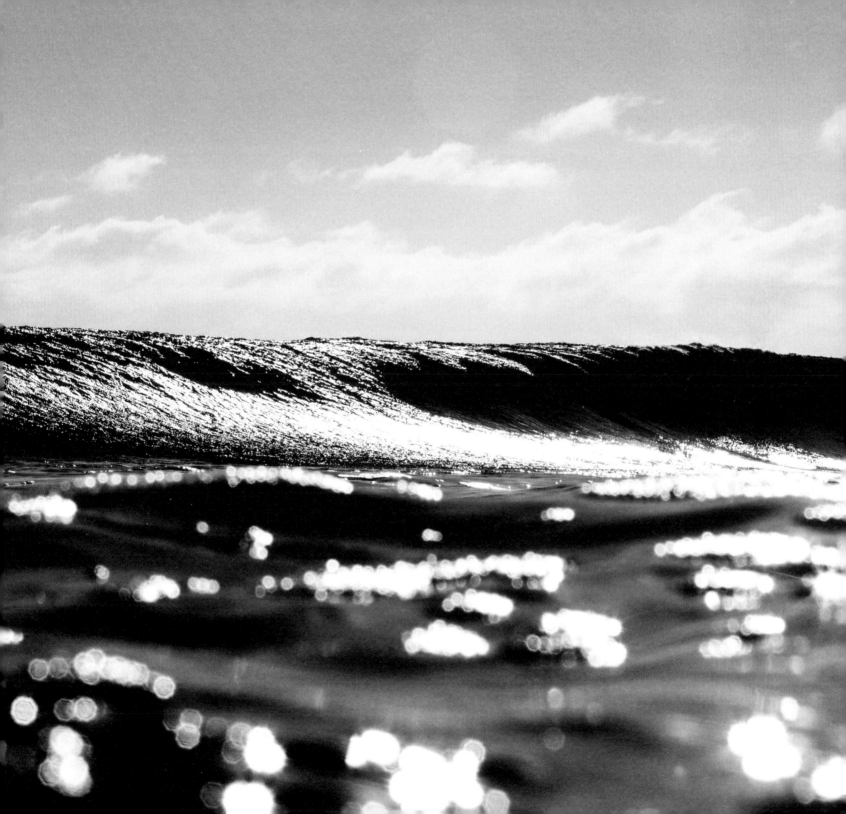

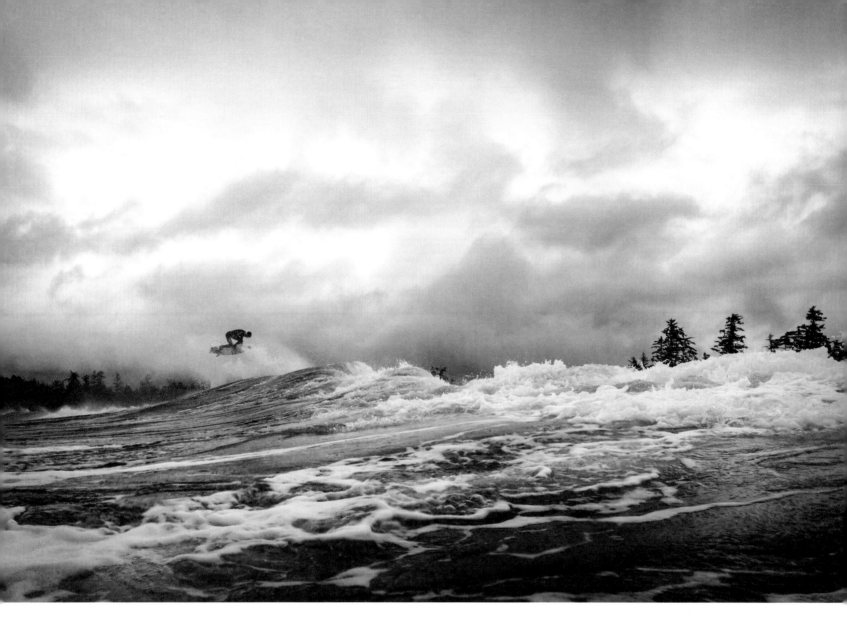

↑ Raph Bruhwiler took Pete Devries and me to a nearby Island in Clayoquot Sound in hopes of finding a decent sandbar to surf alone. Pete demonstrated how good the bar really was as I tried to keep my eye on him while swimming behind the wave.

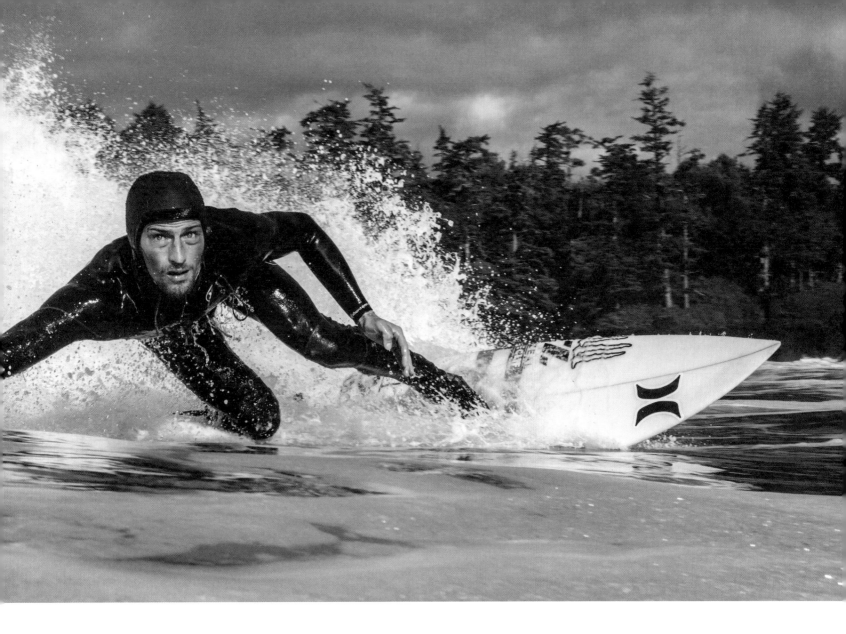

↑ For a very long time, I didn't own a water housing for my camera. I just couldn't afford one and was shooting landlocked for years. Once I finally got one, I felt like I had to make up for lost time. I swam with my camera in all sorts of conditions. Even if it was absolutely terrible I just loved the fact that I would never know what I was going to get. The swell this day was huge, with way too much rip current and wash-through sets, but I continued to try and swim on what felt like a treadmill for hours. Pete caught one all the way to the inside and cranked this bottom turn right in front of me.

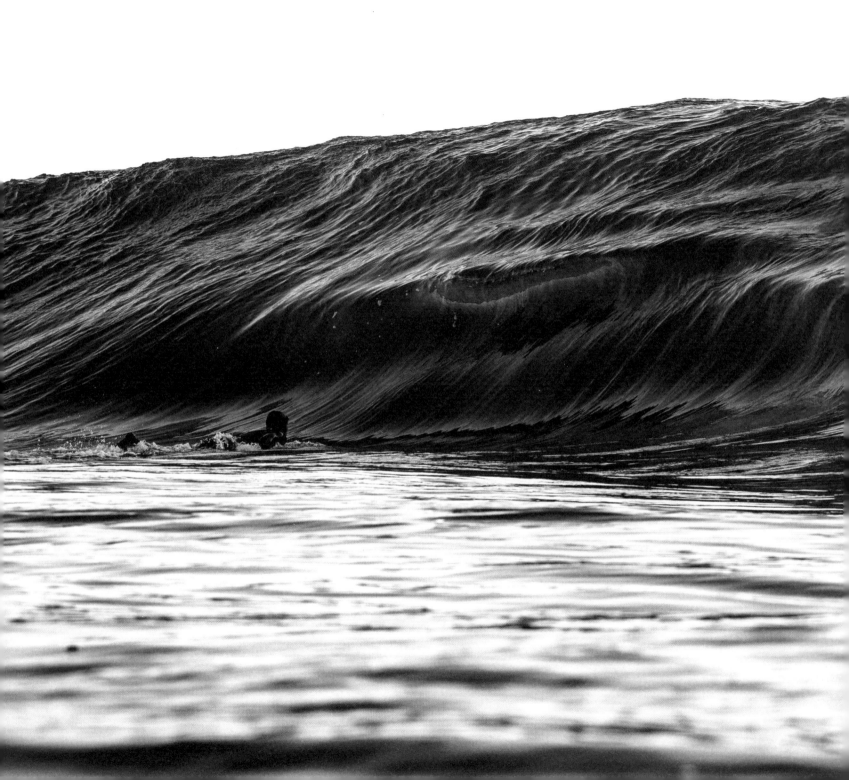

↑ The ocean carries so many different looks depending on the angle you witness them from. This one from a helicopter has to be my favourite new perspective.

← We sat on the beach all day waiting for the wind to switch, but it never did. By the time it glassed off just before sunset, the tide got way too low. Since we'd driven 10 hours to get here, we figured we should give it a dig anyway.

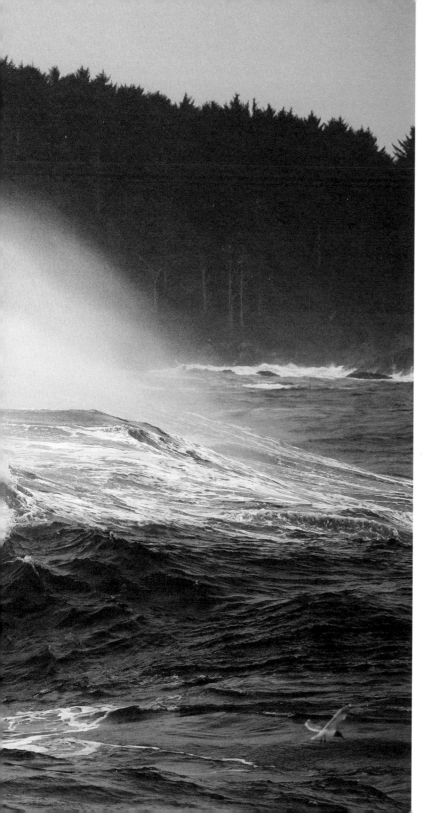

← In the 10 years I've lived in Tofino I've never seen a south swell this large hit our coastline. The ocean seemed angry, the wind was cooking, the power was out all day and it was pissing rain. This classic winter scene on the west coast of Canada made for some seriously entertaining storm watching.

248

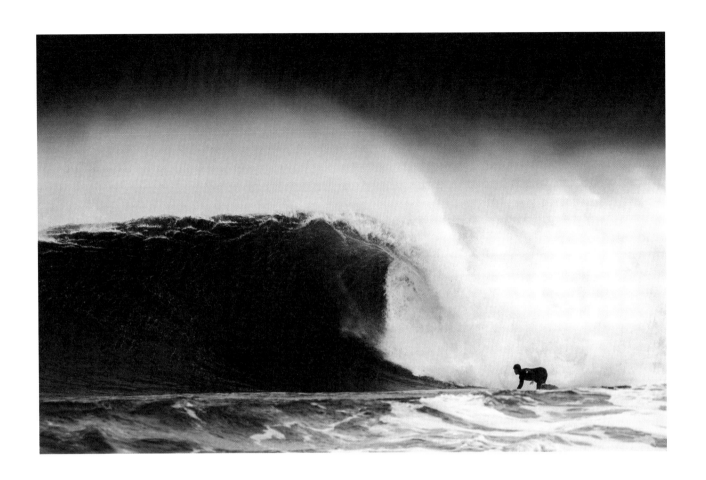

↑ I honestly didn't even believe this wave could hold at this size, but Noah Cohen drove off the bottom and proved me wrong.

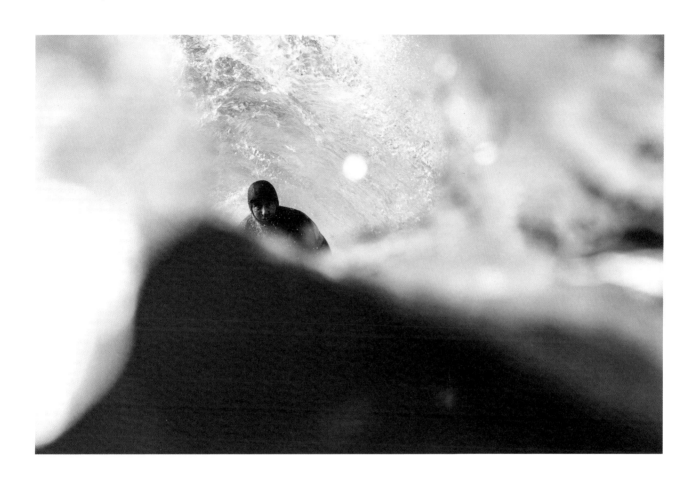

↑ I swam behind legendary local photographer Jeremy Koreski this day. He was shooting with a fisheye lens, so I couldn't help but have him (or his camera) in most of my frames. When Josh Mulcoy took off on this wave, I kept my eye through the viewfinder and made a split-second composition decision as he passed by.

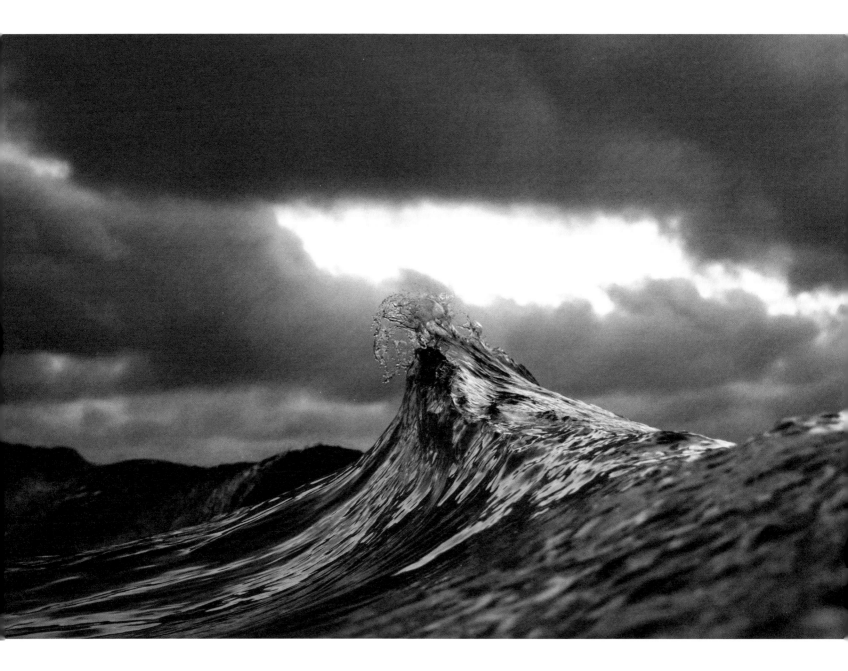

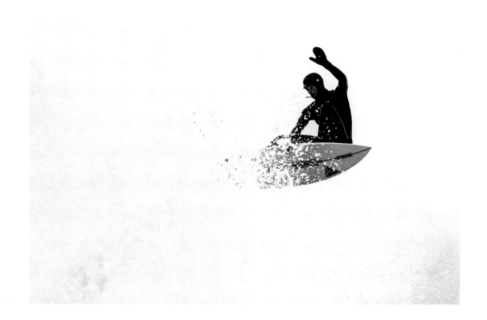

↑ Michael Darling's style is like no other. He's a rare mix of high-performance unpredictability with stylish flow and grace.

« With barely any light left in the sky above, I was just about ready to pack it in when this little bump of swell popped up and encouraged me to keep shooting until it was finally pitch black out.

↳ A sunset that illuminated the entire skyline and a left-handed wave at a right-handed break caught by Isaac Raddysh. Two very rare moments at this undisclosed location on Vancouver Island.

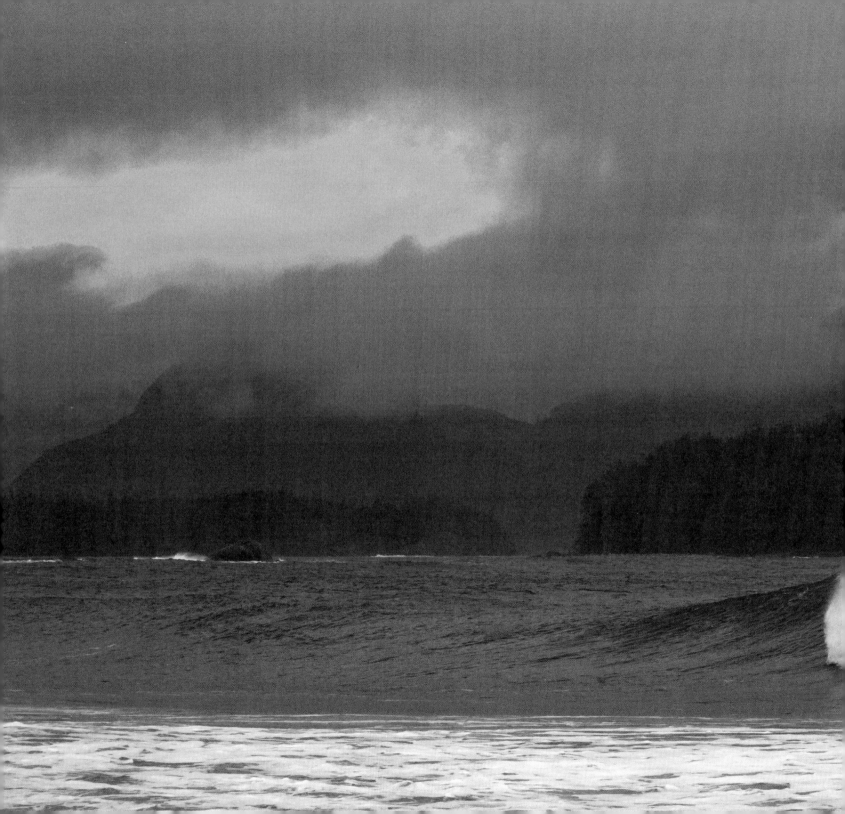

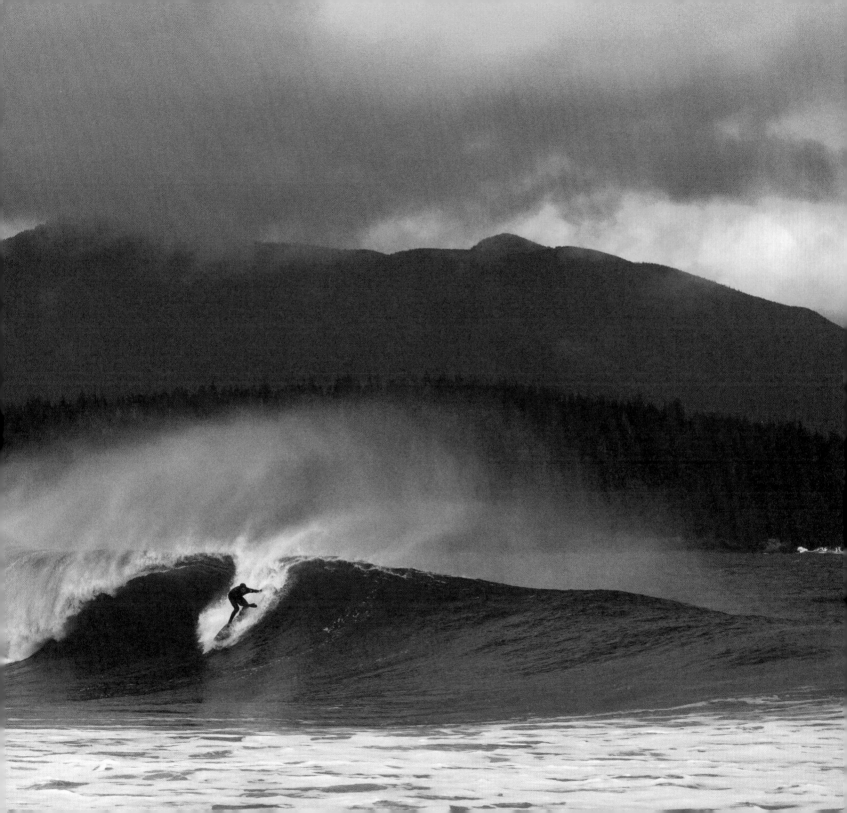

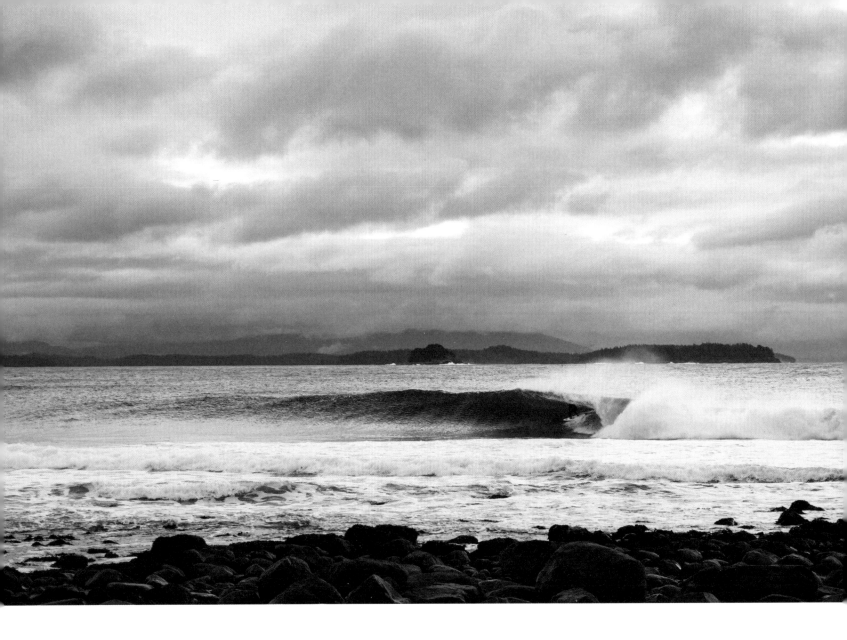

↑ I heard Josh Mulcoy hikes out to this spot in the pitch black with a headlamp on, just to make sure he gets to surf alone before the crowd shows up. As we arrived we watched him get barrelled all by himself over and over again, just like he wanted.

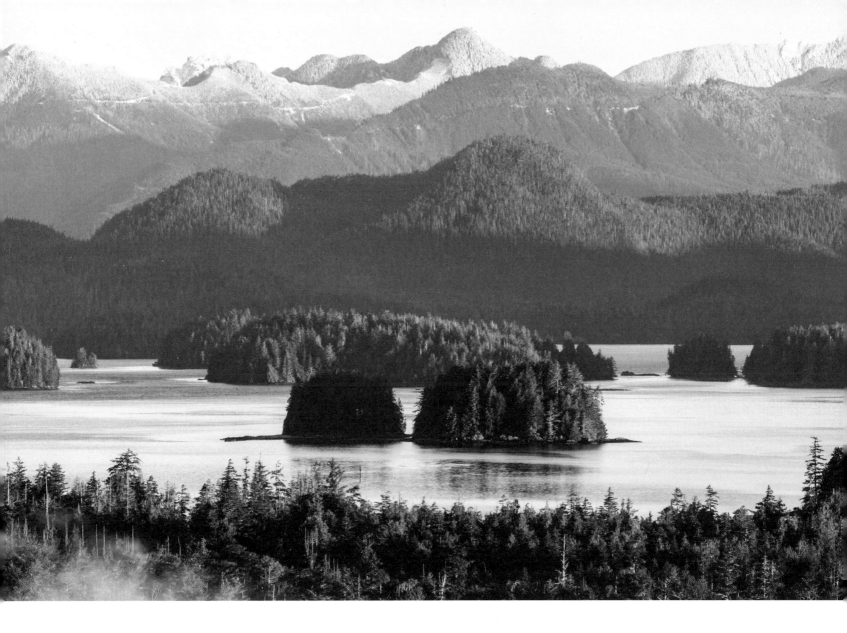

↑ I went for a spur of the moment hike to catch the sunrise on the south side of Pacific Rim National Park with my partner Nora. To my surprise, it was the inlet from the north side that caught my attention, with the mist rising from the beach below.

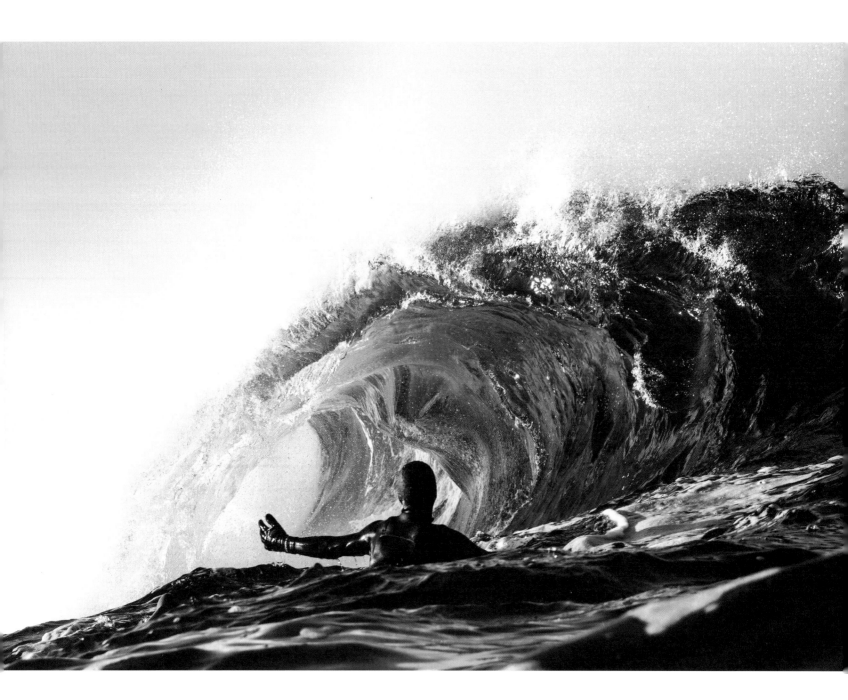

« I've been trying to convince someone to come surf this wave for years now. I'd say one out of a hundred waves that break here is actually rideable. This may or may not have been one of them. Depends on who you're asking.

↓ Andy Jones walks the nose and cheats five, just as the sun rises over the adjacent hills.

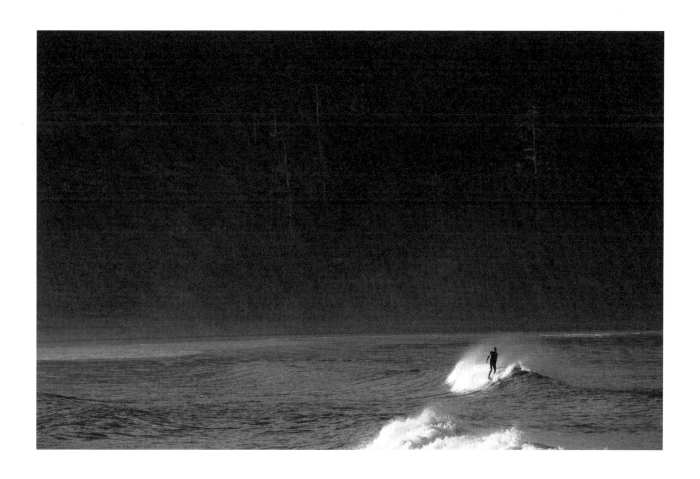

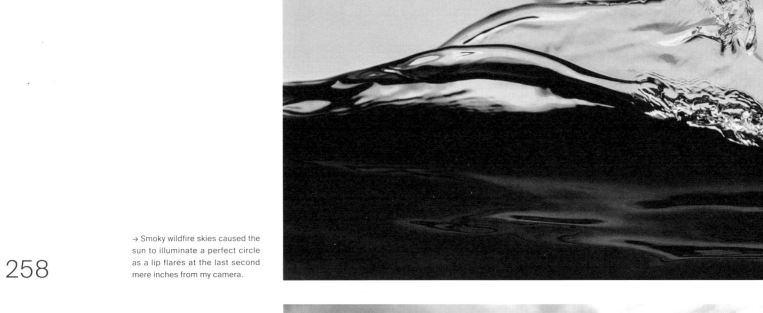

→ Smoky wildfire skies caused the sun to illuminate a perfect circle as a lip flares at the last second mere inches from my camera.

258

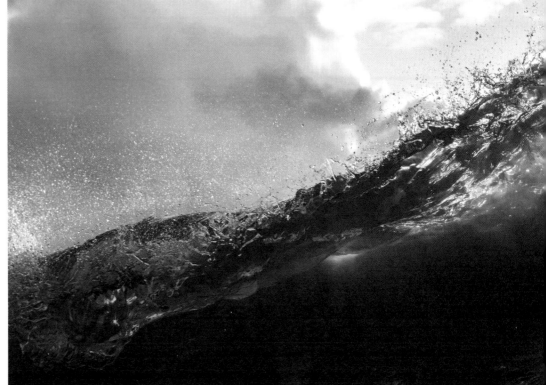

→ "When the wave breaks here, don't be here!"

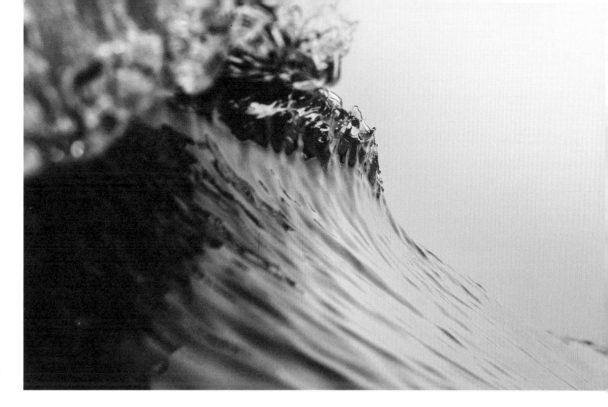

→ Smoky skies, smooth seas and calm conditions.

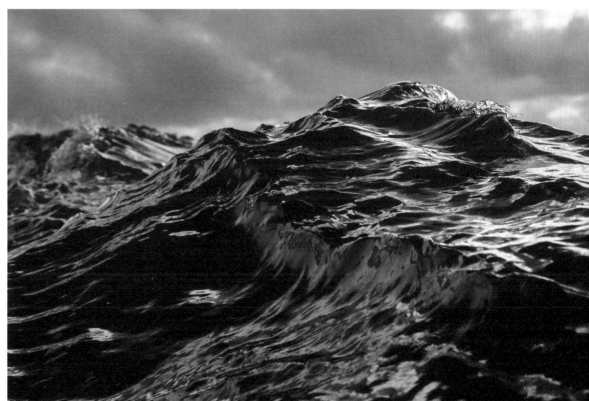

→ This image gives me liquid magma vibes.

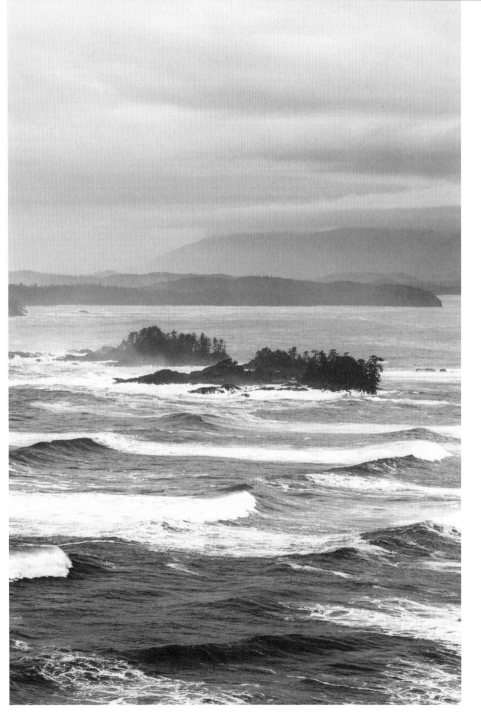

← Twenty-foot swells smashing into this tiny coastal community are nothing new. In fact, it's been happening since long before storm watching became popular.

→ 'A shadow puppet operated by an unseen master' — Noah Cohen

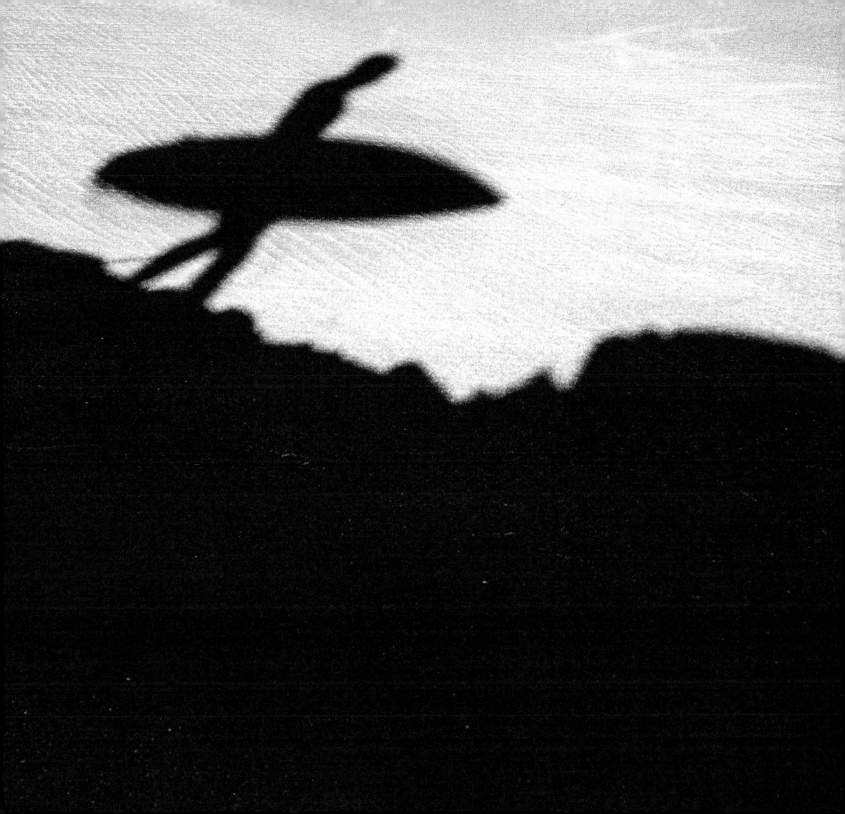

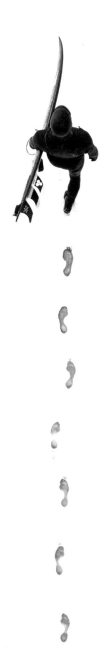

← Who will follow in Pete Devries's footsteps as one of Canada's best internationally known surfers? Only time will tell.

→ I thought I was going to be completely out of position as this wave swung wide and Pete Devries started hustling to get in position. I swam as hard as I could to meet the slab over the reef. As Pete pumped down the line and the wave came over top of us, I knew we had something special. Everything happens so fast when you're shooting in the water, but for a split second I noticed how colourful the water was. Without my realizing it, the sun had popped out of the dark skies just in time to showcase the dynamic colour of the wave. This is probably one of the best surf photos I've ever taken using a fisheye lens.

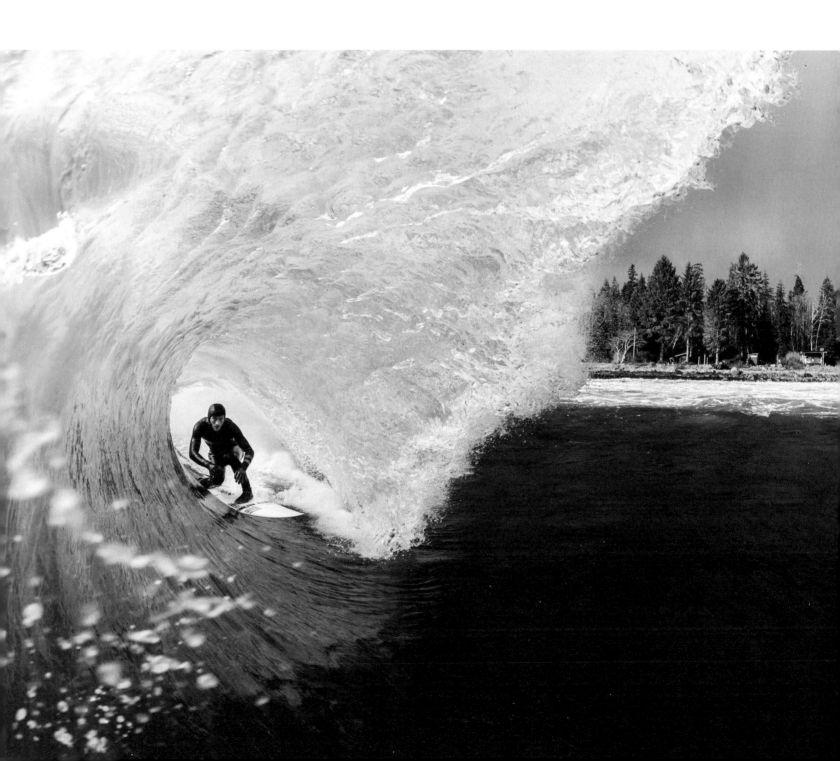

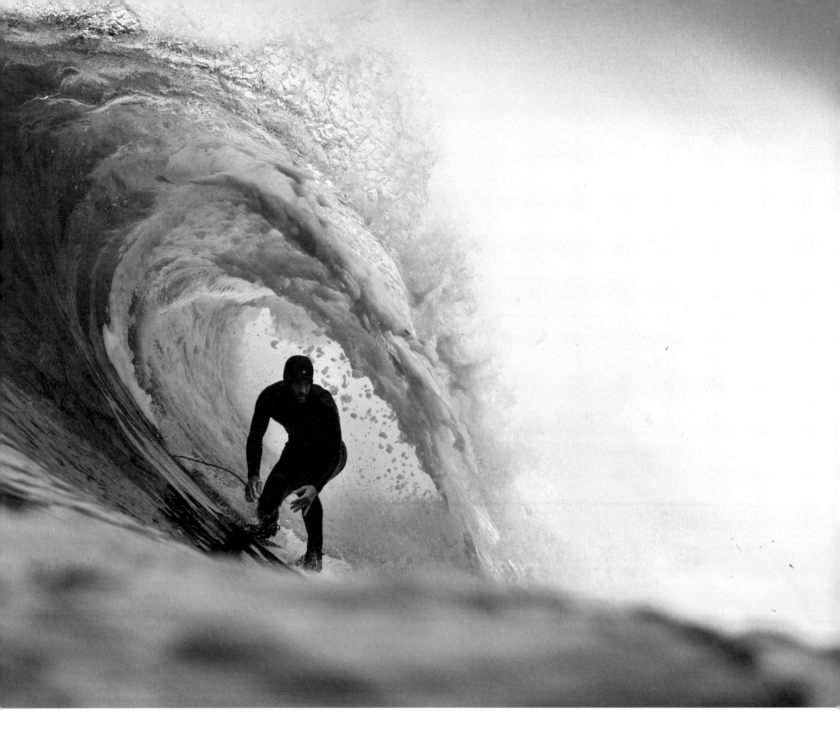

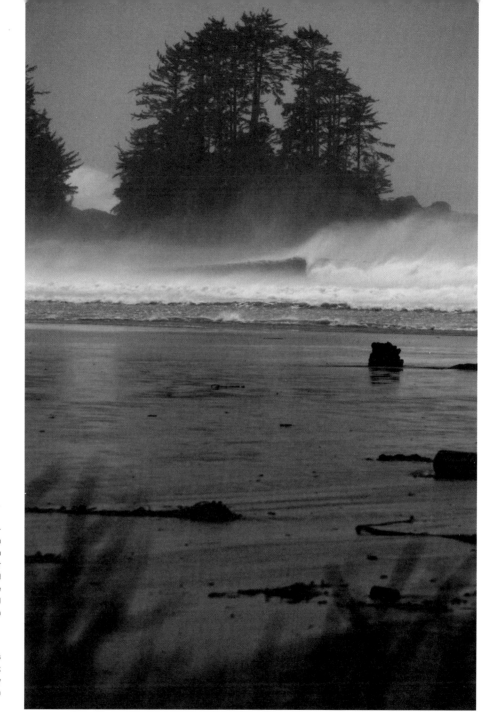

← With two different swell dir-
ections, this wave can be tough
to surf, let alone swim. It's not a
matter of if you get rinsed over
the reef, but when. Pete managed
to find a frothy one through the
fog amongst all the chaos, while I
managed to take the next wave on
the head and called it a day.

→ When the wind howls and it's
raining sideways, this little nook
between two beaches is my
favourite place to storm watch
while checking the surf.

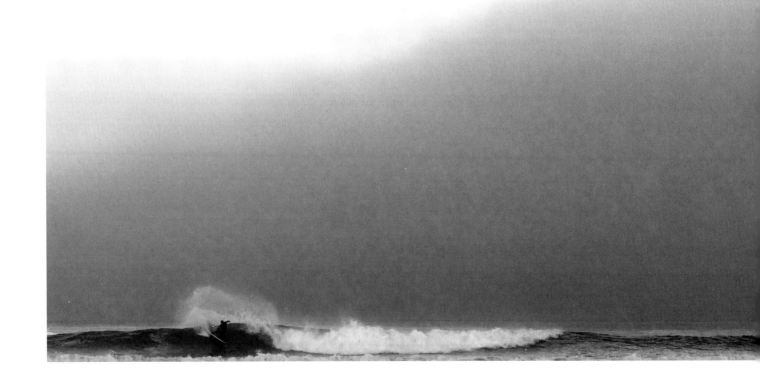

← We slept on the beach in front of this wave during a weekend south swell in the summer. Before we got fogged in, Pete Devries was doing his best to try to spray the full moon.

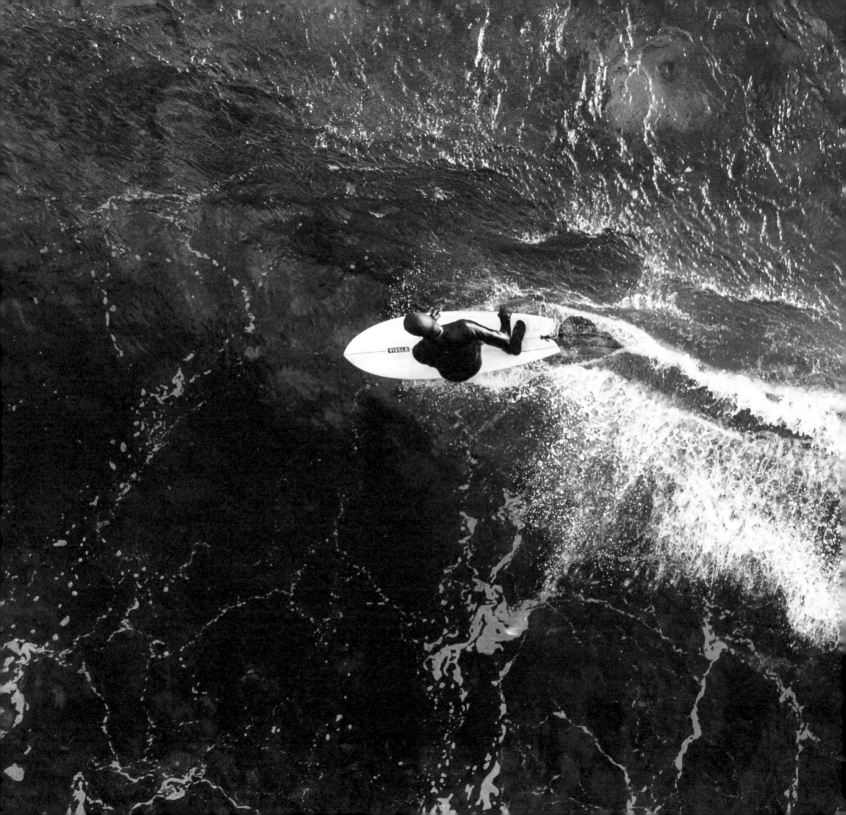

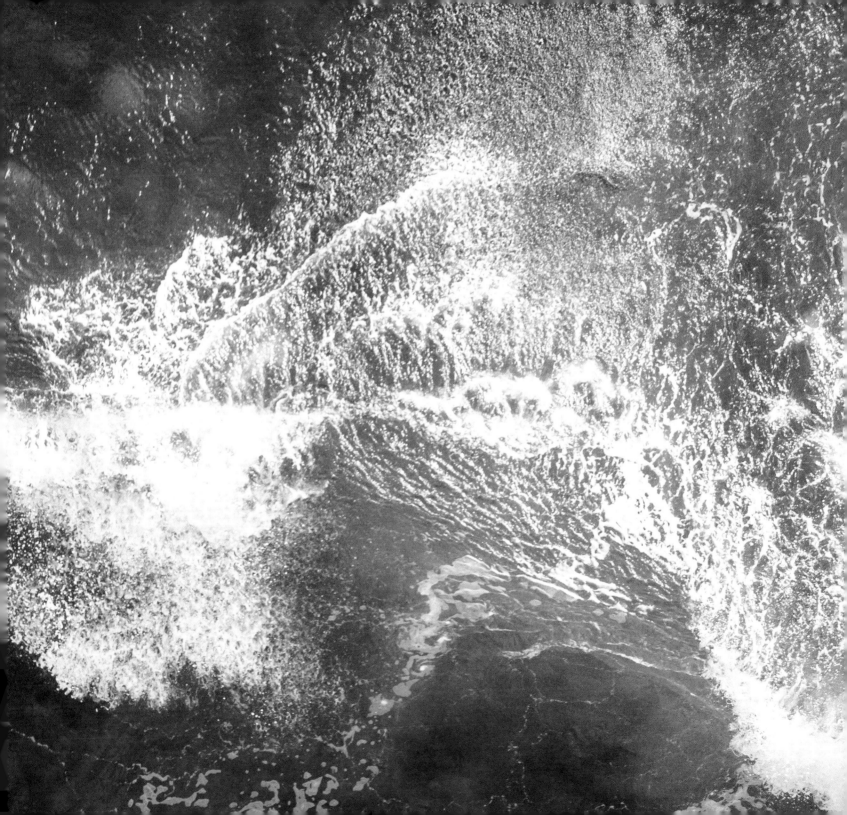

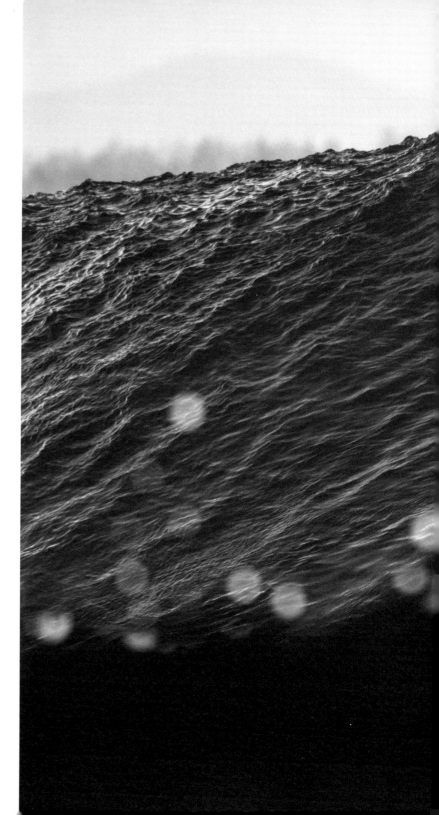

↰ The art of simply going straight: here the simplicity of Michael Darling's approach is undeniably mesmerizing.

→ Back in the day I had a rule for myself: If Pete Devries comes out of three barrels, I swim out with him. This day he went 3/3 on his first few waves, so I started suiting up, only to discover I'd forgotten my fins at home. I was trying to convince myself it was safe to swim here without flippers, but I knew I had to work smart, not hard, and shoot from land.

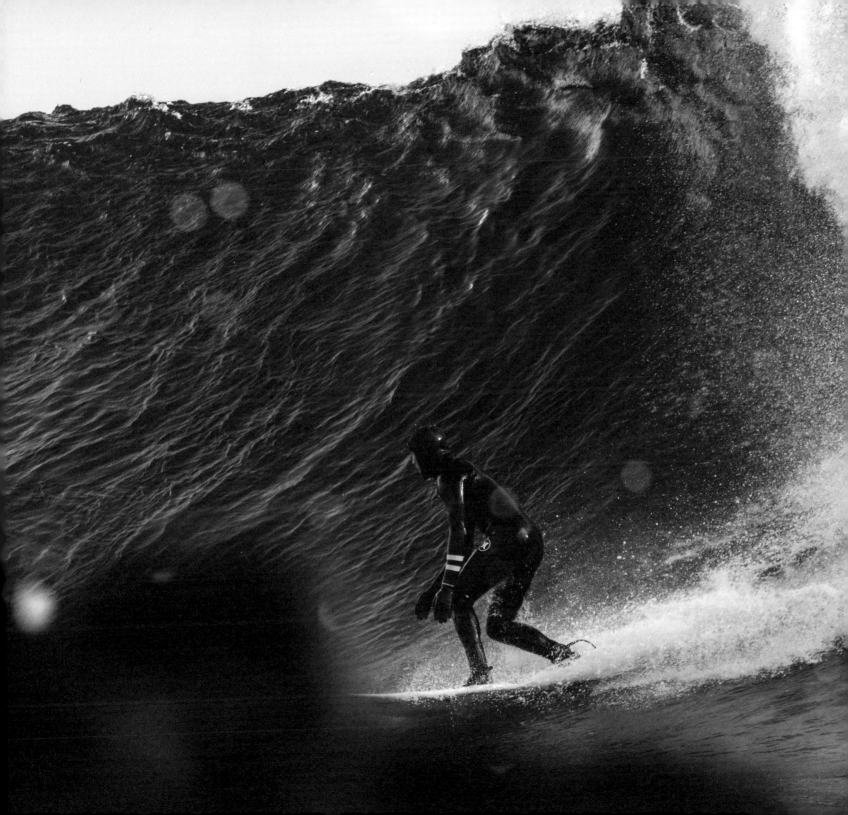

→ This has to be one of my favourite photos of Michael Darling. Handheld speed blurs rarely work, but when they do, the position of the subject is usually off. Given this fickle nature of shooting speed blurs, the frames I shot before and after this one didn't technically work out, and even if they had, the images would have been unusable due to the surfer's position on the wave.

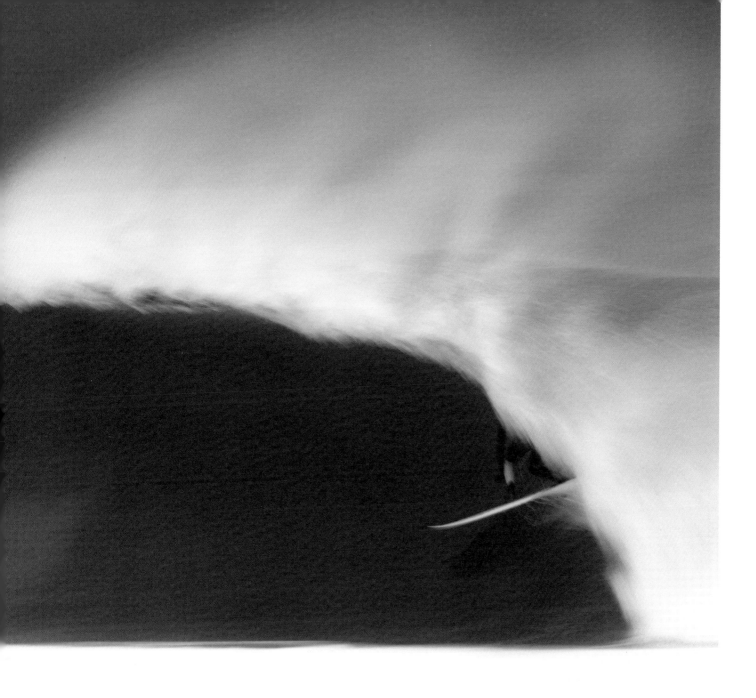

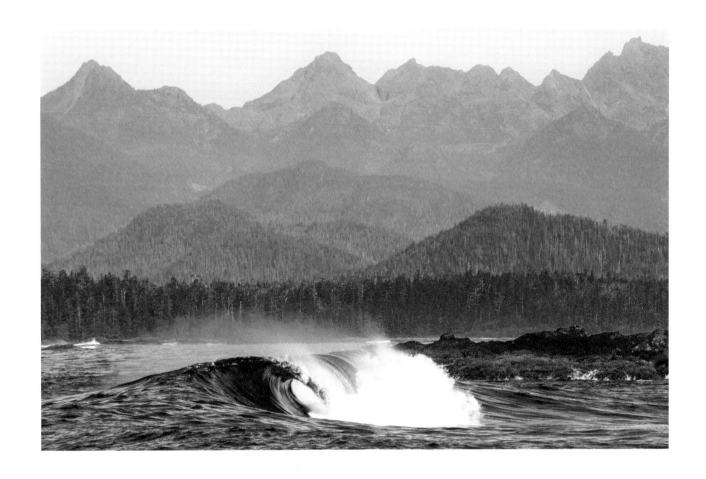

274

↑ Photos can be misleading. This day had overlapping swells, causing the wave to be messy, bumpy and hard to navigate when you're the only one in the water. But every once in a while, a gem like this would come through.

» Andy Jones might be the only surfer to get barrelled on a twin fin at this slab.

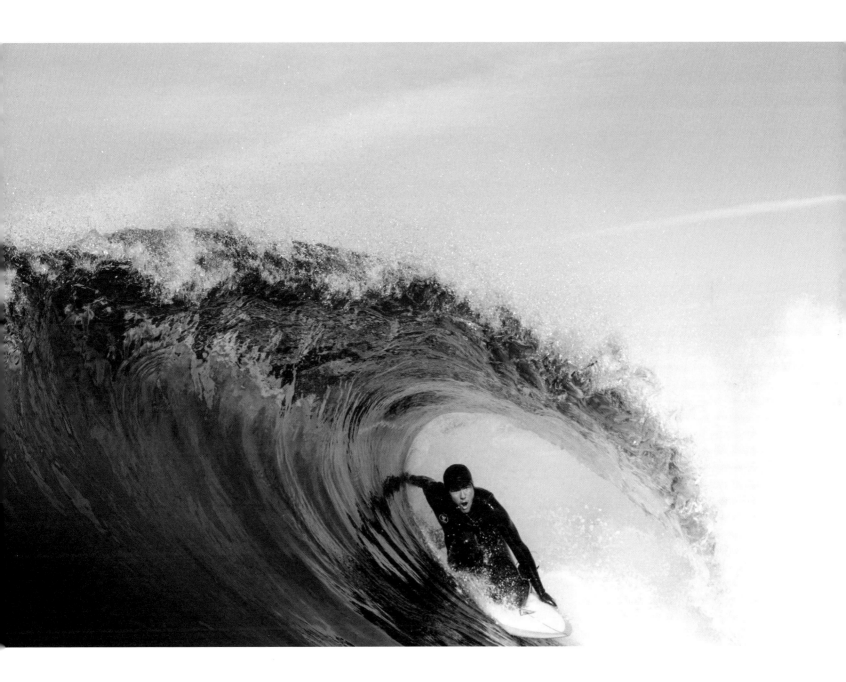

→ Nothing beats surfing and shooting a new wave.

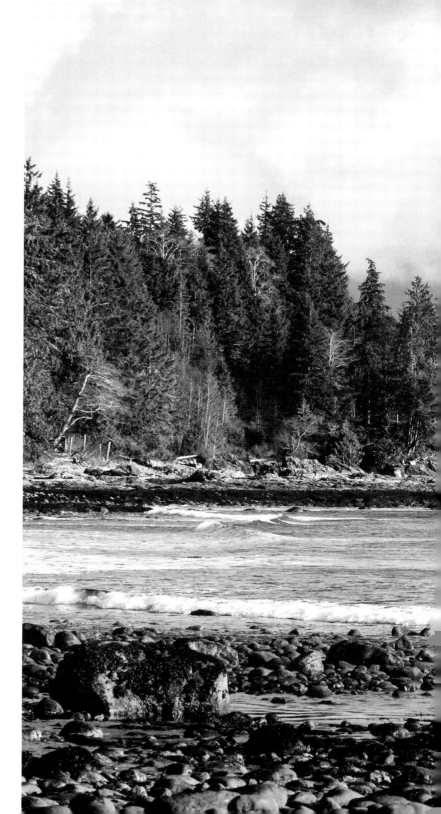

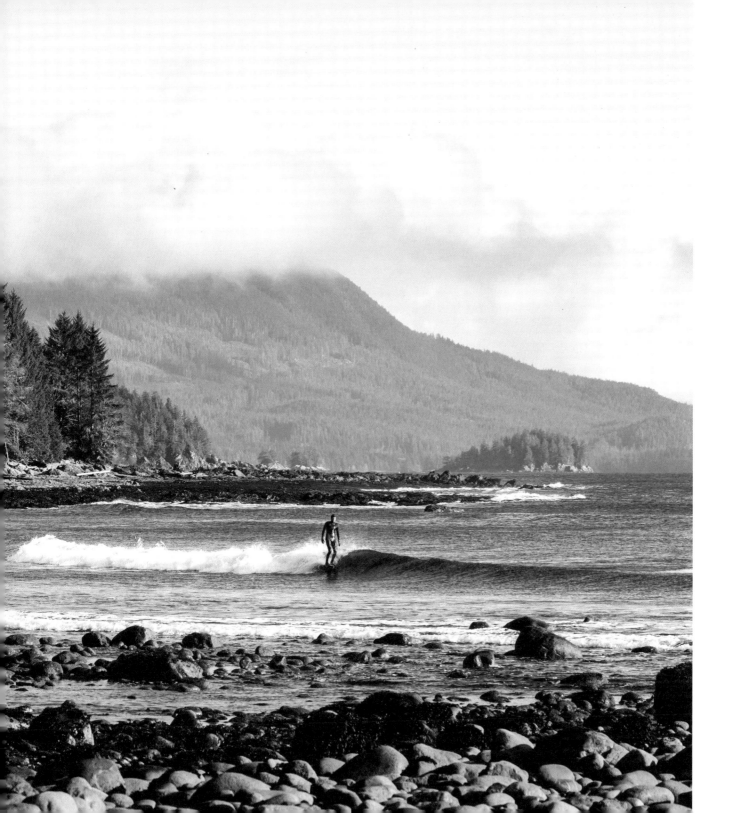

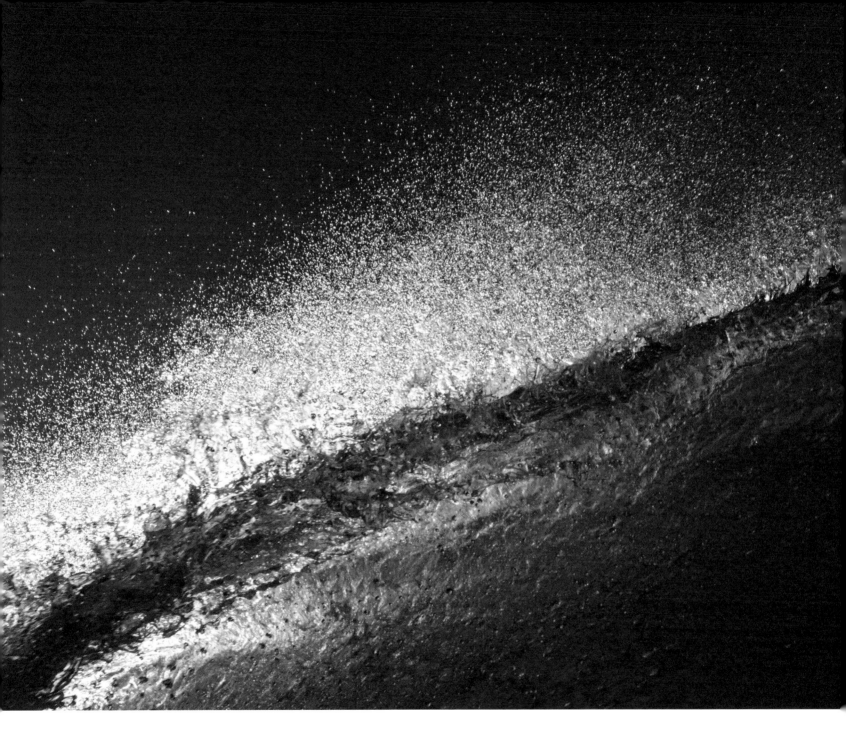

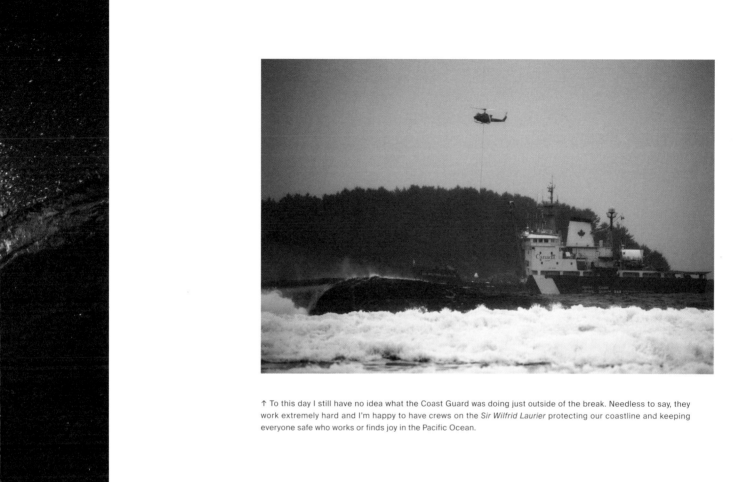

↑ To this day I still have no idea what the Coast Guard was doing just outside of the break. Needless to say, they work extremely hard and I'm happy to have crews on the *Sir Wilfrid Laurier* protecting our coastline and keeping everyone safe who works or finds joy in the Pacific Ocean.

← At this point, my camera had just broken. The display screen stopped working completely and I couldn't view any of my photos. Despite the inconvenience, it was actually pretty fun, shooting blindly and hoping for the best. It was what I would imagine shooting film would be like for some of the surf photography pioneers. I've always had a deep appreciation for those who came before.

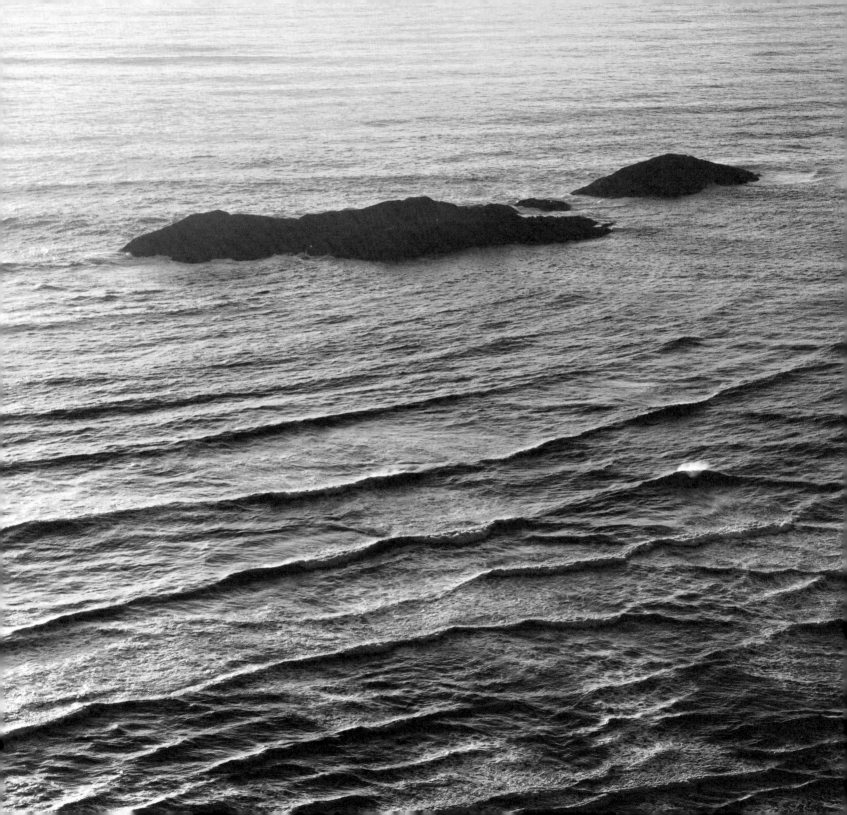

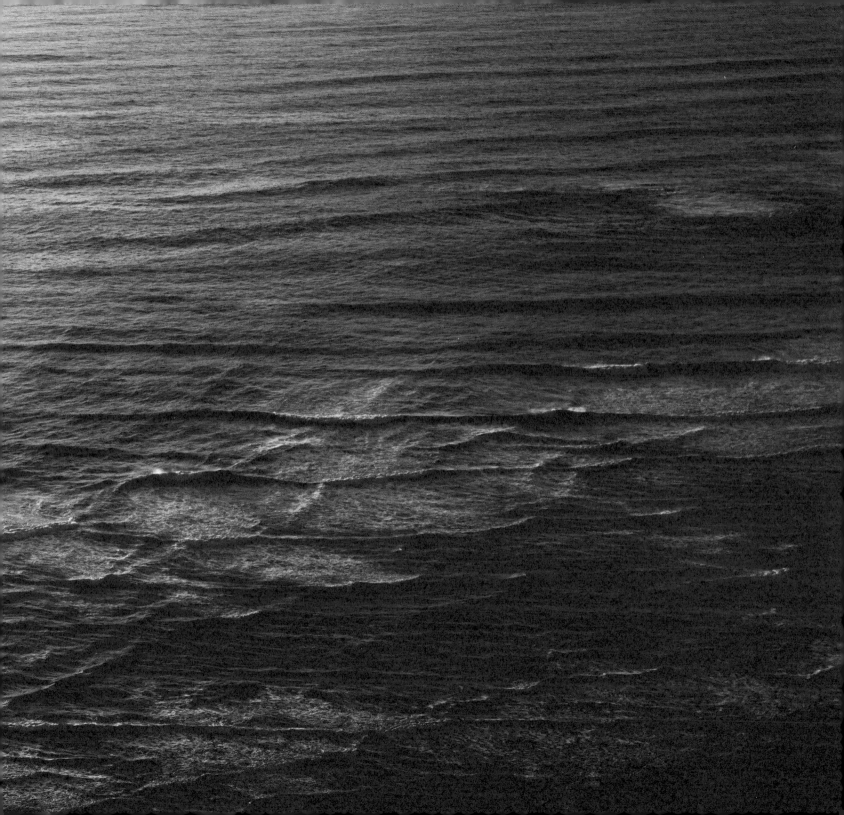

← I took a last-minute helicopter ride during sunset at low tide to check out a slab I've been shooting recently. Turns out we used up most of our time getting there and didn't get to wait for a proper set wave. On the way back I shot as much as I could to make up for the lost effort. Thankfully there was a diamond in the rough amongst all this chaos.

282

→ My first trip to Haida Gwaii beat all of my expectations. This place is so remote that being there sort of feels like you've gone back in time to witness a landscape so raw and untouched. This wave is only accessible by driving along the beach at low tide. The trick is to make sure you leave before the tide gets too high. Otherwise, you're not only stuck out at the spit but your vehicle might get written off too.

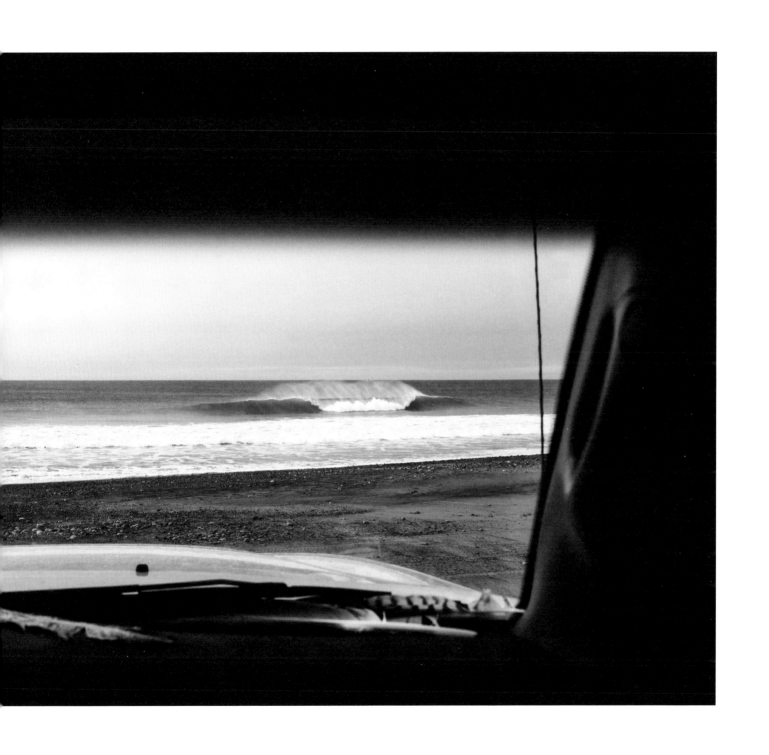

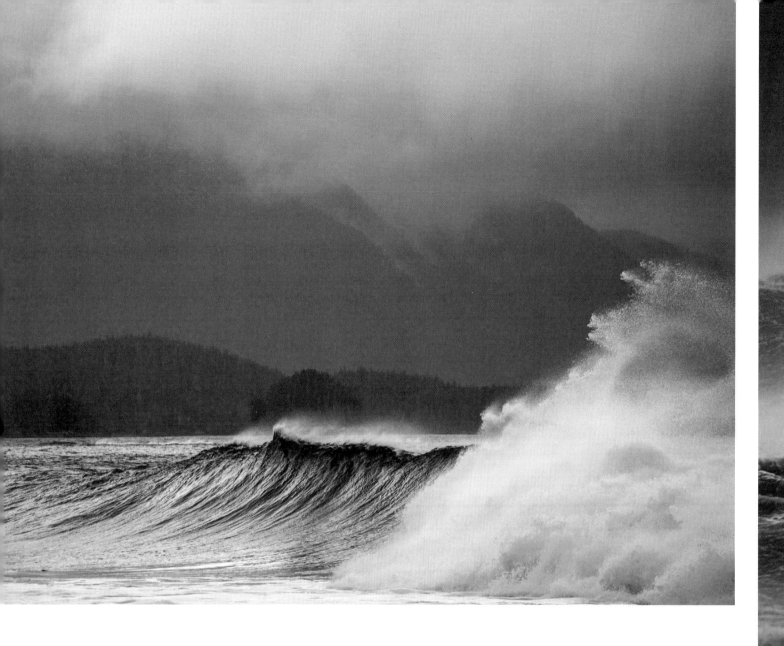

↑ The owner of this spray, Josh Mulcoy, has to be one of the best power surfers in the world, though you would never know it when you meet him, or should I say *if* you meet him. He doesn't like surfing around other people, ever. He moved from a crowded California lineup to quiet Canada in hopes of solitude and isolation. He's as elusive and mysterious as he appears in this photo, which is why I feel like it represents him as a person really well.

→ Tofino during the winter: Rainy, windy, stormy and lonely.

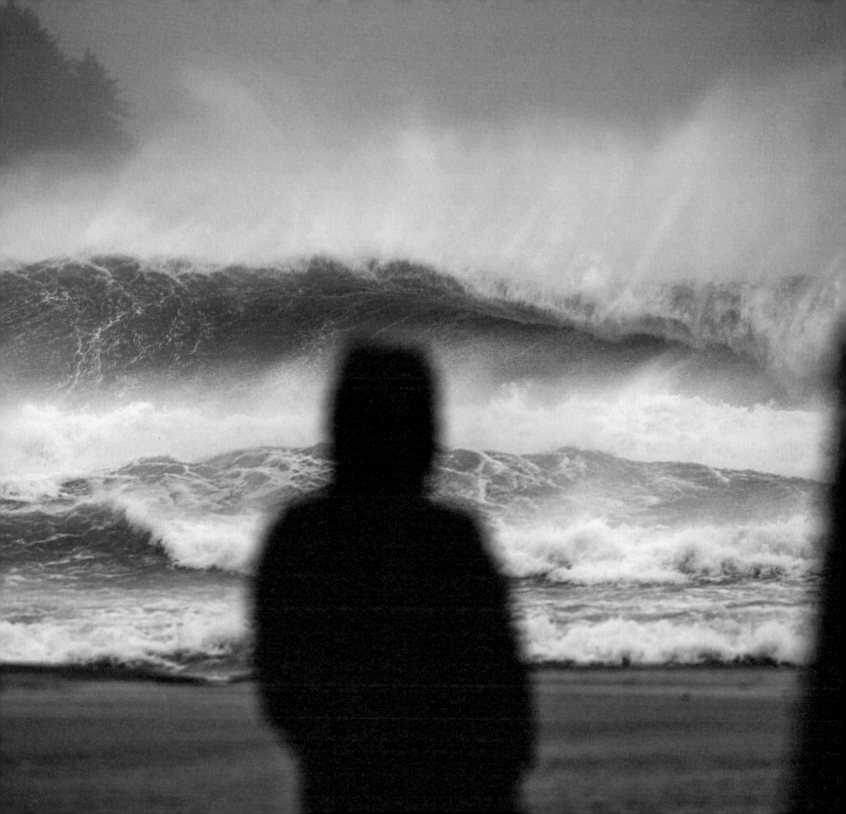

286 → When experimenting with slow shutter speeds I feel more like a painter than a photographer.

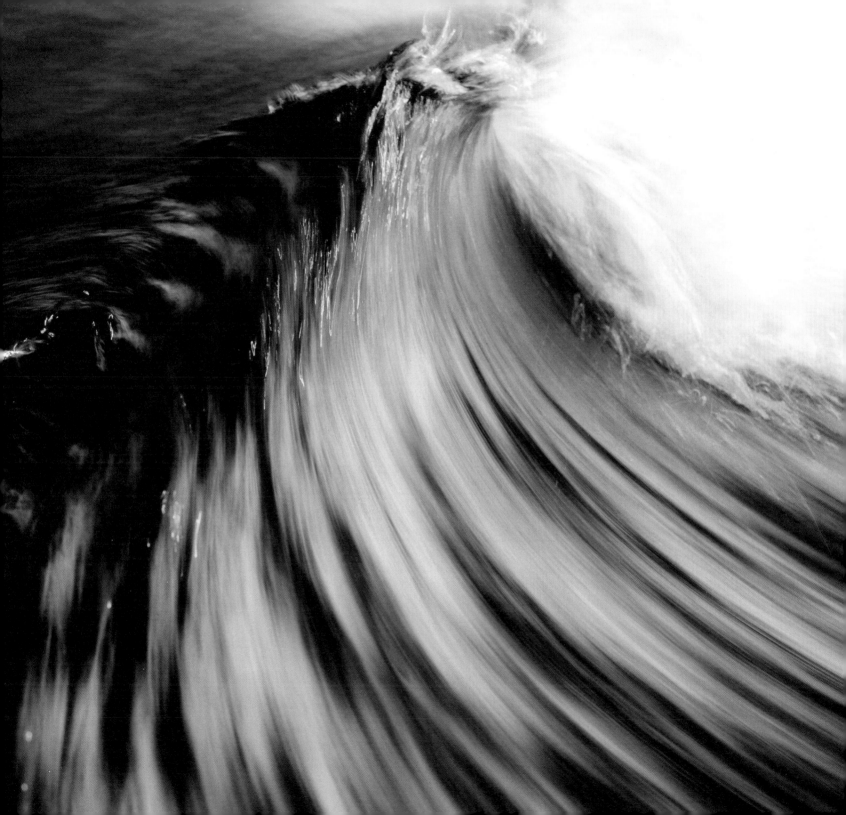

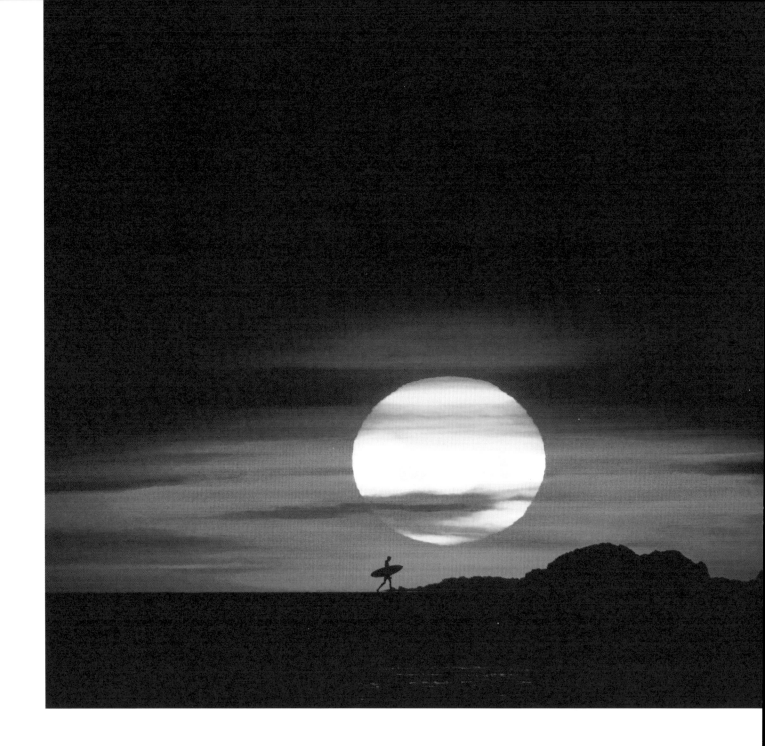

← During the height of the 2018 wildfires, smoke from the burning inter-
ior of British Columbia covered the majority of our province, including
Vancouver Island. Here, Michael Darling heads home from a surf, with an
iconic fireball sinking toward the horizon behind him.

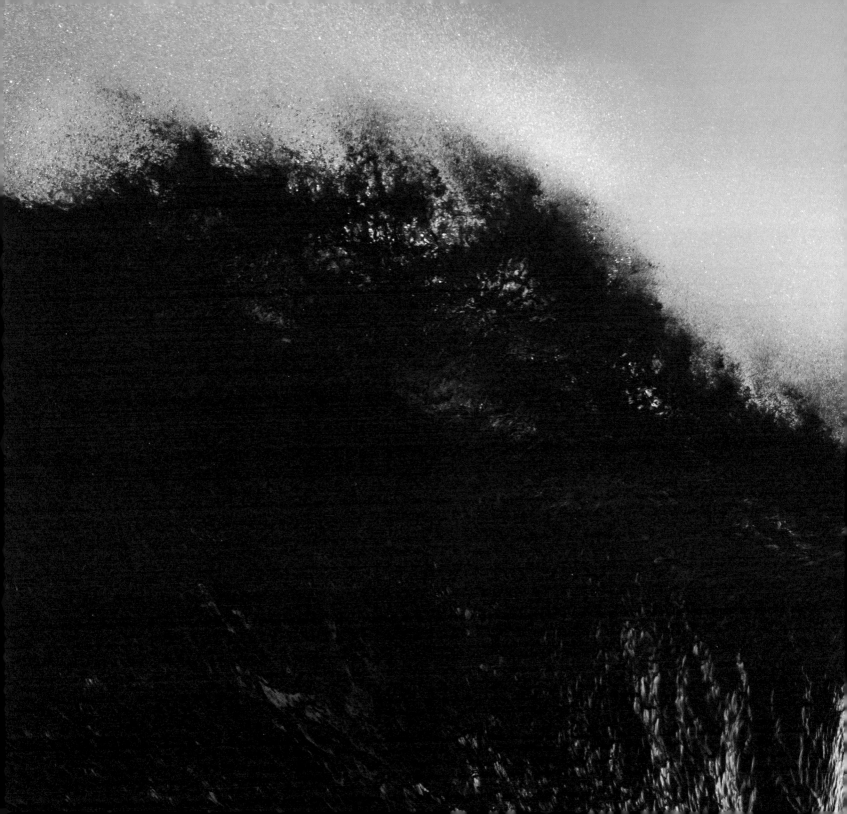

 Water attempting to reach the heavens, only to fall back down to earth.

292

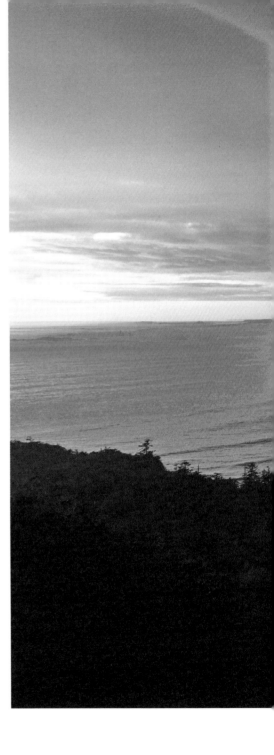

→ I ran up this hill as fast as I could with a backpack full of camera gear, gumboots covered in mud, and a tripod in hand. When I got to the top, I was sweating profusely and sucking back air. This was the best sunset I've ever seen in my entire life, and I made it just in time.

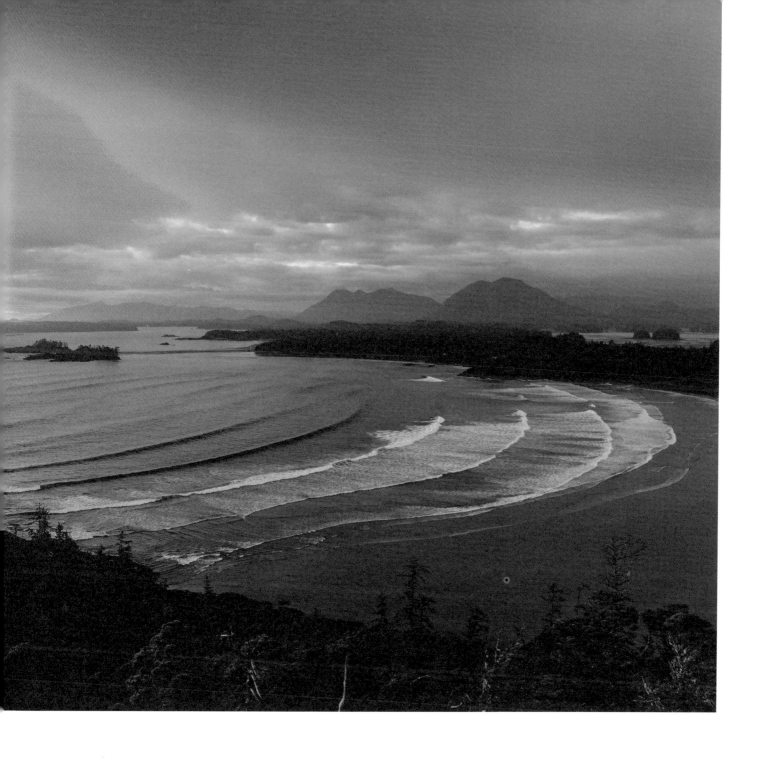

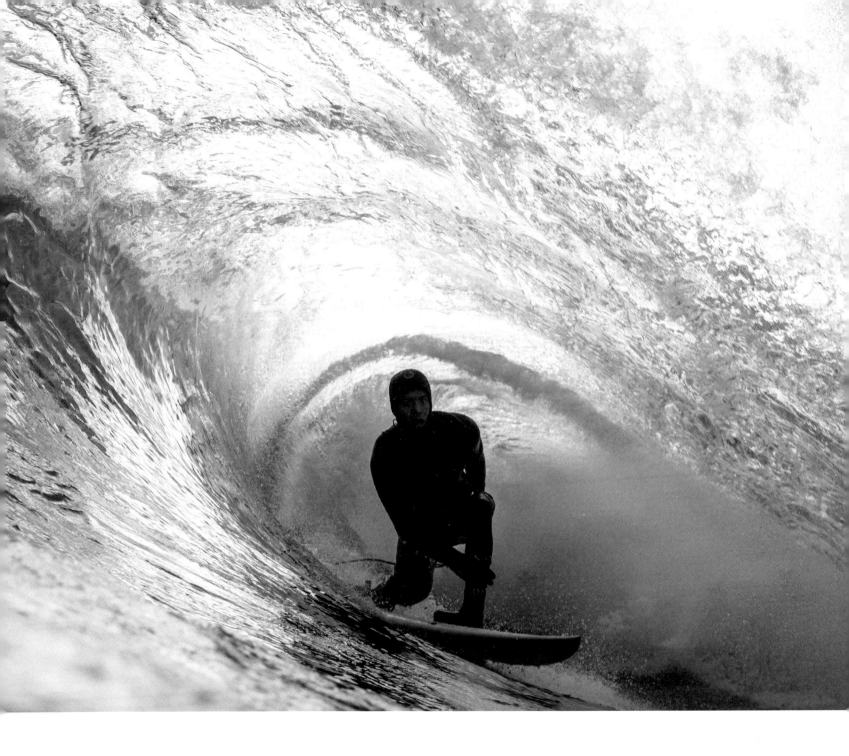

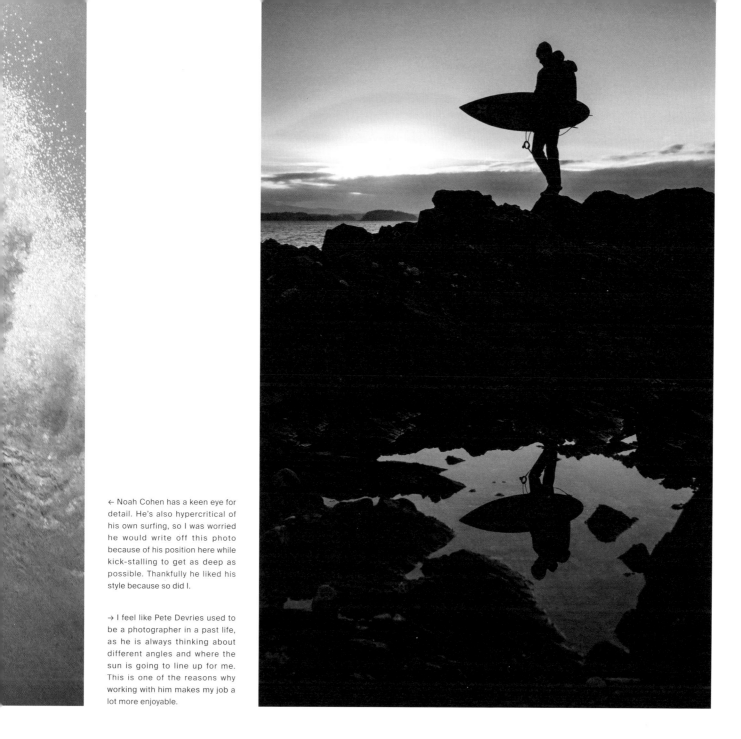

← Noah Cohen has a keen eye for detail. He's also hypercritical of his own surfing, so I was worried he would write off this photo because of his position here while kick-stalling to get as deep as possible. Thankfully he liked his style because so did I.

→ I feel like Pete Devries used to be a photographer in a past life, as he is always thinking about different angles and where the sun is going to line up for me. This is one of the reasons why working with him makes my job a lot more enjoyable.

295

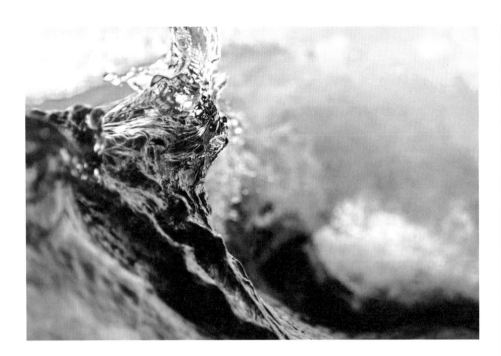

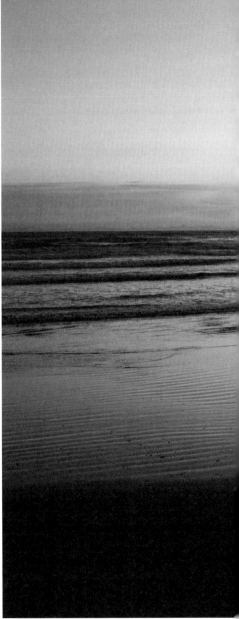

↑ As one part of the wave pushes onto the reef another section of the same wave begins to stand tall and flick forward.

→ A forgettable surf session with an unforgettable sunset as the shore-birds make way for Michael Darling during their yearly migration.

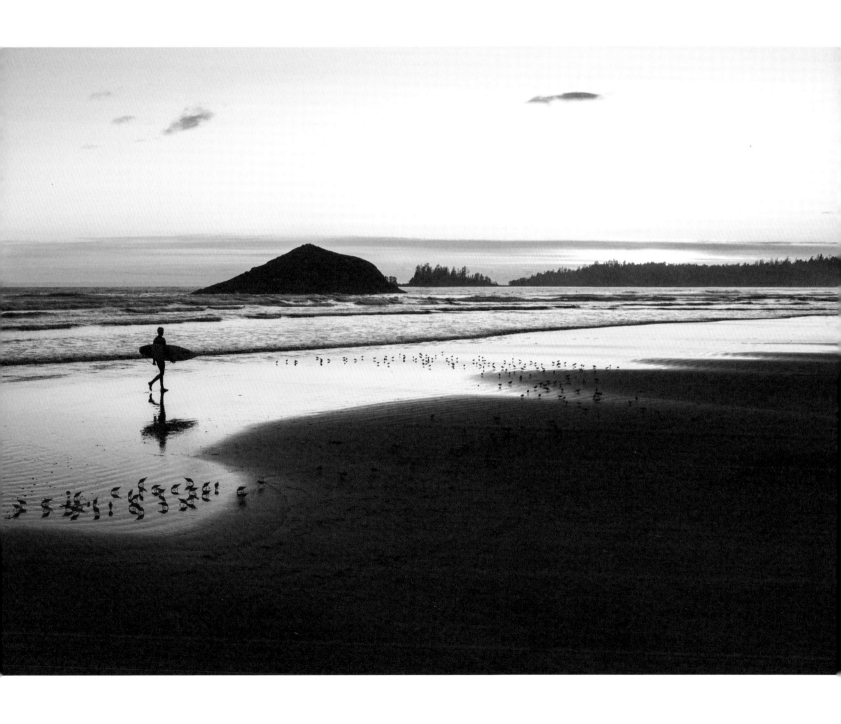

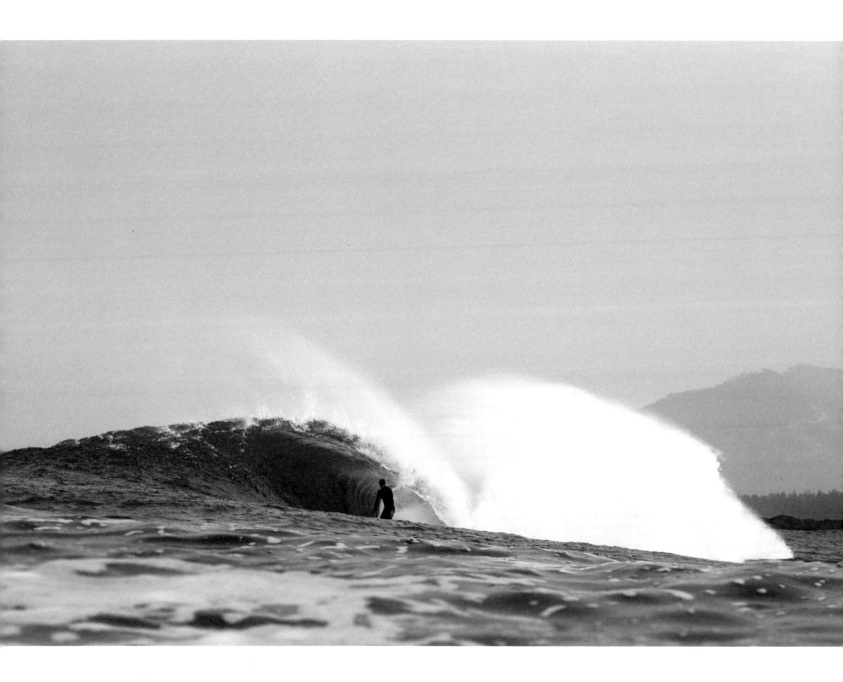

« Pete Devries has made a name for himself by surfing this wave flawlessly. Cold, alone and in the middle of nowhere, getting barrelled.

↓ This particular frame of Pete Devries makes me think of the song "Space Odyssey" by David Bowie.

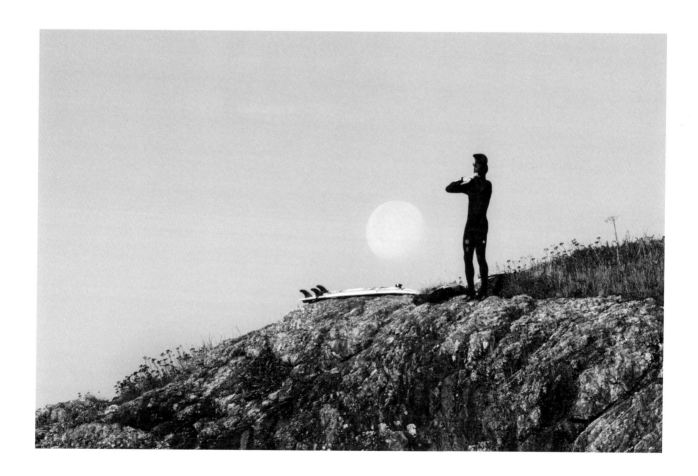

↓ This wave collapsed in front of me and spat its remaining spray into the darkening sky above.

≫ Michael Darling bruised his tailbone shortly after this wave, when his board flipped mid-air and he landed on it with his lower back. He hobbled out of the water and went home to start packing for his team trip to Nova Scotia the next day.

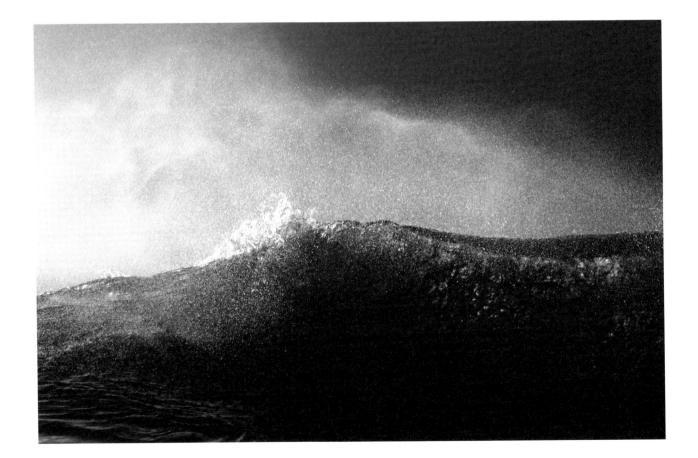

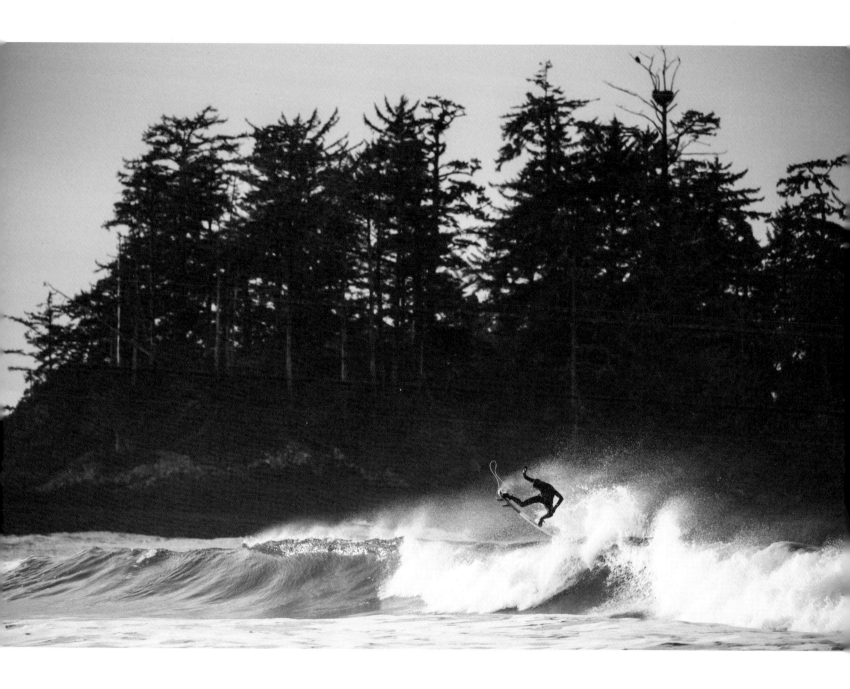

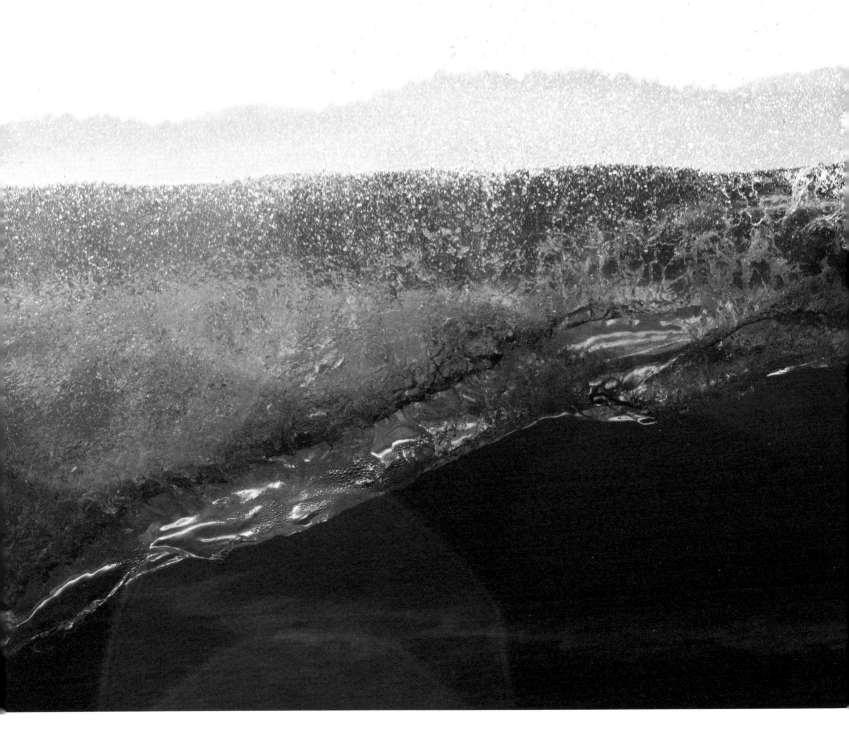

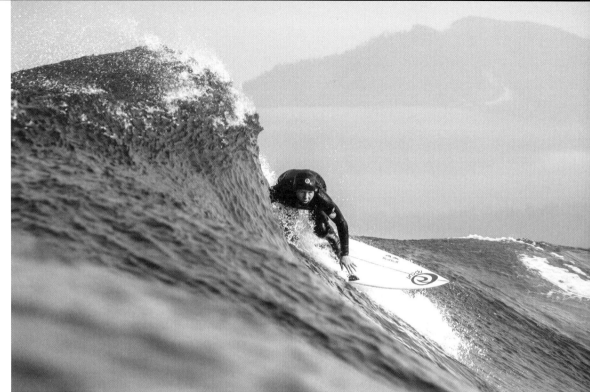

↑ Mathea Olin has really been putting in her time at this spot. It's a notoriously dangerous slab that has made a name for itself over the years, as even a small inside wave could snap a board (or a leg) like a twig

← Having both sunshine and this particular swell direction here is such a rarity. It's a winning combination I've been waiting to witness again ever since.

↳ No wave is ever the same and not all are created equal.

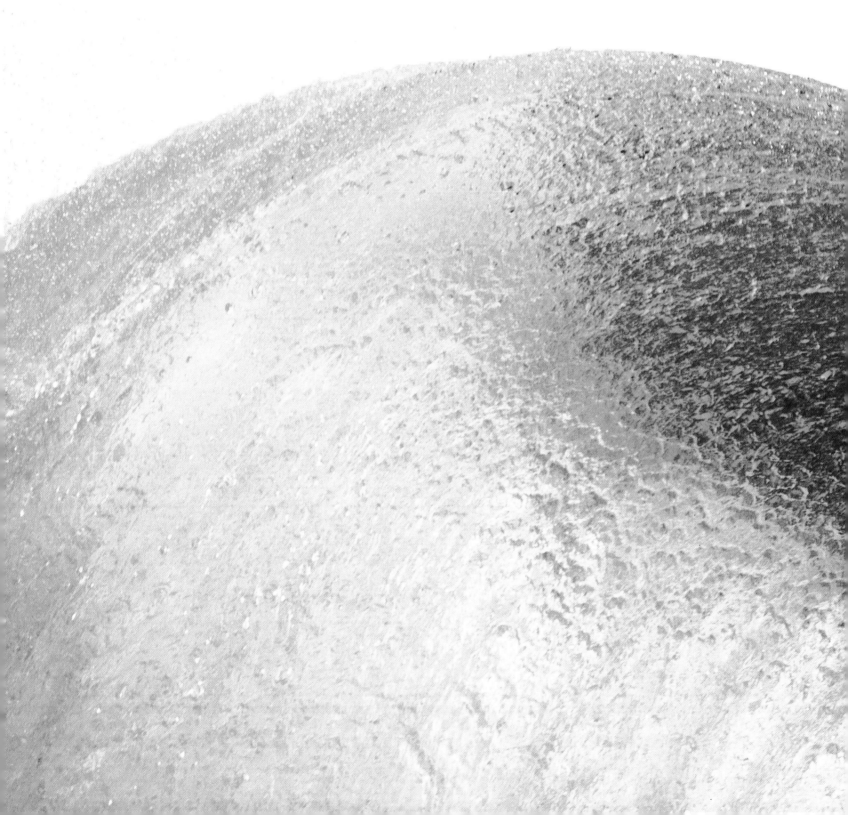

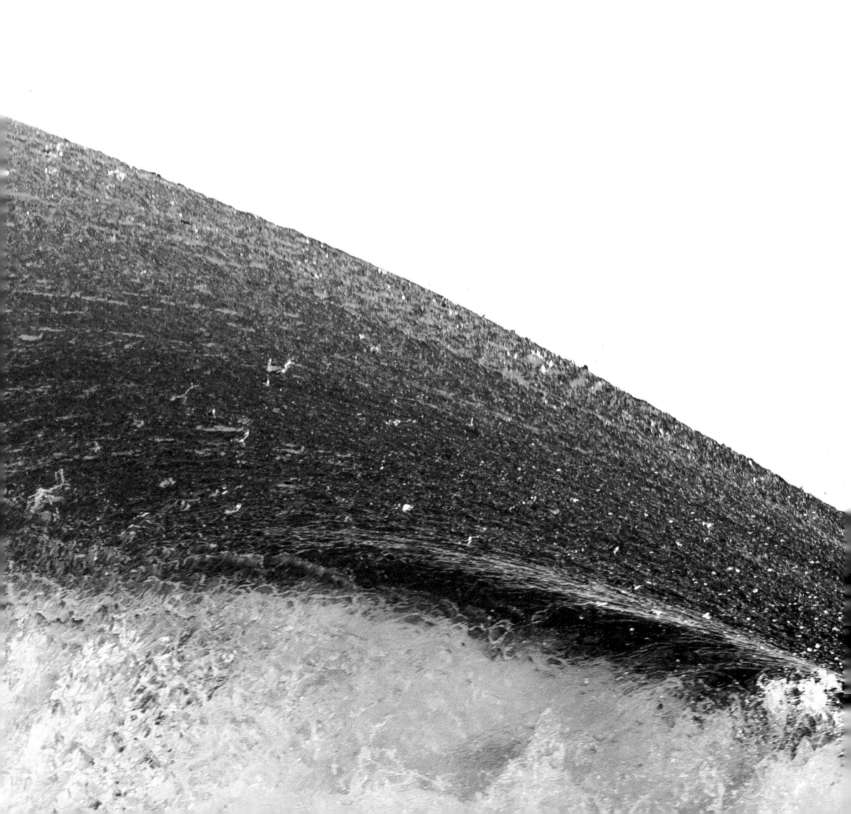

Mom, Dad and Francesca

Nora Boileau Morrison

Stefan Aftanas

Allister Fernie

Blair Polischuk (RIP)

Boomer Jerritt

Brian Hockenstein

Matthew Lettington

John Mandziuk

All of my friends and family

Every surfer and athlete that has allowed me to
take their photo over the years. You know who you are.

ABOUT THE AUTHOR

Marcus Paladino is a professional photographer specializing in cold-water surfing on the west coast of Canada. He grew up on Vancouver Island, where he went on to receive a diploma in photography in 2010. Shortly after, he moved to Tofino for a summer and hasn't looked back. Marcus's work has been featured in various publications around the world, including *SURFER*, *Surfing* magazine, *The Surfer's Journal*, *Explore* magazine, *Tracks* and *Carve*. He has also worked with clients internationally, including Hurley, Monster Energy, Red Bull, Hydro Flask, Reef, Yeti, Clif Bar & Company, O'Neill and Vans. His dedication to showcasing high-performance surfing that continues to be pushed north of the 49th parallel, along with his distinctively artistic approach, has made Marcus one of the most sought-after water photographers in Canada.

All images from this book can be purchased as photographic prints for your home. Please visit marcuspaladino.com for more information.

Copyright © 2021 by Marcus Paladino

First Edition

For information on purchasing bulk quantities of this book, or to obtain media excerpts or invite the author to speak at an event, please visit rmbooks.com and select the "Contact" tab.

RMB | Rocky Mountain Books Ltd.

rmbooks.com

@rmbooks

facebook.com/rmbooks

Cataloguing data available from Library and Archives Canada

ISBN 9781771603997 (hardcover)

ISBN 9781771604000 (electronic)

Cover design by Maks Eidelson

Interior design by Colin Parks

Printed and bound in China

We would like to also take this opportunity to acknowledge the traditional territories upon which we live and work. In Calgary, Alberta, we acknowledge the Niitsitapi (Blackfoot) and the people of the Treaty 7 region in Southern Alberta, which includes the Siksika, the Piikuni, the Kainai, the Tsuut'ina, and the Stoney Nakoda First Nations, including Chiniki, Bearpaw, and Wesley First Nations. The City of Calgary is also home to Métis Nation of Alberta, Region III. In Victoria, British Columbia, we acknowledge the traditional territories of the Lkwungen (Esquimalt and Songhees), Malahat, Pacheedaht, Scia'new, T'Sou-ke, and W̱SÁNEĆ (Pauquachin, Tsartlip, Tsawout, Tseycum) peoples.

All rights reserved. No part of this publication may be reproduced, stored in a retrieval system, or transmitted in any form or by any means – electronic, mechanical, audio recording, or otherwise — without the written permission of the publisher or a photocopying licence from Access Copyright. Permissions and licensing contribute to a secure and vibrant book industry by helping to support writers and publishers through the purchase of authorized editions and excerpts. To obtain an official licence, please visit accesscopyright.ca or call 1-800-893-5777.

We acknowledge the financial support of the Government of Canada through the Canada Book Fund and the Canada Council for the Arts, and of the province of British Columbia through the British Columbia Arts Council and the Book Publishing Tax Credit.